ARTS IN CRISIS

Also by Joseph Wesley Zeigler
Regional Theatre: The Revolutionary Stage

ARTS IN CRISIS

THE NATIONAL ENDOWMENT FOR THE ARTS VERSUS AMERICA

JOSEPH WESLEY ZEIGLER

a cappella books

Library of Congress Cataloging-in-Publication Data

Zeigler, Joseph Wesley.
 Arts in crisis : the National Endowment for the Arts versus America /
Joseph Wesley Zeigler.
 p. cm.
 Includes bibliographical references and index.
 ISBN 1-55652-204-5 : $24.95. — ISBN 1-55652-203-7 : $14.95
 1. National Endowments for the Arts—History. 2. Federal aid to the
arts—United States—History—20th century. 3. National Endowment for
the Arts. I. Title.
NX735.Z451994
353.0085'4—dc20 93-41465
 CIP

© 1994 Joseph Wesley Zeigler
First edition
Foreword © 1990 Garrison Keillor; used by permission

a cappella books
an imprint of Chicago Review Press, Incorporated
814 North Franklin Street
Chicago, IL 60610

5 4 3 2 1

Printed in the United States of America

For my sons,
Damon and Bram

Contents

Thanks for Attacking the NEA

by Garrison Keillor

The following is adopted from the remarks of the author before the Senate Subcommittee on Education, Arts and Humanities on March 29, 1990.

IT'S A PLEASURE to come down to Washington and speak in support of the National Endowment for the Arts, one of the wisest and happiest pieces of legislation ever to come through Congress. I'm grateful to those who have so ably attacked the Endowment over the past year or so for making it necessary to defend it. I enjoy controversy and I recognize the adversary: they are us.

My ancestors were Puritans from England. They arrived here in 1648 in the hope of finding greater restrictions than were permissible under English law at that time. But over the years, we Puritans have learned something about repression, and it's as true today as when my people arrived: man's interest in the forbidden is sharp and constant.

If Congress doesn't do something about obscene art, we'll have to build galleries twice as big to hold the people who want to see it. And if

Congress does do something about obscene art, the galleries will need to be even bigger than that. We've heard three or four times this morning that of 85,000 works funded by the NEA, only twenty were controversial. I don't know why anyone would cite that as something to be proud of.

All governments have given medals to artists when they are old and saintly and successful and almost dead. But twenty-five years ago, Congress decided to boldy support the creators of art—support the creation itself—to encourage artists who are young and vital and unknown, very much alive and therefore dangerous. This courageous legislation has changed American life.

Today, in every city and state, when Americans talk up their home town invariably they mention the arts—a local orchestra or theater or museum or all three. It didn't use to be this way. Forty years ago, if an American meant to have an artistic career, you got on the train to New York. Today, you can be a violinist in North Carolina, a writer in Iowa, a painter in Kansas.

This is a revolution—small and lovely—that the Endowment has helped to bring about. The Endowment has fostered thousands of art works—many of which will outlive you and me—but even more important, the Endowment has changed the way we think about the arts. Today, no American family can be secure against the danger that one of its children may decide to become an artist.

Twice in my life, at crucial times, grants from the Endowment made it possible for me to be a writer. The first, in 1969, arrived when I was young, broke, married with a baby, living on very little cash and a big vegetable garden. I was writing for the *New Yorker* at the time but they weren't aware of it.

I wrote every morning and every night. I often had fantasies of finding a patron. A beggar would appear at my door one day; I'd give him an egg salad sandwich, and suddenly he'd turn into a man in a pinstripe suit, Prince Bob from the Guggenheim Foundation. But instead of him, I got a letter offering me a job for one month in the Poets in the Schools program in Minneapolis, funded by the NEA, directed by Molly LaBerge, which sent young writers into the schools to read and teach. In 1969, there were three such programs: in New York, California, and Minnesota. Today, there's at least one in every state.

It was the first time anybody paid me to be a writer. It was the sort of experience a person looks back at and wonders what would have happened if it hadn't.

In 1974, a grant from the NEA enabled me and my colleagues at Minnesota Public Radio to start *A Prairie Home Companion*. The help of the Endowment was crucial because the show wasn't that great to begin with.

For our first broadcast, we had a crowd of twelve persons, and then we made the mistake of having an intermission and we lost half of them. The show wasn't obscene, just slow. It took us a few years to figure out how to do a live radio show with folk music and comedy, and stories about my home town of Lake Wobegon.

By the time the show became popular and Lake Wobegon became so well-known that people thought it was real, the Endowment had vanished from the credits, its job done.

When you're starting out—I think it is true in the arts as in politics—it seems like nobody wants to give you a dime. When you have a big success and everything you could ever want, people can't do enough for you. The Endowment is there at the beginning, and that's the beauty of it. Now my desk is filled with offers to speak, to write, to endorse, which I've thoroughly enjoyed, but I remember very well when nobody else but my mother and the Endowment was interested. I'm grateful for this chance to express my thanks.

When I graduated from college, the degrees were given out in reverse order of merit, so I got mine early and had a chance to watch the others. I remember the last graduate, the summest cum laude, a tall shy boy who walked up the stairs to the platform and, en route, stepped on the hem of his own gown and walked right up the inside of it.

Like him, the Endowment has succeeded in embarrassing itself from time to time, to the considerable entertainment of us all, and like him the Endowment keeps on going. It has contributed mightily to the creative genius of America: to art, music, literature, theater and dance, which to my wife and other foreigners is the most gorgeous aspect of this country. Long may it wave. I hope it lives another twenty-five years; I hope we will continue to argue about it.

PREFACE

MORE THAN TWENTY years ago, I started collecting and saving materials on the federal government and the arts: newspaper and magazine articles, books, pamphlets and reports, statistical information, and personal histories. When my gleanings started to crowd my office, I stored the collection in my attic. By 1990, I had three giant boxes up there. Early in 1992, Richard Carlin of a cappella books asked me to write a book about the so-called NEA crisis, then in full swing. I welcomed his idea because it meant that my attic collection would at last be used.

I spent the spring of 1992 with my archive, culling from it the story to be told. Then in the summer, I went to an island off the coast of Maine (with no services and no electricity, and so no distractions). I spent my vacation on the sun deck, living with the NEA through my collection. (I must admit, though, that I went off-island daily to buy *The New York Times*, just to keep up with the crisis.)

I wrote this book in the fall of 1992 and revised it in the spring and summer of 1993. The writing was based primarily on my archive. I

interviewed only a few people (Livingston Biddle, Leonard Garment, Hugh Southern, Ana Steele, Pat Williams, and Sidney Yates); given the rampant coverage of the crisis by the media, the story was all there, in print.

A few people, though, did assist me. Judith Balfe, Patricia Mitchell, Chuck Morey, Skip Schreiber, and Margaret Wyszomirski all read my first draft and responded to it. Frank Hodsoll read it and gave me an eleven-page, single-spaced commentary in which he both reminisced about his own experience as NEA chair in the 1980s and pointed out major themes and issues for me to consider. I have been helped by these people; but the ideas here are mine, not theirs.

I also want to thank my editor, Richard Carlin, who steered me through the thickets of both the crisis and publishing; my mother, Margaret B. Zeigler, who at the age of eighty-seven is still sharp as a tack and a pleasure to talk with about issues; my wife Alison, who has enabled me to devote myself to this book; and our two sons, Damon and Bram, both in their twenties, who are part of the new generation that will have to deal with the problems that my generation has left unsolved.

I should point out that in almost a quarter century as a consultant in the arts, I have worked only twice for the National Endowment for the Arts, both long ago: in the early 1970s, when I did some research on theater, and in the mid-1970s when the consulting firm of which I was then vice president (Arts Development Associates) conducted a study for the Endowment of the New York State Council on the Arts. I have never served on the NEA staff or the National Council on the Arts or on an NEA panel, and I have never received an NEA grant. I guess this means that this book has been written by an outsider.

INTRODUCTION

The Essential Balance

I HAVE DEVOTED two years to this book because I care deeply about the arts in America, and I have watched them being compromised and threatened by the American government and the American society. I have seen the arts at war with this country.

Since Spring 1989, the National Endowment for the Arts has been embroiled in a raging battle about its right (and perhaps its obligation) to fund controversial art. The battle has pitted the NEA against conservative members of Congress, the religious right, and, most sadly, against the arts community; while placing the American arts community against Congress, the White House, the religious right, the media, and the American people.

Our government's attitude toward funding the arts has always been problematic at best. It took many years for the NEA to be established, with many people sincerely questioning the need for federal funding of the arts. When the NEA was begun, its mission was twofold: to support arts institutions and individual artists while, at the same time, building a

larger audience for the arts throughout the country. This inherent tension between quality (supporting great art) and quantity (spreading art out across the country) would plague the Endowment from its inception. The NEA crisis has been not an isolated anomaly, but rather another in a long line of painful confrontations between arts and government. I think that in order to understand the crisis, we need to look at the history of the confrontation; and so in this book I will trace the history and will show the indifference, suspicion, and distrust that have ruled it. In this book, I have concentrated on the pain of the relationship; and so I ask the reader to remember that overall, the National Endowment for the Arts has done a praiseworthy job and deserves to be continued. Somehow, we need to find a way to make sure that federal support can be provided honorably and gracefully.

The key to this, I think, is balance. All government agencies exist, serve, and lead the nation by maintaining some kind of balance among justifiable but conflicting interests. As Frank Hodsoll, NEA chair from 1981 to 1989, told me, "It is the role of democratic institutions to balance competing interests. . . . The Endowment's task is to balance its duty to uphold the principle of the rights of artists to be free in their expression with its duty to maintain a reasonable consensus."[1] Hodsoll's successor in the chair, John Frohnmayer, also points out this key need: "There has to be some judgment. There has to be artistic freedom. What we are looking for is balance. . . . Easy to say, nearly impossible to implement."[2]

The NEA crisis has disturbed, and may have destroyed, the essential balance that the Endowment needs to serve the country and its people and their arts. Those who fought in the crisis were not so much fighting each other as they were fighting imbalance. This imbalance manifested itself not just in issues of quantity versus quality of art produced. Other issues raised in this debate were the role of public versus private dollars in supporting the arts; whether government money should fund traditional or experimental works (and what percentage of money should go to so-called cutting edge art); should the government support the arts "establishment" (major museums, symphonies, opera companies, etc.) or devote more of its efforts to smaller and avant-garde arts groups; and whether funding should go to individuals or be limited to institutions. The most disturbing question, perhaps, raised in the debate was the question of accountability: should the Endowment be accountable to the arts community or to the public?

Now, after the crisis, restoring the balance is the only way to save the arts and maintain governmental support for them.

I have tried to maintain a dispassionate, objective stance throughout this book, carefully weighing the evidence for each side, while at the same time suggesting some new alternatives to break the gridlock between these seemingly unresolvable issues. It is my hope that this will inspire a reexamination of the position of the arts in our society, and also the artist's responsibilities to society.

I think the controversy will repeat itself every five or ten years. It has come up in the past, and it will come up again in the future, as long as we continue to fund the arts.

<div style="text-align: right">

—Senator Claiborne Pell (D-RI),
in *Vantage Point*, **Spring 1990**

</div>

ONE

The Useful vs. the Beautiful

From Colonial Days to 1960

WHEN AMERICA WAS founded, in the late eighteenth century, our leaders distrusted government. They chose not pure representative democracy but federalism; and they specifically decided that the states, and not the federal government, should be primarily concerned with the social welfare, or "common good," of the people. Support of the finer things in life on a national level was unlikely, at least in the early days of the Republic. According to Stanley Katz, president of the American Council of Learned Societies, "It has been very hard in a country which is truly a republic and becoming democratic . . . to develop the notion of public patronage. Indeed, if one looks at the whole history of the arts in America, what is most striking about it is the complete divorce between the public and the arts through most of our history."[1]

Despite the disavowal, however, there were calls by national leaders from the beginning to recognize the importance of the arts in American life. The most famous of these calls (and one much quoted by the arts community in the last quarter-century) is John Adams's statement in a

1

letter to his wife Abigail: "I must study politics and war that my sons may have liberty to study . . . mathematics and philosophy, geography, natural history, naval architecture, navigation, commerce and agriculture in order to give their children the right to study painting, poetry, music, architecture, statuary, tapestry and porcelain."

In 1771, the American artist Charles Willson Peale wrote to his friend Benjamin Franklin in Paris that "The people here have a growing taste for the arts, and are becoming more and more fond of encouraging their progress among them." Franklin wrote back: "The first drudgery of settling new colonies . . . is now pretty well over, and there are many in every province in circumstances that set them at ease and afford leisure to cultivate the finer arts."

Our first and third presidents, George Washington and Thomas Jefferson, called for the arts to play a role in American society. Washington, in a March 22, 1781 letter to the Reverend Joseph Willard, wrote that "The arts and sciences essential to the prosperity of the state and to the ornament and happiness of human life have a primary claim to the encouragement of every lover of his country and mankind." In 1789, Washington urged Congress to use its "best endeavors to improve the education and manners of a people; to accelerate the progress of art and science; to patronize works of Genius, to confer rewards for inventions of utility, and to cherish institutions favorable to humanity." Congress did nothing.

Even more sympathetic to the arts than Washington was Jefferson, who, his friends said, "could calculate an eclipse, survey an estate, tie an artery, plan an edifice, try a cause, break a horse, dance a minuet and play a violin." Here was a true Renaissance man: as Russell Lynes described him, "the only President, with the exception of Theodore Roosevelt, to whom the arts were of more than the most superficial concern."[2] In writing the Declaration of Independence, Jefferson drew on the writings of English philosopher John Locke, but he changed Locke's list of inalienable rights from "life, liberty, and property" to "life, liberty, and the pursuit of happiness." Obviously, this was a man who deeply understood the finer things in life. On September 20, 1785, Jefferson wrote to James Madison, "I am an enthusiast on the subject of the arts. But it is an enthusiasm of which I am not ashamed, as its object is to improve the taste of my countrymen, to increase their reputation, to reconcile them to the respect of the world, and procure it its praise."

Thomas Jefferson was apparently in the minority among our founding fathers in facing the issue of censorship: "I am mortified to be told

that, in the United States of America, a question about the sale of a book can be carried before the civil magistrate. Are we to censor . . . what book may be sold and what we can buy? Shall a layman, simple as ourselves, set up his reason as the rule for what we are to read? It is an insult to our citizens to question whether they are rational beings or not."[3]

Elitist and Undeserving

Despite these calls for at least appreciation of the arts, the American people and their government remained basically indifferent to them. As Dick Netzer points out in his book *The Subsidized Muse*, "the arts were considered elitist and as such undeserving of direct public support,"[4] And as Michael Straight, deputy chair of NEA in the 1970s, writes, "Here, as in Europe and in classical Greece, standards and styles in the arts were set by an elite. That elite lost its monopoly on political power with the advent of social democracy that evolved under Andrew Jackson. The majority of citizens, to whom that power passed, then dismissed esthetics as the pastime of an outmoded aristocracy."[5]

In 1826, John Trumbull, president of the American Academy of Arts, suggested to President John Quincy Adams "a plan for the Permanent Encouragement of the Fine Arts by the National Government," including direct aid. Like Washington's 1789 proposal, nothing came of this.

Five years later, a significant event in our nineteenth-century cultural life took place: Alexis-Charles-Henri-Clérel de Toqueville arrived on our shores. De Toqueville, a French aristocrat, came to America in May 1831 and stayed only nine months, until February 1832. He came during the first term of President Andrew Jackson, when a new rabble-rousing democracy was taking hold in the land. While de Toqueville admired the industriousness of Americans, he was taken aback by the new country's lack of cultivation; and his book *Democracy in America* reflects this surprise:

> Democratic nations . . . will habitually prefer the useful to the beautiful, and they will require that the beautiful should be useful.[6]
> Is it your object to refine the habits, embellish the manners, and cultivate the arts? Avoid the government of a democracy, for it would not lead you with certainty to the goal.[7]
> In aristocracies, a few great pictures are produced; in democracies, a vast number of insignificant ones.[8]

Above all, de Toqueville saw the arts in America as ruled by utility—only those that can be proven useful will be supported in the new land. Through the rest of the nineteenth century, utility and mercantilism continued to rule. There were occasional calls for government action on the arts, but nothing came of them. In 1842, Congress passed the first federal antiobscenity law prohibiting importation of any "indecent and obscene prints, lithographs, engravings and transparencies." In 1873, the Comstock Law (named for prochastity partisan Anthony Comstock) led to the elimination of thousands of "improper" paintings and books, and a ban on importation or mailing of materials on sex education and birth control, including world classics like Boccaccio's *Decameron*. At the same time, the new "merchant princes" (Carnegie, Mellon, Rockefeller, Vanderbilt, and others) led in the forming of our primary orchestras and museums. While local city governments sometimes participated in the growth of the arts as the owners of museum buildings, there was no call from the "princes" for help from the federal government; that was simply unthinkable.

The first formal bill for the establishment of a federal arts council was introduced in 1877 by Representative Samuel Cox of New York; but other Congressmen saw no value in it, and it died. In 1909–1910, under Presidents Theodore Roosevelt and William Howard Taft, there was a stronger effort. It started with Roosevelt, who, like Jefferson, relished the company of artists and writers and regularly invited them to the White House. During his presidency, Roosevelt established a Bureau of Fine Arts by executive order, "to advise on plans for all future public buildings" in the city of Washington. Later, he named thirty artists from throughout the country to be members of a Council of Fine Arts. Taft went further, sponsoring an act of Congress which on May 17, 1910 created the Commission of Fine Arts. Like the bureau, the commission was primarily concerned with the District of Columbia, but also was established "to advise generally on questions of the arts when required to do so by the President or by any committee of either house of the Congress."[9] The main difference was that the new commission was set up to concentrate on the *quality* of art to be supported. Senator Elihu Root of New York was a key player in the passage of the commission legislation. He wrote (twenty-five years later, in 1935) that the reason for the commission was "essentially to avoid wasting public funds on ill-considered and ill-advised works of art proposed for public purchase at the whims of individual congressmen promoting their constituents."

He recounted how government involvement in determining the value of works of art began:

> Sometime about the early spring of 1910 some Senator had introduced . . . a resolution providing for the purchase by the Government of a number of paintings that nobody wanted to buy. . . . All the members of the committee had an uncomfortable feeling that the pictures were probably worthless . . . but no member of the committee felt any such confidence in his own knowledge and judgment about such things. . . . We all felt that the committee ought to have some way of getting an expert opinion to guide it in making its report. . . and we finally determined to ask Congress to provide for the appointment of a fine arts commission.

He concluded by saying that the commission had saved the government from "God knows how many atrocities."[10]

In 1914, President Woodrow Wilson made an executive order that all plans involving art in Washington that concerned the federal government had to be submitted to the commission, and that nothing could proceed until the commission had ruled on it.

The commission did not pay attention to the arts outside Washington, and so it was not a national body. As noted by Fannie Taylor and Anthony L. Barresi, "The Commission—the first arts council to be established within the executive branch of government—could have been an important vehicle for arts encouragement. However, necessity for such federal support was apparently not perceived by the council or by Congress at that time."[11] Still, the commission did allow the federal government to oversee and control art. As Russell Lynes said in his book *The Lively Audience*, "Whether it has been just or proper, the Congress has had its say directly or indirectly about the arts every time it has appropriated funds for an office building, a courthouse, a library, a post office, or a monument, and it has not been reluctant to make its aesthetic opinions known."[12]

The other major development in arts funding in the first fifth of the twentieth century came through the drafting of income tax and inheritance tax legislation in 1913 and 1916. By providing tax deductibility for charitable giving, Congress opened up support for all nonprofit endeavors. Neither President Wilson nor Congress viewed the legislation as a specific commitment to the arts, which were not mentioned (it cited "educational, scientific and charitable activities"). But arts organizations,

like many other charitable groups, have rightfully and dynamically built a strong case for their being designated 50l(c)3 (tax-exempt) corporations by the IRS and so enjoying deductibility for gifts to them.

The WPA

Under Franklin Roosevelt's New Deal, the federal government became involved in the arts in a major way. The U.S. Customs Bureau ban on James Joyce's *Ulysses* was overturned by a federal court in 1933; and in 1934, FDR established what came to be known as the Section of Fine Arts in the Treasury Department to commission artists to decorate courthouses and post offices throughout the land. Then, in 1935, the New Deal's Works Progress Administration (WPA) was expanded to include four specific projects for artists: the Federal Art Project, the Federal Music Project, the Federal Theatre Project, and the Federal Writers' Project. In the midst of the Depression, the artist was at last being recognized.

Called by Dick Netzer "the largest effort in history—ancient or recent—to aid individual artists directly,"[13] the WPA put high numbers of artists to work. At its height, the Federal Music Project involved 16,000 musicians, and the Federal Theatre Project employed 14,000 actors to play to 25 million people in theaters, parks, and on city streets. Over eight years, from 1935 to 1943, the WPA arts projects spent a total of $160 million, a significant amount of money at that time.

The work created by the WPA was both extensive and seminal. The Federal Music Project sponsored new orchestras like the Buffalo Philharmonic, Pittsburgh Symphony, and Utah Symphony. Artists like Ben Shahn, Jackson Pollock, and Mark Rothko created some of the 50,000 paintings sponsored by the Federal Art Project. Aaron Copland and Virgil Thomson wrote for the Music Project, and John Steinbeck and Robert Frost were among many authors working for the Writers Project. John Houseman, Lee J. Cobb, and Orson Welles worked for the Federal Theatre Project. A whole generation of creative people was sustained by the WPA.

Yet despite its importance, the WPA was not an arts program but a *work* program. In a depression, it was the administration's way of giving people work, not a program to subsidize creativity. Extraordinary work may have come out of it, but creativity was not its purpose; jobs were.

The WPA often was a source of uneasiness for the government as well as the artists it supported. As Judith Balfe and Margaret

Wyszomirski note, "Many of the WPA projects . . . were regarded as artistically experimental, and a number were politically critical of social conditions or public policies and officials. . . . The WPA was a federally-directed program . . . that bred intra-organizational conflict and political frustration among both national and state officials."[14] Most colorful and most controversial of all WPA programs was the Federal Theatre Project (FTP). Hallie Flanagan, who had led the Experimental Theatre at Vassar College, was appointed to head the FTP, and she described its beginnings:

> The Federal Theatre came into being because Mr. Harry Hopkins, administrator of the Works Progress Administration, believed not only that unemployed theatrical people could get as hungry as unemployed accountants and engineers, but—and this was much more extraordinary—that their skills were as worthy of conservation. He believed that the talents of these professional theater workers, together with the skills of painters, musicians and writers, made up part of the national wealth which America could not afford to lose.[15]

In *Theatre Arts* magazine of November 1935, Ms. Flanagan stated her intentions: "We need throughout America a number of theatres, experimental in nature, specializing in new plays by unknown dramatists, with an emphasis on regional and local material. We need Negro theatres in Harlem, St. Louis, and Alabama. . . . We need a theatre adapted to new times and new conditions; a theatre which recognizes the presence of its sister arts."[16] And her boss Harry Hopkins promised "free, adult, uncensored theatre."[17]

But that was not always delivered. The FTP mounted almost 850 classic and new plays. Most celebrated were Orson Welles's productions: *Doctor Faustus*; a black *Macbeth* produced in Harlem; a *Julius Caesar* with parallels to Mussolini's fascist Italy; and most particularly Marc Blitzstein's *The Cradle Will Rock*. This work was prolabor and antibusiness, and it made Franklin Roosevelt's New Deal very nervous. Just as *Cradle* was about to open in New York, the FTP disowned it, and refused to let Orson Welles and John Houseman use their theater. Welles and Houseman arranged to use another house, and marched through the streets with their audience to it. Denied his musicians (who sided with the FTP and refused to play), Blitzstein played his music on an old piano onstage. The opening of *The Cradle Will Rock* became a

symbol of WPA artists' fight for independence from government bureaucracy and interference.

Of the FTP's plays, eighty-one (or nearly 10 percent) were criticized by congressmen or congressional witnesses. Everett Dirksen of Illinois called FTP productions "salacious tripe," and the Republican National Committee, citing *Bill of Divorcement*, asked, "Could any more suggestive or salacious titles be found for plays to parade before the American public? Are the people of this country to be taxed to support such vulgar and villainous activities?"[18]

In August 1938, the House Un-American Activities Committee (HUAC), chaired by Martin Dies, began investigating the WPA arts projects, with special attention to the Theatre and Writers Projects. Hallie Flanagan appeared before the committee in November, and was suspected of being a communist (because she had studied theater in Russia). When she mentioned the Elizabethan playwright Christopher Marlowe, Representative Joseph Starnes said, "Tell us who Marlowe is, so we can get the proper references. . . . Is he a communist?"[19]

In June 1939, the House passed an appropriation of $1.75 billion for the WPA, but stipulated that none of that money could be spent on the FTP. The Senate agreed, and FTP died. In 1943, Roosevelt canceled all WPA programs; the Second World War had dramatically eased unemployment, and so they were not really necessary to provide work. But the loss of these programs was very significant. As Michael Straight points out:

> The artists who were mobilized by Roosevelt created works that were brilliant and enduring. The programs that employed them contained the seeds of their own destruction. They were created to alleviate unemployment, so they were made superfluous by economic recovery. They treated artists as propagandists for the New Deal rather than as servants of the nation. So they left a bitter legacy. The opponents of the New Deal came to look upon the arts as adjuncts of the ideas which they had feared and fought against. They became antagonistic to public funding of the arts and delayed its reemergence for almost thirty years.[20]

The Midcentury Years

For the next twenty years, the federal government's primary support of the arts was through tax deductions for contributions; as we shall see,

not a small thing, but still not a specific program. There were, in these years, some modest efforts: Senator Hubert Humphrey and Representatives Jacob Javits and Frank Thompson introduced bills to establish federal arts councils, but all of them were killed by House Rules Committee Chair Howard Smith; Harry Truman charged the Commission of Fine Arts to conduct a two-year study of government and the arts (which resulted in a proposal for a National Cultural Center, which eventually became the Kennedy Center). Dwight D. Eisenhower, at the urging of Health, Education and Welfare (HEW) Undersecretary Nelson Rockefeller, called in his 1955 State of the Union Message for an advisory commission on the arts: "The Federal Government should do more to give official recognition to the importance of the arts and other cultural activities. I shall recommend the establishment of a Federal Advisory Commission on the Arts . . . to advise the Federal government on ways to encourage artistic endeavor and appreciation."[21] Eisenhower was not requesting granting authority for this new advisory commission; still, Congress did nothing in response to it.

Disinterest and disregard were not the only responses to efforts to involve the federal government with the arts. Sometimes there were serious attacks. Russell Lynes described one at the beginning of the Cold War:

> In 1946 the State Department exhibition program incited congressional fury. It had spent $49,000 to purchase seventy-nine paintings by contemporary American artists in order, it said, to fulfill the requests that it had received from diplomatic missions abroad. . . . The spokesman for the congressional attack was Congressman Fred Busbey of Illinois. "I have seen pictures of the paintings," he said. "Some of them are so weird that one cannot tell without prompting which side is up." . . . Such was the mood in this time of "red scare" and "un-American activities" investigations that arguments like this were taken seriously. . . . The State Department ordered the exhibition closed in Prague, where it was being shown, and shipped back to Washington. The paintings were sold as "war surplus" at ten cents on the dollar.[22]

The biggest scare was in the late 1940s and early 1950s, in the era of Senator Joseph McCarthy and the House Un-American Activities Committee. Many artists who had first come to prominence through the WPA were now summoned to Washington to testify before HUAC

or McCarthy, to recant their earlier communist leanings and to name their "fellow-travelers." From 1947, when Congress first held public hearings on communism in the film industry, to 1954 when Joseph McCarthy was censured by his fellow Senators, nearly 15,000 people were affected by "blacklisting," and Hollywood was decimated by it. Ronald Reagan, as president of the Screen Actors Guild, helped the investigators. In the theater, Elia Kazan cooperated with HUAC and named names; but playwrights Lillian Hellman and Arthur Miller refused to go along and pleaded the Fifth Amendment. Miller, in 1953, presented *The Crucible*, which paralleled the McCarthy witch-hunts by telling the story of witchcraft in Salem, Massachusetts, in 1692. When he applied for a passport to attend the opening of *The Crucible* in Brussels, it was denied him. To the U.S. government, he was *persona non grata*.

At the height of this messy period, more than fifty anticommunist films were made by a Hollywood seeking to appease the right-wingers. Ironically, it was not until over twenty years later, in 1975, that the House Un-American Activities Committee was abolished. In the late 1940s and early 1950s, HUAC and McCarthy had America in their grip, and the arts community was running scared. As Anthony Keller points out, "When members of Congress . . . wanted to slap down a proposal to use Federal dollars and agencies to aid the arts, it was often in the House Un-American Activities Committee tradition of associating the fruits of artistic creativity (most of all, modernism) with Godless Communist ideology, and artists with radical behavior and unsavory conspiratorial political connections."[23]

A major player in the red scare was Richard Nixon. As a congressman from California, he often accused artists of being communists. One particular Nixon target was Anton Refregier, who had painted a mural in a San Francisco post office. In July 1949, Nixon wrote to an American Legion commander, to thank him for inquiring about "whether anything can be done about removal of Communist art in your Federal building." Nixon said: "I realize that some very objectionable art, of a subversive nature, has been allowed to go into federal buildings . . . Congress should make a thorough investigation of this type of art . . . with a view to obtaining removal of all that is found to be inconsistent with American ideals and principles."[24]

The years 1947–1954 were a low point in the history of the government-arts relationship. Artists were an easy target of the communist witch-hunters; many were liberal and had belonged to "leftist" organiza-

tions in their youths. In this overheated atmosphere, it is not surprising that the uneasy relationship between government and the arts reached new depths.

TWO

Birth of the Agency

1961–1969

AMERICA WAS ALMOST 180 years old when it made its first commitment to direct support of the arts by the federal government. The National Endowment for the Arts was very much a product of John Kennedy's New Frontier program. The young and attractive president and his elegant wife Jacqueline surrounded themselves with artists. Robert Frost recited a poem at Kennedy's inauguration, and a hundred artists—some of them avant-garde and radical—were invited to participate in those festivities. Pablo Casals and others performed at state dinners, and "Camelot" was very sympathetic to the arts.

Kennedy had run in 1960 on a platform with a plank calling for a federal advisory agency on the arts. Early in his term, a specific controversy fueled the call for government action. The Metropolitan Opera in New York was involved in a labor dispute in the summer of 1961, and Kennedy asked Labor Secretary Arthur Goldberg to mediate. Goldberg added to his report an elegant plea for government action: "The arts must assume their place alongside the already accepted responsibilities

13

for health, education and welfare. Part of this new responsibility must fall to the federal government for precisely the reasons that the nation has given it a role in similar undertakings."[1]

A bill was introduced in Congress for an advisory council on the arts, but it was laughingly put aside when a representative from Virginia proposed an amendment that would make poker playing an art. Faced with this scorn, Kennedy chose to go ahead by executive order, and had one prepared to set up a council (with Richard Goodwin as Assistant for Arts and Humanities); it was sitting on his desk in the Oval Office, unsigned, on November 22, 1963.

In 1962, Kennedy had appointed August Heckscher of the Twentieth Century Fund to be a consultant on the arts in the Executive Office of the President; and Heckscher presented in 1963 a report, *The Arts and the National Government*, which built on Arthur Goldberg's call. That same year, less than a month before his death in Dallas, Kennedy spoke on the arts when receiving an honorary degree of doctor of law at Amherst College:

> I see little of more importance to the future of our country . . . than full recognition of the place of the artist. . . . Society must set the artist free to follow his vision wherever it takes him. . . . And the nation which disdains the mission of art invites . . . the fate of having nothing to look backward to with pride and nothing to look forward to with hope. . . . I look forward to an America which will steadily raise the standards of artistic accomplishment and which will steadily enlarge cultural opportunities for all our citizens.[2]

It is interesting that Kennedy in this speech concentrated not on arts institutions, but on the individual artist. He was talking about the essence of creativity, and the essential freedom that must serve and sustain it.

In the midst of all these elegant calls for action, the nation's cultural establishment was not totally behind government financing of the arts. The American Symphony Orchestra League (ASOL), the service organization for orchestras, was very suspicious of government involvement. In 1953, an ASOL survey had found 99 percent of orchestra board members opposed to federal aid; by 1962, 57 percent of board members

of community orchestras (the smallest) favored it, but only 5 percent of board members of the majors (biggest) did.[3] Philip Hart, in his book *Orpheus in the New World*, describes the ASOL as "only peripherally involved in the campaign throughout the 1960s for the establishment of federal aid to the arts."[4]

Following the assassination in Dallas, Kennedy's moves toward federal support for the arts were carried forward by the Johnson administration; what had started as part of the New Frontier became a project of the Great Society. Roger Stevens succeeded August Heckscher as special assistant to the president on the arts in May 1964. Stevens was asked to develop support in Congress for a permanent arts agency. In August, he testified to the National Democratic Platform Committee and urged a plank on behalf of the arts: "to encourage further support of the arts, giving people a better chance to use increased leisure and recognizing that the achievements of art are an index of the greatness of a civilization."[5]

The landslide victory of Lyndon Johnson in 1964 meant that the nature of Congress changed: a much more liberal group of senators and representatives came in, who were sympathetic to arts legislation. Senators like Hubert Humphrey, Jacob Javits, and Claiborne Pell were joined by Representatives John Brademas of Indiana and Frank Thompson of New Jersey to form an initial coalition to fight for it. In mid-1964, Congress passed a bill establishing a National Council on the Arts as an advisory body, basically enacting what Kennedy had proposed in his executive order. Then, on March 10, 1965, the Johnson administration (led by Claiborne Pell in the Senate) introduced a bill calling for direct support of the arts and humanities. This would eventually become the National Foundation on the Arts and Humanities Act, the parent of NEA.

Despite the new sympathy in Congress, there was opposition. The Republican Policy Committee said, "The arts and humanities are thriving today and will continue to thrive so long as the deadening hand of the federal bureaucracy is kept from the palate [sic], the chisel and the pen."[6] The primary opposition came from Representative H. R. Gross of Waterloo, Iowa. Gross introduced a "preferential motion" in the House, which would have deleted the enacting clause from the bill, thus making it meaningless. " 'I have offered the motion,' said Mr. Gross, 'in the hope that the members of the House will ... kill off this monstrosity here and now without any more fuss and feathers.' The motion was duly

read by the clerk of the House. The deliberation ceased—and Mr. Gross lost by thirty-six votes. . . . Thus the curtain fell.*"[7]

The passing of the National Foundation on the Arts and Humanities Act of 1965 was made possible by an alliance between the arts and the humanities. The arts were still suspect to many people; but the humanities, with their concentration in higher education, were easier to approve. Supporters of the arts joined with mostly academic supporters of the humanities to work for passage of legislation creating a National Foundation for the Arts and Humanities, with an endowment for each field. The humanities had the political muscle to deliver a bill, as Jacob Javits later noted: "The joining together of the arts and the humanities put the bill through. Otherwise, it could never have passed without that enormous education lobby. What started as almost a joke eventually became a great national achievement."[9]

A congressional declaration of purpose gave the reasons for the new agencies: "The encouragement and support of national progress and scholarship in the humanities and the arts, while primarily a matter for private and local initiative, is also an appropriate matter of concern to the Federal government."[10] And the "Explanation of the Bill" outlines the NEA's function:

> The [NEA] provides matching grants to States, to non-profit or public groups, and grants to individuals engaged in the creative and performing arts for the whole range of artistic activity. . . . A major objective of this legislation is to stimulate private philanthropy for cultural endeavors and State activities to benefit the arts. . . . The term "the arts" includes, but is not limited to, music (instrumental and vocal), dance, drama, folk art, creative writing, architecture and allied fields, painting, sculpture, photography, graphic and craft arts, industrial design, costume and fashion design, motion pictures, television, radio, tape and sound recording, and the arts related to the presentation, performance, execution, and exhibition of such major art forms.[11]

* Livingston Biddle, who wrote the enabling act, reflects that the conservative challenge to the NEA hasn't changed much over the last thirty years: "The same arguments were used back in the 1960s. It's interesting to look at the words they used then. . . . I find the pattern of discomfort existing from the very start."[8]

On September 29, 1965, in the Rose Garden of the White House, Lyndon Johnson signed the legislation, Public Law 209. Echoing Kennedy, the president said:

> Art is a nation's most precious heritage. For it is in our works of art that we reveal to ourselves and to others the inner vision which guides us as a nation. And where there is no vision, the people perish. We in America have not always been kind to the artists and the scholars who are the creators and keepers of our vision. Somehow, the scientists always seem to get the penthouse, while the arts and humanities get the basement. . . . This bill . . . bring[s] active support to this great national asset, to make fresher the winds of art in this great land of ours.[12]

Johnson's and Congress's action in starting the Endowment was a momentous undertaking. It showed that support of the arts was an appropriate concern of the federal government. With a tiny appropriation, the agency could not have a massive financial effect; but the very fact of the funding—the presence of the government and its caring— would make a major impact psychologically. The passage of the bill meant that, at long last, culture had a national presence.

Ironically, just before enthusiasm for the new NEA was sweeping through official Washington, there came an event that underlined a potential conflict between the arts community and the government. In June 1965, Lyndon and Ladybird Johnson hosted a White House Festival for the Arts: both visual and performing arts were presented in the executive mansion. Harold Taylor called the festival a " 'coming-of-age in America in the field of the creative arts,' a recognition of the fact that America was no longer neglecting the arts and that, in fact, the 'cultural explosion' of the Sixties had been acknowledged by federal and state governments with economic and political support."[13] Many of the major artists of the day were invited to participate; but some refused to come as a protest against Johnson's foreign policy and especially the then-expanding Vietnam War. In turning down the invitation, poet Robert Lowell spoke for numerous other artists:

> I am conscience-bound to refuse your courteous invitation. . . . Although I am very enthusiastic about most of your domestic legislation and intentions, I nevertheless can only follow our present foreign policy with the greatest dismay and distrust. . . . We are in

danger of imperceptibly becoming an explosive and suddenly chau-
vinistic nation, and we may even be drifting on our way to the last
nuclear ruin. . . . At this anguished, delicate and perhaps determining
moment, I feel I am serving you and our country best by not taking
part in the White House Festival of the Arts.[14]

Novelist John Hersey did go; but instead of reading from *A Bell for
Adano* or *The Wall*, he read from *Hiroshima*, his 1946 book about
America's atomic destruction of that Japanese city, and a major indict-
ment of war. Livingston Biddle describes the reaction: "Lady Bird
Johnson's lips were tightly drawn, her eyes slightly narrowed but com-
posed. She sat very straight and waited until there was a pause before
rising and walking quietly and quickly and very erect from the room."[15]

The White House Festival of the Arts was a disaster. When a presi-
dent made a special effort to acknowledge the value of the arts, he was
scorned and rejected by the artists themselves. As Frank Getlein noted,
"It will be a very long time before another president invites the arts
crowd *en masse*. If there is a certain separation between American art
and American Presidents, it is not entirely the fault of the Presidents."[16]

At the same time that the National Endowment for the Arts was
being created, William J. Baumol and William G. Bowen of Princeton
University were writing their landmark book *The Performing Arts: The
Economic Dilemma* for the Twentieth Century Fund. This book made a
case for both private and public support of the arts because of their
inherent money-losing nature, and it was to become a bible for the arts
industry in the United States. Baumol and Bowen conclude their chap-
ter "Government Support in Practice" with a prophetic warning: "The
. . . future of government support to the arts in this country is by no
means automatically assured. It will depend heavily on the effort de-
voted to convincing Congress and the general public of the need and
appropriateness of this sort of program."[17]

The First Chair: Roger Stevens

It was inevitable that Roger Stevens would be the first chair of the
NEA: he was a primary Democratic fund-raiser, he had already moved
into the White House to succeed August Heckscher, and he was also
chair of the Kennedy Center (then under development). To work with
Stevens, the law provided for a National Council on the Arts: twenty-six
citizens appointed by the president and confirmed by the Senate to

serve as an advisory body. The 1965 act was specific in who these people should be: "private citizens of the United States who are widely recognized for their broad knowledge of, or expertise in, or for their profound interest in the arts [who] have established records of distinguished service, or achieved eminence in the arts . . . practicing artists, civic cultural leaders, members of the museum profession, and others who are professionally engaged in the arts."

The Council is not really a "board of directors," because they are only advisory and raise no money, and because the chair has the ultimate power to make all grant decisions and all policy decisions. But the Council has been a key player at the Endowment, and its relationship to the chair has affected both grants and policies. Stevens's first Council members were an aristocracy of the American arts,* and they "functioned virtually as NEA staff, originating project ideas and carefully reviewing individual grants."[18] As Michael Straight points out, Stevens "deferred to the National Council on the Arts and never tried to overrule it."[19] Given his individualistic approach and the Council's "cultural powerhouse" nature, the NEA's first days were heady and exciting.

The money in the first year was very modest: despite an authorization of $5 million, NEA was appropriated only $2.5 million in program funds, which, combined with $34,308 in Treasury Funds,** gave the agency $2,534,308 to be allotted to arts organizations and individuals. By 1969, growth in Treasury Funds and in the allowance to states in the State-Federal Partnership, joined with some growth in Program Funds, brought the NEA to more than triple its initial funding level:

Growth in NEA Funds in First Years ($ in millions)[20]

Year	Grants	States	Treasury	Education	Total
1966	2.500	0.034			2.534
1967	4.000	2.000	1.966		7.966
1968	4.500	2.000	0.674		7.174
1969	3.700	1.700	2.357	0.100	7.857

* Marian Anderson, Leonard Bernstein, Anthony Bliss, Agnes de Mille, Rene d'Harnoncourt, Richard Diebenkorn, Helen Hayes, Charlton Heston, Harper Lee, Gregory Peck, Sidney Poitier, Richard Rodgers, Oliver Smith, John Steinbeck, and Isaac Stern.

** Treasury Funds are monies from the U.S. Treasury awarded to NEA to match gifts *to* NEA from private sources as support for NEA grant recipients.

Despite this growth, however, the appropriations path through Congress was not always smooth. In 1967, for instance, the House appropriated only $4 million for national grants, a drastic slash from the $32 million requested by Johnson. Charles Mark, who worked for Stevens in the first NEA years, describes the situation in 1968, when both reauthorization and the annual appropriation were at stake:

> Suddenly, Rep. Anderson (R-IL) was on his feet calling for a reduction in the authorized total proposed. He said it was past time to establish priorities responsive to what he considered the most pressing needs of American life, and it was obvious to him the arts and humanities were not high on that list. Other Congressmen joined in opposing the bill. Rep. Bow (R-OH) remarked: "Certainly at this time there is not a soul on this floor who does not realize that we are at war. . . . we cannot have guns and butter. And this Endowment is guns with strawberry shortcake covered with whipped cream and a cherry on top." . . . The House took the hint and voted 272 to 123 to drastically amend downward [the appropriation]. . . . The whole experience gave everyone the belief that the arts and humanities were incidentals in the minds of those who controlled our fate.[21]

Two congressmen who voted for the reduction were Gerald Ford and George Bush.

In the reauthorization process in 1968, there were notable disagreements between House and Senate. For instance, the House voted to reauthorize for only one year, but then the Senate chose to restore the two-year reauthorization (still less than the original, 1965, three-year authorization). The House, too, decided to forbid grants to individuals, but the Senate restored them (though they added that the individuals had to be "of exceptional talent," a caveat impossible to enforce).

With its monies both modest and unsure, the NEA in its first years was rather limited in what it could do. Its first grant, in October 1965, was a $100,000 check delivered by Hubert Humphrey to Lucia Chase in Brooklyn to "keep alive" the American Ballet Theatre. Two years later, the same amount went to the Joffrey Ballet. The New York Shakespeare Festival received the same amount of money in its first grant; other organizations, ranging from Alvin Ailey's American Dance Theatre to the Boston Opera Company to the Negro Ensemble Company received smaller grants in the first three years of the agency's existence. There were three special projects undertaken early: the American Film Institute

(which Johnson had promised when he signed the bill) to be the research and development arm of the film industry, begun with $1.3 million from NEA and like amounts from the Ford Foundation and the Motion Picture Association of America; the Laboratory Theatre Project, which used $1,351,000 over a three-year period to pay for theaters in Providence, New Orleans, and Los Angeles to provide free performances for schoolchildren; and (most innovative of all) the Artists' Housing project, which used $1 million to enable the J. M. Kaplan Fund to establish and develop Westbeth, an artists's housing and work center in a former Bell Telephone Laboratory in Greenwich Village, New York. This last project was a special favorite of real-estate mogul Stevens.

Roger Stevens was passionate about some arts and uninterested in others; as Philip Hart says, he "tended at times to back projects that especially interested him personally or were favored by individual Council members."[22] Mostly lacking in the early years was support for museums, opera companies, and orchestras—the last perhaps because of the antigovernment funding feelings within the American Symphony Orchestra League.

Early Problems with Individual Artists

In NEA's first years, special attention was paid to the individual artist. Almost 15 percent of grant funds went to support the work of solo creators: painters, sculptors, composers, writers, and choreographers. While the total amount of money later went down, support of individuals continued to be stressed; and while the vast majority of grants were not controversial, the program did occasionally get the Endowment into trouble.

The Visual Arts Program (under commuting consultant Henry Geldzahler of New York) made $5,000 individual grants to painters and sculptors; in 1967, sixty such grants made a total expenditure of $300,000. The panel that decided on these grants consisted of the "cream" of American fine arts, including Walker Art Center director Martin Friedman, critic Barbara Rose, sculptor George Segal, and painter Robert Motherwell. Most of the panel's grant recommendations were for artists doing "nonrepresentational" work, subject matter more exotic than still lifes, landscapes, or portraits. And the nonrepresentationalism was starting to bug Congress! In a hearing before Senator Claiborne Pell, numerous traditional artists complained that the NEA was turning its back on their kind of art:

Frank Wright, president of the Council of American Artists Socie-
ties, stated: "Works of artists already awarded grants include some
appalling selections, and only eight out of 60 can be called represen-
tational. . . . No one can complain if a painter wants to have a tantrum
on canvas. . . . But to call the results fine art is something else." The
next witness was Michael Werboff, an elderly New York portrait
painter: "After the creation of the Council . . . under the protection of
the Federal moniker, there is nothing to which the traditional artist
can appeal for defense of their rights as contemporary American
artists. . . . It puts the American traditional artist into the hands of
their worst enemy."

As Senator Pell concluded the hearings he . . . said he hoped that
the exchange of opinions had cleared the air, and that . . . "encourage-
ment should be given to forms of art that have a message or at least
that we can comprehend."[23]

Particularly distressful to the "representationalists" was the fact that
NEA panelists (who recommended grants) were anonymous. The rea-
son for this secrecy was to protect panelists from grant applicants
seeking favors. But the witnesses before the subcommittee in 1967
insisted that panelists were being elitist and were awarding grants to
their friends in a "closed shop." They demanded that American artists
had a right to know who was on the panels. Senator Pell responded: "I
see no harm after the panel has finished its work when they can no
longer be exposed to pressure, to letting the names be known."[24] So very
soon thereafter, NEA was announcing names of panelists—an early
adjustment to a political demand.

In three and a half years, from fall 1965 to spring 1969, Roger Stevens
and the NEA gave out about $25 million in federal funds. This money
was matched by nearly $70 million in nonfederal, private money. Many
people in the arts world wanted Stevens to remain in the NEA chair
after the election of Republican Richard Nixon in 1968; but it was
highly unlikely that a Democratic fund-raiser (who had raised funds
against Nixon in 1952 and 1956) would be left in such a position.
Stevens had to get out. As he was leaving, he appeared with August
Heckscher at a Drama Desk meeting at Sardi's in New York, where he
said, "I'm not as pessimistic as most people think they should be. Some
95 percent of those on the boards of trustees of arts organizations are
Republicans. They're going to see to it that money is available to make
up the huge gap."[25] And in *Cultural Affairs* he wrote, "I prophesy . . . that

the national government will eventually make hundreds of millions of dollars available to the arts."[26]

It had been a sometimes trailblazing and always noble beginning. Despite some potshots from Congress, there had been growth in the appropriation, and Stevens left the chair convinced of the inevitability of federal support of the arts. He and a stellar National Council on the Arts had much of which to be proud.

THREE

The Golden Age
and After

1969–1980

OVER ITS FIRST few years, the National Endowment had changed to the point where it no longer needed a visionary as its chair, but rather an advocate. In Nancy Hanks, it found a perfect builder for its growth phase.

Nancy Hanks came out of the South (North Carolina and Duke University). As a young adult, she went to work for Nelson Rockefeller, first in Washington and then in New York. For the Rockefellers, she headed the panel that produced the seminal 1965 study *The Performing Arts: Problems and Prospects*; she later chaired the board of the American Council for the Arts. She was appointed NEA chair in August 1969. She had an unerring political instinct, and a charm that could be put to fabulous use in the halls of Congress: "Exactly how Nancy Hanks 'gets' to people on Capitol Hill is something of an art in itself. Unlike officials of other agencies, she never takes any staff along on her missionary visits. (When she was nominated for her job . . . Hanks made a point of visiting every Representative and Senator who would receive her, a record that surpasses even that of such dogged Congressional back-

scratchers as Henry Kissinger and Nelson Rockefeller.)"[1] And as Livingston Biddle writes, "Nancy was a valiant leader. She won friends in the Congress. She won the support of the Nixon and Ford administrations. She had particularly powerful friends in Leonard Garment and Nelson Rockefeller, but they would not have been as forthcoming if they had not liked and admired the arts chairman."[2]

The surprising—and totally unexpected—alliance that Nancy Hanks built was with Richard Nixon. The new president was no friend of artists in the McCarthy era; therefore, it was widely assumed that his White House would be unsympathetic to the arts. Still, Hanks and her agency offered to Nixon an opportunity to side with something attractive. Leonard Garment tells the story:

> Nixon had a very good sense about fine arts. He disliked the modern stuff, but he had a serious interest in the traditional arts, the great works. He could see very easily the argument that Nancy made for putting the Nixon stamp on the development of the arts in America. It was the classic strategy: "Hit 'em where they ain't." Surprise the snobs: For God's sake—Richard Nixon has become a patron of the arts! Also, there was so much antagonism toward Nixon over Vietnam—particularly among young people—that to do this was a way of introducing a touch of ambivalence. And Nancy herself was a wonder. There was softness to her appearance, softness to her voice—everything was soft about her except her ambition for the arts. There she was titanium.[3]

The New York Times told how Hanks handled Nixon: "When Hanks asked Nixon to name his highest priority for the Endowment, he said that it should try to reach more people. 'What you are talking about, sir, is totally impossible to accomplish without money,' she told him. Nixon duly promised he would back a bigger budget. 'It's the kind of thing a great President would do,' Nixon reportedly told an aide at the time."[4]

Within months of her appointment to the chair, Hanks was enjoying strong support from the president. His January 1970 budget called for a near-doubling of NEA funds. Under Nixon and Gerald Ford, the growth of NEA with Hanks as chair was phenomenal—a whopping 1400 percent, from $8,250,000 in 1970 to $123,850,000 in 1978.*

* The money growth was paralleled by similar growth in applications (from 2,000 to almost 20,000) and in grants (from just under 600 to more than 4,000).

Nancy Hanks's political instincts shepherded this growth; for the 1970 request of $12 million, she personally visited 150 senators and representatives, and persuaded two-thirds of them to change their negative votes to positive ones.

When Hanks came to NEA in 1969, there were no formal programs in support of museums, orchestras, and opera. These were started in the early 1970s; and by 1973, the three programs claimed a total of $12,836,595, or 46 percent of program funds. It was Hanks herself who promoted NEA funding for arts institutions. She addressed a museum conference in 1973 and said: "There has been a tremendous awakening of the nation's consciousness to all areas of cultural activity. We see our institutions—theatres, orchestras, as well as museums—reaching out into the community. We see our individual creative people respected throughout the world. We see government . . . recognizing its responsibility . . . to support a vital cultural life."[5]

The story of the orchestras' arrival at NEA is especially colorful. As noted earlier, the American Symphony Orchestra League had discouraged orchestra leaders from seeking federal government aid. Then, in 1969, the "big five" orchestras—Boston, Chicago, Cleveland, Philadelphia, and New York—commissioned a study by McKinsey and Company of their funding futures. McKinsey reported that earned income was dropping (from 71 percent of expenditures in 1963–1964 to 64 percent in 1967–1968), that the five combined "income gaps" totaled $1 million, and that deficits would more than double in the next four years if additional sources of income were not found. Late that year, the board chairs and managers of seventy-seven orchestras met in New York to discuss the implications of the McKinsey study. The newly appointed Nancy Hanks came to that meeting and encouraged the orchestras to come to the Endowment for help. Of course they came—and most got grants.

Going to New York to invite the orchestras to come aboard was typical of Nancy Hanks: growth was her point. When she was not lobbying on Capitol Hill, she was traveling across America, stimulating the arts in communities. She was a perfect ambassador, and the arts community dubbed her the "mother of a million artists." Nixon appointed her to a second term in the fall of 1973. She was the builder of a golden age of the National Endowment for the Arts, and her own prominence flowed from that; as Margaret Wyszomirski points out, "Pre-NEA, Nancy Hanks was on the margins—politically, artistically, and even socially—just as the agency itself was. In moving the

endowment to the center of the arts world and establishing its social and political support, she also found her particular 'niche.'"[6] Michael Straight, in his biography of Hanks, shows the growth in the 1970s in what he calls "Nancy Hanks's Fact Sheet":

	Number in 1965	Number in 1975[7]
Professional orchestras	58	110
Professional opera companies	27	45
Professional dance companies	37	157
Professional theaters	23	145
Museums	1,700	1,880
Regional media centers	1	40
Community cultural centers	6	25
Small literary magazines	450	700
Independent presses	200	350
State arts agencies	12	55
Community arts agencies	175	900

Hanks herself, speaking to the National Committee of Advocates for the Arts, described her golden age: "Let me quote John Canaday: 'What we were calling a culture boom in 1959 has become in 1976 a deep-rooted cultural growth that has yet to come into full flower.' If what Canaday says is true . . . this growth process is still accelerating. There will come a time when the shift will be more to maintenance. But, right now it's the flowering time."[8]

Despite Vietnam and Watergate, the mid-1970s were a relatively positive time in America; and Nancy Hanks presided over a can-do expansionism in the arts. People everywhere were coming up with new ideas and new projects, and the Endowment was endorsing and supporting them. It was mostly a reactor, responding to the impulses of others. And under political genius Nancy Hanks, within the NEA there was the balance that I have said is essential.

Funding of Individuals Under Hanks

Under Nancy Hanks, Endowment support of the individual artist continued; and while it grew in dollars, it fell as a percentage of the whole

($538,325 or 11.96 percent of program funds in 1968; $2,142,355 or 7.7 percent in 1973). And as with Roger Stevens, support of individual artists caused occasional trouble. As David Dempsey said of Hanks in 1974, "She is gambling that artists can be subsidized by the Government while still retaining their independence,"[9] and sometimes the gambling backfired. In the first half of the 1970s, there were two incidents where Nancy Hanks faced the wrath of Congress over support of individuals.

In 1973, novelist Erica Jong was granted a $5,000 fellowship to write poems and to revise her novel *Fear of Flying*. The novel was one of the first to present frankly a woman's sexual journey. The NEA award letter specified (as did all fellowship awards) that if the work were published, credit had to be given to the Endowment for its support. Erica Jong found a publisher; in 1974 *Fear of Flying* was issued, and the Endowment was thanked on its first page. The next page carried the title of Chapter One: "En Route to the Congress of Dreams, or, The Zipless Fuck."

Fear of Flying was a smash hit in 1974. Many Americans read it, saw that NEA had subsidized its writing, and called or wrote their Congress members to protest. The NEA was facing hearings on its 1975 appropriation, which made the controversy all the more serious. Senator Jesse Helms of North Carolina (who fifteen years later would be at the center of the NEA crisis) joined the protest. He wrote an angry letter to Hanks protesting the funding of Jong's novel:

> It is my understanding . . . that the National Endowment for the Arts donated $5,000 of the taxpayers' money to a person named Erica Jong so that she could produce a reportedly filthy, obscene book called *Fear of Flying*.
>
> I have not read the book, so I cannot personally vouch for the characterization of it. I assume that you have read it and that you either (1) deny that it is filthy and obscene, or (2) consider it a manifestation of "art" which the taxpayers should support.
>
> If neither supposition is accurate, then I would inquire if you have considered requesting Erica Jong to refund the $5,000.
>
> In any event, would you be good enough to supply me with an explanation of the mentality in your agency which prompted the disbursement of funds for such a purpose—in the name of art?

Hanks replied:

> As you know, each year our Literature Program provides fellowships
> to poets, fiction writers, playwrights and critics. These fellowships are
> not designed to fund specific works. They are intended to assist
> published writers of exceptional talent to enable them to set aside
> time for writing, research and travel. . . . In applying for a fellowship
> for creative writers, Miss Jong submitted examples of previously
> published poetry. . . . It was on the basis of this work that the
> fellowship was awarded to her. In this case, as in all fellowship
> awards, the Endowment exerts no control over the work the artist
> does after receiving a grant. . . .
>
> It is the Endowment's position that excellence should be sup-
> ported without restrictions, in order to prevent Federal assistance
> from becoming Federal control of the arts. . . . I appreciate your
> sharing with me your concern. If you have further questions, please
> do not hesitate to contact me. I would be pleased to discuss this
> matter further with you, should you so desire.

Helms was not assuaged by her response:

> Thank you for the July 2 letter bearing what purports to be your
> signature. I cannot believe that you wrote it, or approved it. In any
> case, I note that the concluding paragraph invites "further questions,"
> if I have them. I have just one: Why did you not answer the questions
> in my letter of June 12?
>
> I still desire to have your opinion of Miss Jong's book. If I cannot
> be given a response to that question, it is my intent to discuss the
> National Endowment for the Arts on the floor of the Senate and in
> any other public forum which may be appropriate.

Hanks again tried to mollify the prickly conservative:

> To answer your questions of June 12: *One*, I have not had the
> opportunity of reading *Fear of Flying*. In any event, I believe my
> personal evaluation of this novel would be irrelevant. In my recent
> letter, I pointed out that literature fellowship applicants are judged by
> outside literary experts on the basis of their past achievement. *Two*,
> we have not considered requesting Miss Erica Jong to refund the

$5,000 grant. Even if we wished to, our General Counsel advises me that there would be no legal basis on which to do so. . . .

Three, we believe that the policies of this agency are sound. . . . In this connection, please let me quote from a speech I delivered to the Associated Councils on the Arts: "What about the artist who receives no-strings-attached support and creates a work that triggers controversy? Nurturing the broad range of the Nation's creativity is far more important than the few tempests that arise." I say that because of my conviction that the cornerstone of any culture is the nurtured talent of its creative artists.[10]

In the end, with the help of Sidney Yates in the House, the crisis passed. Helms dropped his objections, and Yates led the appropriation process without mention of *Fear of Flying*. The Endowment was lucky.

Meanwhile, though, at home in the Endowment offices, all was not unity. Michael Straight was deputy chair of NEA: he was a scion of the Willard Straight family, a novelist and former editor of *The New Republic*, a man who had been considered for the NEA chair before Hanks was appointed, and very much an American patrician. Straight disagreed with Hanks on *Fear of Flying*. When he published his *Nancy Hanks: An Intimate Portrait* in 1988, Straight made an astounding statement: "My own view was, and still is, that, in this instance, Senator Helms was right, and Nancy and her supporters were wrong."[11] Straight's disagreement with Hanks forecast the NEA's future problems, not only with right-wingers like Helms but also with the old-line Northeastern elite.

The other crisis happened earlier, soon after Hanks came in. The Literature Program had been giving grants for a couple of years to George Plimpton for publication of the *American Literary Anthology*, a collection of fiction, poetry, and criticism from small literary magazines. Plimpton was the editor of the *Paris Review*, a raconteur and *bon vivant*, and a darling of New York's supper set. The money had been awarded in individual grants to him personally. The first anthology was published by Farrar, Straus and Giroux in 1968, and Random House published the second in 1969. The second volume contained a one-word poem by Aram Saroyan (the playwright's son), "lighght." And "lighght" caused a ruckus. Congressman William J. Scherle of Iowa, who had once said that "Culture should not be spoon-fed to an effete elite at the expense of the general public,"[12] launched an attack on "lighght." He said, "If my kid came home from school spelling like that, I would have stood him in

the corner with a dunce cap," and called George Plimpton a "society playboy and jet-setter."[13] Scherle told how his staff assistant had called Plimpton to find out what "lighght" meant. Plimpton's answer was cutting: "You are from the Midwest. You are culturally deprived, so you would not understand it anyway."[14]

Hanks worked her way through the halls of Congress and charmed the legislators to keep supporting the NEA. The crisis passed. Then, in 1970, while NEA was facing another reauthorization, George Plimpton began work on the third anthology. He was using a third grant from the Literature Program, awarded before Nancy Hanks came in, but the anthology would be published while she was the chair. This anthology had a story called *The Hairy Table* by Ed Sanders. Its first words were "Her delicate tongue of flame slid into the crinkles of my ass, jabbing here like a sparrer, sucking there like a cuttlefish dragged from its hole. I filled her snatch full of air and gently drew it out in cunt-spurts, tasting the salmon moisture of the wheezes. . . ."[15] Writing like this would give William J. Scherle apoplexy!

Nancy Hanks and Michael Straight called George Plimpton and asked him to remove *The Hairy Table* from the third anthology. Plimpton refused, saying "Nancy said it would cost the Endowment millions, cut it to ribbons. I sympathized with her position, but I told her that she just couldn't do it. Then she said she would have to stop publication of the anthology. I told her a storm would break out. But she said she had to think of the Endowment, that this thing could kill it!"[16]

Hanks and Straight went to New York to negotiate with Plimpton. Hanks announced that she was canceling the anthology after the third volume appeared, which meant that Plimpton would have to find other funding for a fourth edition already being planned. He decided to excise *The Hairy Table* from the anthology supported with NEA funding, and include it in another edition that was printed with private sector money. The crisis was averted; the Endowment could go on and be reauthorized, because behind the scenes Hanks had preserved the essential balance between artistic freedom and Congressional concern and oversight. Michael Straight describes how the crisis was avoided:

> The Endowment was at that moment six years old. If Aram Saroyan could wound it, then Ed Sanders might finish it off; or so we feared. My inclination was to act before we were acted upon. The Chairman was wiser. She confirmed her assumption that the procedures had not been fully adhered to in the case of *The Hairy Table*. She per-

suaded George to agree on this critical issue. Then, disavowing any interest in the contents of *Anthology/3*, she cut off its funds on procedural grounds.[17]

The resolution of the *Hairy Table* crisis was an agreement among three Establishment people; Nancy Hanks the Southern lady, George Plimpton the Gotham celebrity, and Michael Straight the patrician got together in New York and worked it out. Nancy Hanks "confirmed her assumption that George had promised to adhere to some procedures"; she then "confirmed her suspicion that the procedures had not been fully adhered to"; and then "she persuaded George to agree" to cancellation. Some people would say that Nancy Hanks was censoring George Plimpton: that George was misbehaving, and that the "mother of a million artists" was disciplining him.

Nancy Hanks's willingness to restrict George Plimpton's use of public money, and to honor Congressional concerns, flowed from her political genius; and that political genius enabled her to maintain the key balance between artistic freedom and the need for oversight. She fit perfectly the positivist mentality of the National Endowment in the first half of the 1970s, and she brought it in the Bicentennial Year, 1976, to the height of its powers.

Hanks's relationship to the National Council on the Arts was very different from Roger Stevens's. Stevens and his first Council members were peers, equals—and their actions and decisions were a true collaboration. Hanks was not from the arts community; she was much more a political than an artistic force. She controlled the Council as Stevens had never tried to do. The Council, in Hanks's years, did little more than ratify the chair, who was very strong in her management of them. Michael Straight describes Hanks's "imposing her will . . . on the issues that mattered most to her."[18] Toward the end of Hanks's second term, the Council started to balk a bit. In the words of NEA staff member Ana Steele, some Council members began to feel that Hanks "wasn't listening to them or that they were being expected to rubber-stamp her."[19] In any case, Hanks was very strong, and the Council was relatively weak.

Expansion Arts and Challenge Grants

In her years at the Endowment, Nancy Hanks began two programs that changed the agency's philosophy and approach to giving: Expansion Arts and Challenge Grants.

The Expansion Arts program came in the aftermath of the 1968 urban riots. The government was looking for ways to reach out and involve (and maybe assuage) minorities. From a political point of view, a new program for the "disadvantaged" could be a major asset. And so Hanks and her staff, in 1971, started Expansion Arts "to help the growing numbers of professionally directed community arts groups with activities involving ethnic and rural minorities whose cultures had been inadequately supported in the past."[20] The first director of the program, Vantile Whitfield, came out of a community arts center in the Watts neighborhood of Los Angeles (one 1968 riot locus); he was succeeded in 1978 by A. B. Spellman, who described Expansion Arts as "concerned with bringing the arts to communities that have little access to established arts institutions—that is, minority communities or low-income urban neighborhoods or rural areas. . . . Our grantees are at a more developmental level, both artistically and administratively."[21]

In its first year, fiscal year (FY) 1971, Expansion Arts had only $307,600 to give, but it grew very rapidly:

	Number Grants	Grant Money	% Program Funds
1972	68	$1,137,088	5.5%
1973	194	2,524,556	9.1%
1974	293	7,442,000	16.2%

In the 1980s, the program went back down as a percentage of program funds, to the point where, by the end of that decade, it was hovering around 5 to 6 percent. But the number of grants kept growing steadily and in 1988 totaled 435. In short, the minority arts community in America responded strongly to Expansion Arts, and made it a core program of the Endowment.

The traditional percentage of an establishment organization's funding covered by an NEA grant has always been tiny: 2 or 3 percent of the Boston Symphony's funding, for instance, might be Endowment money. In the case of Expansion Arts organizations, however, this percentage is usually higher. For one thing, the budget of a community-based minority organization and the money raised by it are apt to be much smaller than an establishment arts group's; so a $25,000 or $40,000 grant will be a much higher proportion of both costs and funding. Because of this higher percentage, Expansion Arts took on a much more determinant function.

Some organizations that received their first NEA money from Expansion Arts—like Dance Theatre of Harlem—later graduated from that program to take a place in a discipline program (like Dance). Others have stayed inside the Expansion Arts universe and have held a privileged position there. Questions have always swirled around the program: "Is Expansion Arts a way to *begin* things?"; "How can we move organizations beyond it, into the discipline programs?"; "Is Expansion Arts its own fiefdom?" As Michael Straight says, sometimes Expansion Arts looks like "an endowment within the Endowment."[22] It is as much social service as it is an arts-funding program.

If Expansion Arts was devoted to minority and disadvantaged arts organizations, Challenge Grants were the opposite: a reward for America's primary establishment institutions. First tested in 1974 with a special grant to the Metropolitan Opera, Challenge Grants were formally inaugurated in 1976, Nancy Hanks's last year, with five primary goals:

1. To increase private support
2. To improve administration, especially in long-range planning
3. To build audience participation
4. To foster cooperation among arts groups
5. To encourage citizen involvement in cultural planning

Emphasis was primarily on four kinds of need: to eliminate debt; to build endowments; to help with cash flow; and to pay for capital improvements. These few grants, from the 1978 NEA Annual Report, show the range of Challenge Grants and their stress on long-term stability:

- Art Institute of Chicago, $500,000 to launch a five-year comprehensive fund-raising campaign to eliminate annual deficits and achieve financial stability.
- Dallas Museum of Fine Arts, $75,000 to establish an endowment and cash reserve, as well as to meet increased operating costs associated with development of new curatorial, educational, and exhibition programs.
- Lincoln Center for the Performing Arts, $500,000 to develop a Deferred Gifts Program to make available to Lincoln Center's individual donors the most advantageous gift plans under cur-

rent tax laws; to broaden the base of support for the Mostly Mozart Festival; to develop a mechanism and system whereby televised performances from Lincoln Center can generate revenue for the Center and for the performing artists.

- Martha Graham Center for Contemporary Dance, $250,000 to raise funds to eliminate an accumulated deficit and to establish an endowment fund.

- Richmond Symphony, $150,000 to meet increased operating costs by increasing the endowment fund, to initiate a cash reserve, and to purchase and install an acoustical shell.

The program required that every dollar received from the federal government be matched with three dollars of new or increased private, nonfederal money. To succeed, an organization had to end up with four times as much money as awarded by NEA; if you got $750,000, then you had to raise $2,250,000 and therefore have $3 million by the close of the three-year grant term. On this kind of scale, Challenge Grants could become a major impetus for long-range development; they married the federal government to the future of America's primary arts institutions.

The reaction to the Challenge Grants program was huge. In the first three years, NEA gave out $82.4 million to 326 organizations (much more than the $50 million that Gerald Ford had proposed when he announced the program). Over the first decade, from 1977 to 1986, 771 organizations were awarded $193 million, which leveraged more than $1 billion in private sector funds, a more than five-to-one match, much better than required.

"The President's request for challenge grant appropriations brings us sheer joy," wrote Nancy Hanks in *The Cultural Post* soon after the program was inaugurated, "because we believe that the program offers tremendous potential for raising ongoing support from private and non-federal public sources. The three-for-one provision means the arts will maintain a high level of pluralistic support. This will continue the American tradition, different from that of other countries, of maintaining cultural institutions through a multitude of sources."[23]

Both the Challenge Grants and Expansion Arts programs were manifestations of Nancy Hanks's political genius. Expansion Arts provided a way for NEA to be involved with the disadvantaged, and Challenge Grants with the advantaged. By the end of Nancy Hanks's second term,

the National Endowment for the Arts was politically connected everywhere, and its operation was superbly balanced.

The Carter Years

Running for president in 1976 and asked about the arts, Jimmy Carter said, "I would like to see government aid to the arts decentralized."[24] That became the theme of the next four years.

Carter appointed Livingston L. Biddle, Jr., to the chair of the NEA. Biddle, like Straight a patrician, came from the Philadelphia Main Line and had attended Princeton with Claiborne Pell of Rhode Island, who led the fight for the NEA bill in 1965. (In fact, as an assistant to Pell, Biddle had conceived and drafted the legislation.) He worked as deputy NEA chair for Roger Stevens; headed up the Division of the Arts at Fordham University in New York; was chair of the board of the Pennsylvania Ballet; and had written four novels about his native Philadelphia, two of them bestsellers. Biddle returned to Washington in 1973, first as director of NEA's Office of Congressional Liaison, then as staff director of Pell's Senate Subcommittee on Education, Arts and Humanities (where he drafted the Challenge Grant Program). Biddle was very much an "insider," and his appointment worried some people. In an editorial on November 5, 1977, *The New York Times* said, "If Senator Pell is bent on increasing his already considerable power over the Endowments, Mr. Biddle could find himself in the uncomfortable position of having to defend the integrity of his agency against the man to whom he owes his appointment."[25]

The NEA that Biddle took over in 1977 was very different from the tiny agency founded in 1965. After some growth under Roger Stevens, it had really come of age under Nancy Hanks. Her own lobbying within the Nixon-Ford administration and the participation of orchestras and museums (the most powerful of the arts groups) in NEA grant programs had brought an appropriation level in her last year that was fifteen times larger than in her first; and the staff had increased by more than four times (from 28 to 150). As Lawrence D. Mankin points out, "The year of 1977 became a time to pause, face criticism, and revise the management operations of NEA, and to adjust to a new political environment."[26]

A major ally for Biddle was Joan Mondale, wife of the new vice president, "Joan of Art" as she came to be called. Trained in crafts herself, Mrs. Mondale became the nation's primary lobbyist for artists

and arts organizations; she was named honorary chair of the Federal Council on the Arts and Humanities, an advisory group of agency and departmental heads that had been created by the 1965 legislation but had lain dormant until Biddle revitalized it. "Joan of Art" turned the vice president's house into a gallery of contemporary art. She was fond of saying, "It is at the local level where artists are bred, audiences are formed and organizations receive their mandate."[27] Mrs. Mondale was a fabulous ambassador for the arts on a local level.

Mondale's major allies in Congress were John Brademas and Claiborne Pell; Brademas was an Indiana congressman who was Pell's counterpart in the House. They played key roles in setting up the Institute of Museum Services, a separate agency (though part of the National Foundation for the Arts and Humanities) to provide operating support for museums; it was started in late 1977 with an appropriation of $4 million (which has grown to $25 to $30 million). Brademas was a particularly strong NEA booster, who (perhaps naively) believed that the NEA had reached a point where it would be difficult for a member of Congress to oppose further funding. He commented at the time: "Today, the arts are politically salable. Now a Congressman could get into more difficulty voting against the arts than for. All the evidence points to the fact that Federal support has become not only acceptable but popular."[28]

With this mood on Capitol Hill, there was some growth in NEA's appropriation, from $123,850,000 in FY 1978 to $158,795,000 for FY 1981. Linked to this growth was an expansionism characteristic of the Carter years. Biddle continued Hanks's growth emphasis, and by the end of Carter's and his term, the Endowment was full-blown.

By the end of the Biddle term, NEA programs were not only discipline-based, but also dealt with generic areas such as Folk Arts and Interarts. Biddle also created special functions to deal with special interests, like an Office of Minority Concerns and an Office for Special Constituencies "to make the arts more accessible to handicapped people, older adults, veterans, and people in hospitals, nursing homes, mental institutions, and prisons."[29] (This office awarded only $487,415 in grants in FY 1981, but the grants were very visible in the Carter world.)

Throughout the Biddle tenancy, the National Endowment for the Arts was known as a place where "populism" was at war with "elitism." Populism (favored by Mondale, Brademas, Pell, and Biddle himself) stressed access—availability of the arts in all communities and the

worthiness of local enterprises. In contrast, elitism stressed the Western European classical arts as found in primary institutions in major cities (Boston, New York, Philadelphia, Chicago, San Francisco, and Los Angeles), and also the new and experimental and sometimes exotic. The populism-elitism controversy raged in the media from 1977 through 1980. Biddle himself, seeking to preserve the appropriate and essential balance, said, "What we are talking about is making the best-quality art available to the greatest number of people."[30] *The New York Times* responded for the arts and media establishment in this 1977 editorial: "The President referred last March to the Endowment's 'elitist image.' . . . Such comments arouse concern that the Endowment will now be steered onto a more 'popular' course, which may be more useful politically but less rigorous intellectually."[31] By 1979, decentralization of NEA funding was being identified in the *Times* as a disturbing trend:

> There is now a discernible and growing trend toward the politically popular policy of assisting newer, more regionally dispersed "populist" groups rather than traditional "elitist" cultural institutions. . . . The agency's approach to the dilemma of geographic access versus quality at the arts agency was succinctly explained by [P. David Searles, deputy chairman for policy and planning]. "There is a clear understanding at the endowment that we do consider geography in making grants. If there are two institutions of the same quality and one exists in an area of the country where there is considerable arts activity and the other exists in an area where there is less, the grant will go where there isn't as much activity."[32]

Perhaps the most telling comment was from choreographer Agnes de Mille: "Most of the money is being thrown away. It's being used for political purposes. They're spreading it around geographically, like Kiwanis, because every state has its senators and congressmen. What do they care in Alaska if Martha Graham continues creating? Or what do they care in Oklahoma if Ballet Theatre continues? Our intent in the beginning was to help the highest, the best. The whole tendency today is to help the unknowns and the unproven, but all that does is encourage mediocrity."[33]

On the other side of the argument was Joseph Duffey, chair of the companion National Endowment for the Humanities, who minced no words when he said to Michael Straight: "You are a God-damned elitist . . . and we are going to rid this government of elitists like you! You and

your God-damned Ivy Leaguers think you can run this country in your patronizing way. I am here to tell you that from now on, the people, not the Ivy Leaguers, will hold power!"[34]

At the core of the populism-elitism debate was politicization. Nancy Hanks may have been a political genius, but her politics were quiet and behind the scenes. Under Biddle, the NEA was a kind of political football. Those who faulted the populist approach tended also to charge that decisions at NEA were made on the basis of politics. As critic Hilton Kramer wrote, "Are we really prepared to endorse Senator Pell's philistine notions of culture, and President Carter's apparent politicization of it, as official national policy?"[35]

Again striving for balance, Biddle led an Endowment that awarded approximately half its funds to "haves" and half to "have-nots." In Biddle's first full year, funding of minority projects rose nearly 40 percent, from $8 million to $11 million. In 1980, he instituted Advancement Grants, a Challenge-like program for long-range development of community-based and emerging organizations that lacked administrative sophistication. NEA's Advancement Announcement specified the gaps it sought to fill: "a too-narrow funding base; regular cash flow crises; insufficient money for fundraising staff, promotion, or audience development; a board without fundraising skill or access to funding sources; underpaid artists and overworked administrative staff; and a rudimentary financial system that hinders cost control and planning."[36] Congress appropriated $750,000 for Advancement in FY 1981; the Challenge Grant program administered it; and fifteen organizations received grants in the first year,* a group of alternative and minority companies that would today be called "politically correct." Whereas Challenge was more often than not devoted to endowment, Advancement was devoted mostly to administrative strengthening: helping organizations to grow in their management and to find ways to be competitive in an ever-more-complex arts community.

Biddle later wrote about how these programs contributed to the essential balance:

* Capitol Ballet Company; Center for Positive Thought; Dashiki Project Theater; Elma Lewis School of Fine Arts; Ethnic Folk Art Center; Frederick Douglass Creative Art Center; Jazzmobile; LA Theater Works; Museo del Barrio; Negro Ensemble Company; Philadanco; Repertorio Espanol; Road Company; Studio Museum of Harlem; and El Teatro Campesino.

The guiding principle of balance is essential. . . . The design may change from year to year, but like a work of art, it must be a balanced and unified design. I brought changes in minority attention, new programs for jazz and musical theater, panel responsiveness, council participation, funding levels, and evolving partnerships, but I did not alter a total balance.[37]

With his insider background, Biddle enjoyed rather smooth sailing through Congress. He was very much a gentleman and very much part of the Capitol Hill Club. In his relations with the National Council on the Arts, he sought to expand its responsibilities and involvement in grant-making decisions. There came to be Council committees on Budget and on Policy and Planning; the latter prepared the Endowment's first Five Year Plan, submitted to Congress in 1979. Biddle did not presume the same authority or dominance that Hanks had, and the Council began to be more and more restive; they started concentrating their attention less on grant making and more on policy.

A problem with Congress did come in 1978 and 1979, when Sidney Yates of Chicago, chairman of the House Appropriations Subcommittee on the Interior and Related Agencies and so the House guardian of NEA, ordered an investigation of the agency with particular attention paid to application review. Livingston Biddle tells how it came about: "When I first appeared before Yates in early 1978, to testify on the next budget, he took me aside and he said, 'You know, Biddle, this agency is now twelve years old, and nobody's ever looked at it very closely. . . . Before you get immersed in this, and the problems become yours, I'm going to have a full-scale appropriations committee investigative study of the National Endowment for the Arts.'"[38]

Work started in July 1978 and was finished in March 1979 with the issuance of an eighty-one page report. In it, the investigators found the NEA "deficient in its management policy and practices to the extent that the NEA . . . fails to meet its legislative mandate."[39] Biddle was taken aback. As he tells in his book *Our Government and the Arts*:

That evening, I recall meeting Sidney Yates at an arts function. . . . He told me that he understood the investigative report had been completed but that he had not yet seen it. Had I had a chance to read it through?

"Not entirely," I answered. "But to some extent."

"What was your reaction?" he asked in a friendly tone.

"I was outraged," I told him.

He looked surprised. "Outraged?" he asked after a short pause. . . .
"All right," he said with a slight and partly aloof smile. "Tell me
about it, in writing."[40]

Biddle and his staff prepared a rebuttal nine pages longer than the
report:

> [The report] consistently misrepresents our mandate and operations.
> . . . We find the report so flawed both conceptually and technically as
> to be almost without merit. . . . The report misinterprets our legisla-
> tive mandate . . . draws sweeping conclusions based on supposed facts
> that are breathtakingly inaccurate, gives almost no recognition to ad-
> ministrative reforms undertaken within a very tight budget during
> the very time of the investigation, and finally, is haphazard and often
> reliant on gossip and hearsay in its methods of reporting.[41]

Sidney Yates, always a supporter of the NEA, sided with Biddle and
buried the report, saying "I found nothing instructional or beneficial
about the endowment's work commented upon. It isn't what I in-
tended."*[42]

Livingston Biddle presided over the NEA's fifteenth anniversary in
1980. It celebrated the spending of nearly $1 billion on 40,000 grants
since 1965, with each federal dollar bringing many times that in match-
ing private money: a quantitative achievement. Yet despite the celebrat-
ing, the relationship of the arts to government was still awkward and
remained uncomfortable. Pollster Louis Harris, as chairman of the
American Council for the Arts, called on the Carter administration to
match its positive talk with positive action, and he listed six grievances:

> The Internal Revenue Service makes it difficult to take tax deduc-
> tions when artists and performers use their homes as studios.
>
> The IRS has ruled that artists who contribute their works to
> museums may deduct from taxes only the cost of materials, not the
> works' market value. But collectors who donate art works may deduct
> the market value.

* Frank Hodsoll, NEA chair from 1981 to 1989, says of the report, "While it was in many
respects overdone, there was also much truth in it. A number of its recommendations should
have been addressed seriously."[43]

The IRS makes it difficult for arts organizations to qualify as tax-exempt nonprofit organizations. As a result, tax payers are less likely to contribute to the arts.

The newly revised copyright law fails to assure royalties to performers on phonograph records that may sell millions of copies.

Federal employees, who contribute $71 million in the annual Government unified charity drive, are given no opportunity to direct part of their gifts to arts activities.

The Postal Service has proposed increases in nonprofit mail rates that by 1988 would raise mail costs to 15 times what they were in 1970.[44]

These federal rules revealed that the government was not doing all it could to support the arts, despite the NEA's phenomenal growth. They also reveal that, at its heart, the government was still not as sensitive to the needs of the arts community as it could be; and the arts community, on its side, still harbored resentment, suspicion, and distrust.

FOUR

The Reagan Years

IN FISCAL YEAR (FY) 1980, the National Endowment for the Arts was part of a federal superstructure that was spending $700 million on culture.* NEA's own appropriation was $154,610,000; its staff of 325 was processing grants to 5,000 organizations and individuals. During that year, it was reauthorized for five more years, at levels ranging from $175 million for FY 1981 up to $306 million for FY 1985. The agency appeared to be very secure.

In 1980, a presidential election year, Jimmy Carter was challenged by Ronald Reagan. During the campaign, Reagan issued a statement on the arts and humanities: "I will end as soon as possible the politicization of the National Council on the Arts so conspicuous during the Carter-Mondale administration. . . . As to what levels of funding I would

* The superstructure included the Endowments for the Arts and Humanities, the Institute of Museum Services, the Smithsonian Institution, the National Gallery of Art, the National Trust for Historic Preservation, and the Corporation for Public Broadcasting. All of these together received one-half of 1 percent of the federal budget.

recommend for the future, I cannot say. I would hope that we could see a steady increase. . . . Artistic creativity cannot be bought but it can be encouraged and should be without domination by any governmental body."[1] It was a good and positive statement, and it led people in the arts to believe that the former Hollywood actor would be a champion of the arts.

Once elected, Reagan appointed Robert S. Carter (no relation to Jimmy) as chairman of a transition team on the NEA. Republican chairman of the District of Columbia and head of a public relations firm, Carter too seemed sympathetic: "Reagan isn't the kind of fellow who's going to cut back on the arts."[2]

The honeymoon, however, was soon over. David Stockman, Reagan's director of the Office of Management and Budget (OMB), reportedly spent fifteen minutes on the matter before concluding that both Arts and Humanities endowments were "ineffective or of low priority and could be cut by at least one-third."[3] And the Heritage Foundation, a conservative Washington think tank, issued a report that severely criticized Livingston Biddle's attempts to spread NEA funding, maintaining that the NEA had become more concerned with politics than with the arts, and urging that the Endowment redefine its mission to support of art and artists.* In a few short weeks, the new Reagan administration had deserted the NEA.

Added to this were complications within Congress. Though Sidney Yates would still be chairman of the key House Appropriations Subcommittee, the new Republican control of the Senate meant that Claiborne Pell of Rhode Island would no longer chair the key committee there. Senator Jacob Javits of New York, and Representatives Frank Thompson of New Jersey and John Brademas of Indiana—all three champions of the arts—lost their bids for reelection and so were leaving Washington. Each party would now control one house of Congress, and there would be fewer friends of the arts in both.

The Reagan administration assaulted the NEA within two weeks of the inauguration in February 1981. Looking for budget cuts to trim the 1982 deficit, the OMB proposed a 50 percent cut in NEA appropriations, to $88 million in FY 1982,** and growing to only $92 million in

* This is especially ironic in light of the attacks on the NEA by the Heritage Foundation and other conservative groups in the late 1980s, when they faulted the agency for supporting individual artists.

** Interestingly, even before Reagan came in, there had been calls for cutting. Jimmy Carter, in

FY 1985 (a drastic drop from the projected $306 million authorized in 1980). Behind the administration's draconian proposal was a very strong feeling that arts funding should come not from government but from the private sector. But there was also an acknowledgement by the Stockman office that the proposed cuts might meet major resistance: "Most artistic and cultural institutions maintain strong ties to business and corporations through appointments on boards of directors. A proposal to halve the budgets of the endowments could generate strong opposition."[4] With the proposed 50 percent cut came a request that FY 1981 funds be cut in the middle of the year, thereby lowering both current and future funding.

The pair of proposals triggered vocal and vigorous dismay in the arts community. People assumed that the Stockman OMB move was a first step toward eliminating the Endowment—and they answered it with calls for protecting and preserving the agency. The American Arts Alliance, which was the primary advocate for the country's major arts institutions, led the response; it was joined by other national arts organizations like the American Council for the Arts (ACA), the National Assembly of State Arts Agencies (NASAA, for state arts councils), and the National Assembly of Local Arts Agencies (NALAA, for community arts councils). The reaction, though, was very much an official "inside-the-beltway" response, staged by institutions and organizations, not reaching or involving many individuals. Livingston Biddle, still chair at the time, notes in his memoirs the lack of a broad-based initiative: "One might wonder what the leaders in the arts outside Washington, in the private sector, in states and local government were doing at this time. I think they were stunned and confused. Many hoped that it was a bad dream that would dissipate."[5]

The Task Force

President Reagan, who had not been personally involved in the Stockman proposal for cuts, was soon barraged by complaints from a number of his friends in the arts community. Three months after the OMB attack, he announced the formation of a Task Force on the Arts and Humanities, a blue-ribbon panel of thirty-six citizens to advise him on three issues: (1) expanding private support for the arts and humanities;

1980, had asked the NEA to cut $8.8 million in Challenge Grants and Administrative Funds, in an effort to balance the 1981 budget.

(2) involving more nongovernmental opinion (from individuals and private-sector groups) in federal arts and humanities decisions; and (3) restructuring of federal arts and humanities funding, including the National Foundation on the Arts and Humanities, the two endowments, and the Federal Council on the Arts and Humanities. Reagan named fellow actor Charlton Heston, University of Chicago president Hanna Gray, and ambassador-at-large for cultural affairs Daniel Terra as cochairs, *Reader's Digest* counsel Barnabas McHenry as vice chair, and thirty-two other members, including Princeton University president William Bowen, New York City Commissioner of Cultural Affairs (and former NEA Visual Arts chief) Henry Geldzahler, Nancy (Mrs. Zubin) Mehta, Arthur Mitchell of the Dance Theatre of Harlem, Franklin Murphy of the Los Angeles *Times-Mirror*, and Beverly Sills of the New York City Opera. In a statement on May 6, Reagan said:

> Our cultural institutions are an essential national resource; they must be kept strong. While I believe firmly that the federal government *must* reduce its spending, I am nevertheless sympathetic to the very real needs of our cultural organizations and hope the Task Force will deliver to my desk by Labor Day a plan to make better use of existing federal resources and to increase the support of the arts and humanities by the private sector.[6]

Some people on the arts-advocacy side (leading the fight in the spring of 1981) viewed the Task Force as Reagan's way of justifying either a cancellation of the endowments or their transformation into "public corporations," much like the Corporation for Public Broadcasting (which is quasi-independent and gets multiyear appropriations from the federal government). The advocates assumed that the Task Force would be a death knell for the NEA. They cornered Charlton Heston, who turned out to be quite friendly. Heston commented:

> The White House was originally a little surprised at the level, the *volume*, of response in the arts community. . . . I said to them, "You have to recognize that people in the arts . . . are highly visible. . . . You're going to hear from them." . . . Over the years, it has gradually been perceived—I think accurately—that the arts and humanities, again, in the President's phrase, are a vital resource and should be preserved. . . . The government has consistently fallen over backwards to avoid seeming to interfere, because that's a very delicate thing.[7]

Through the late spring and summer of 1981, the Task Force held hearings across the country and sought answers to the three questions Reagan had put to them. In October, they released their report, which noted that contributions to culture approached $3 billion per year, and that the two endowments (Arts and Humanities) provided 10 percent of this (or $300 million). Somewhat surprisingly, the Task Force agreed with Sidney Yates, Claiborne Pell, Livingston Biddle, and the arts advocates; it gave a strong endorsement of the NEA and rejected the Stockman-OMB proposal for halving its funding: "Basically, the National Endowments are sound and should remain as originally conceived. . . . Furthermore, we endorse the professional panel review system, which puts judgments in the hands of those outside the Federal government, as a means of ensuring competence and integrity in grant decisions."[8]

Coming just as Congress was wrestling with the FY 1982 appropriations, the Task Force report played a major part in rebuilding support for the Endowment; it helped to restore the balance. Congress ended up appropriating $143,456,000 for FY 1982, down only about 10 percent from FY 1981's $158,795,000.

A New Chair: Frank Hodsoll

Behind the scenes at the White House, Francis S. M. ("Frank") Hodsoll, deputy to Chief of Staff James A. Baker, was the chief advocate for the Task Force as a way of settling the question of whether the NEA and NEH deserved continued funding; and he became the Task Force's point of contact with the White House. Reagan nominated Hodsoll to be the new chair of the Endowment when the Task Force report was presented to him.

Hodsoll came out of California, received a bachelor's degree at Yale and law degrees from Cambridge and Stanford, and worked briefly at the old-line New York law firm of Sullivan and Cromwell, and then in the State and Commerce Departments and at the Environmental Protection Agency. At Yale, he had majored partly in the history of art, had acted, and had produced radio shows and a concert of singing groups at Carnegie Hall. Livingston Biddle describes him as "a great figure of a man, large in the dimensions a linebacker could envy, quick in intelligence, long in experience with political life, shorter in the arts."[9] For the first time, the chair of the Endowment would be a person without previous professional involvement in the arts. Frank Hodsoll came from

The first four NEA chairs. L to r: Livingston Biddle, Nancy Hanks, Frank Hodsoll, Roger L. Stevens. *Ankers Photographers, courtesy of the National Endowment for the Arts.*

politics, and he was their master. He was also very much Reagan's choice; so while the arts community was not charmed by him, it had no choice but to give him a chance. Roger Stevens, Nancy Hanks, and Livingston Biddle all came to his swearing-in ceremony.

If Hodsoll had not taken the NEA chair, he might have stayed at the White House and functioned as an in-house adviser on the arts. There was a tradition for this: Harold McPherson and Abe Fortas had served Johnson in this capacity, Leonard Garment worked for Nixon, and Peter Kyros and Joan Mondale advised Carter. None of these people were arts professionals; but all of them had a sensibility that embraced the arts, and all of them played pivotal roles in working with the NEA chair and acting as a liaison to the chief executive. When Hodsoll left to become NEA chair, there was no one else who took up this advisory function for Reagan (or later for Bush). This lack of a partisan in the inner circle may have created a gap that would affect and limit the status of the NEA within government.

At NEA, Hodsoll delivered. He turned out to be very smooth and adroit, a good listener, and a fast learner. Early in his tenure, he ex-

pressed his point of view: "The times call for an expanded national, non-partisan coalition for the arts, made up of our artists and arts institutions, greater leadership for greater support for the arts among private and public leaders, and a much closer and ongoing relationship between the Endowment, corporations, foundations, and individual donors."[10]

Still, though, money slowed under Hodsoll. It had grown substantially under Stevens, and vastly under Hanks; under both Biddle and Hodsoll, it was less than the inflation rate. Here are the figures for all four chairs:

Chair	Fiscal Years	Average Annual Growth
Stevens	1966–1970	57%
Hanks	1970–1978	161%
Biddle	1978–1982	4%
Hodsoll	1982–1989	2%

With the scarcity of money, there were few new programs initiated (only a Locals Program, started in the mid-1980s to give substantial funding for development of local arts councils, provided it was matched with new local public dollars over three years; by 1989, the modest investment had triggered $34 million in new state and local government funding). Other Hodsoll initiatives were a 28 percent increase in Challenge monies, a revitalization of the Advancement Program, a community foundation initiative to assist minority access to private funds, and a new National Center for Film and Video Presentation, which won for the Endowment both "Oscar" and "Emmy" awards.

Hodsoll used his position as a Reagan insider to convince the president to establish a President's Committee on the Arts and Humanities (to encourage more support from the private sector), and also to begin the Presidential Medal in the Arts, given annually to honor artists and patrons. His position on the inside may also have provided insulation for the arts in the 1980s. Coming out of the foreign service and a long career in government, he was a negotiator—and he made sure that all sides got a hearing. Grace Glueck, in an article in *The New York Times* in 1985, pointed out this diplomacy, and also Hodsoll's comfort in vetoing some grants:

Mr. Hodsoll appears now to have established himself as a chairman to reckon with. Although he makes it clear that his mandate is from the Reagan Administration, his approach seems to be on the liberal side of that Administration, and he has taken a lively interest (some say too lively) in promoting avant-garde and experimental work. . . . The "elitist-populist" question seems to have faded away, due to Mr. Hodsoll's skill at nurturing both grass-roots and more established constituents. . . . Mr. Hodsoll himself, unlike his predecessors, takes a very active role in reviewing panelists' recommendations. And he has even vetoed some of them. Last year, he caused a flap in the art world by suspending indefinitely a program of fellowships for critics in the visual arts, after a report . . . pointed out weaknesses in the program. . . . On the plus side for the endowment is the case of the painter Peter Saul, winner of a $25,000 fellowship in the visual arts. His recent work has contained vitriolic portrayals of President Reagan in situations that are, to say the least, unholy. "We do fund good artists, and if they do things that are political, that's their business," says Mr. Hodsoll.[11]

Frank Hodsoll was a master of balancing.

Problems in the 1980s

The tradition at the National Endowment has been that applications approved by panels (of citizens) and then approved by the advisory National Council on the Arts are also approved by the chair, who technically has the final say and the ultimate authority. The first three chairs of the agency generally followed this principle. Hodsoll also kept this tradition, though he instituted a new system of bringing selected panel recommendations to Council attention and then making his own decisions—occasionally reversing panels or even the Council. (Like Hanks, Hodsoll was a strong chair, in control of the Council.)

Hodsoll occasionally got into trouble over his management of the granting process. In 1982, he sent twelve applications back to panels for reconsideration; when some of them came back with new approvals, he marked five for rejection. Some in the arts community got worried, and Richard Goldstein in the *Village Voice* attacked Hodsoll as a conservative, calling the rejected groups "small, new, unorthodox, and broadly social. . . . The single most ominous thing about Hodsoll's NEA is its retreat from full disclosure. Like so much else about his administration,

this, too, reflects the chairman's ties to the White House, and his determination to keep the NEA from pursuing an independent course."[12]

Hodsoll's more substantial later tinkering with the granting process got him into trouble not only with the arts community but also with Congress. In late 1987, he proposed that panel recommendations on grants be undertaken with "stricter discipline and greater consistency." He was calling for a less intuitive and more systematic way of granting Endowment funding once artistic merit had been determined. As he now remembers:

> I instituted computers at the NEA . . . and I used them to collect information on what the panels were doing. I began to notice that some arts institutions that were rated highest by panels were getting a smaller percentage of their projects funded than were others rated much lower. So I started asking questions: "Why is this?" And then I got some scatter diagrams produced; and I discovered that it was just all over the place: more here, less there, without any apparent explanation. And I said, "Wait: once the panels have made their artistic judgments, we have a responsibility to the taxpayers to have some rationale for how we parcel out the money." My overall point was, if you have something that's rated high by a panel, then that high ranking should be reflected in the size of the grant. I couldn't see how there was any rational argument against that.[13]

Although Hodsoll's computer-based analysis seemed reasonable, many members of the individual panels were upset by what they considered to be an unwarranted intrusion into the grant-making process. Some members of the National Council (but not a majority) objected to Hodsoll's idea because they wanted to maintain the panel system as it was. Arts institutions reacted vehemently to the idea, saying that "bottom-line, bureaucratic thinking was about to crowd out artistic judgment." Baltimore's Walters Arts Gallery director Robert P. Bergman spoke for the arts community: "Instituting a formula . . . will result in rewarding larger institutions, or, in the worst case, will reward profligacy and impose cutbacks on medium, small, and emerging institutions." Both Claiborne Pell in the Senate and Sidney Yates in the House were appalled by the clamor. Yates told the chair, "I've never seen such a storm created. Every concerned organization we heard from has expressed opposition to what you're doing." Pell urged that Hodsoll make no

changes in the panel system "until you have completed a thorough re-examination of the implications of such a move."[14]

Yates inserted language into the Endowment's FY 1989 appropriation to restrict the agency's proceeding with Hodsoll's idea. In the end, though, some panels more or less went forward with the concept, if not the exact methodology. Hodsoll's political dexterity allowed him to negotiate a compromise, and this crisis too disappeared.

Hodsoll's most difficult time was in the mid-1980s. The Endowment had granted $40,000 to the Virginia Opera, and their 1983–1984 season included a production of Verdi's *Rigoletto*, transplanted to New York's Little Italy and flavored with Mafia references. Congressman Mario Biaggi of the Bronx took great exception to the production, maintaining that it offended and insulted Italian Americans, and he fired off a letter to Hodsoll on January 18, 1984:

> At issue is the public advertisement campaign promoting this opera . . . featur[ing] a gangster theme from the 1920s in New York. The insult to Verdi's opera and the Italian American community is compounded in the ads by a figure of a man dressed in a black suit and white hat emerging from the letters Rigoletto which themselves are riddled with bullet holes. In addition, most gangster figures in the production have Italian names advancing the idea that all of the criminals of the era were Italian.
>
> It is most regrettable to see federal funds used to denigrate a particular ethnic group by promoting a stereotype. I, therefore, call upon you to publicly disassociate the Endowment from the advertisements and other promotions affiliated with Rigoletto. Further, I call upon you to contact the Virginia Opera Company and have them cease and desist from this type of advertisement.
>
> Finally, I call upon you to institute new monitoring policies in the Endowment to ensure that federal grant funds are not misused in this type of offensive fashion. As a senior Member of the House Education and Labor Committee which oversees the Endowment, I assure you of my deep concern in this matter and my expectation that the matter will be remedied.[15]

Hodsoll responded:

> We are sorry that the production has aroused concern. However, I am sure you can understand how important it is for the Endowment to

avoid any appearance of involving itself in the artistic affairs of those receiving support from us. . . . Our enabling legislation states in its declaration of purpose "that it is necessary and appropriate for the Federal Government to help create and sustain not only a climate encouraging freedom of thought, imagination and inquiry, but also the material conditions facilitating the release of this creative talent." Clearly, the Endowment cannot take a contradictory position. . . .

I should perhaps add that I have looked at the advertising material that you cited, and that I personally found it in poor taste. I would prefer that the Virginia Opera Association had not disseminated it. However, I feel I am not in a position to interfere in this matter in any official capacity.[16]

After this exchange of letters, Biaggi proposed an amendment to the NEA authorizing legislation to "limit discriminatory activity," and to guard against any grantee using federal funds "to denigrate any ethnic, racial, religious or minority group." The fact of this amendment forced a hearing, on June 28, 1984, at which both Biaggi and Hodsoll testified:

MR. BIAGGI: The Virginia Opera Company chose to sponsor the Italian opera, "Rigoletto." The format . . . was offensive not only to myself but to many other Americans of Italian origin. It was offensive for the basic reason that it chose to glorify, at least in the promotional material, an ethnic stereotype that I do not believe that we should encourage or support with public funds.

. . . I continue to maintain that public funds need to act in the public interest. I call for public accountability. . . . The point is there should be a sensitivity. I don't think we should have censorship. But censorship and sensitivity, what separates them is a very fine line. I think it's incumbent upon your agency, Mr. Hodsoll, to be aware of it, in making grants, that you should sensitize the people that are receiving them. Let them know that there's a feeling out there that large groups of people don't like to be offended.

MR. HODSOLL: I am not here today to urge the Congress to turn a blind eye to how federal funds are expended. It can be argued that one of the reasons the Endowment has survived these 20 years is precisely because it has a system of safeguards designed to assure that only those projects and productions of the highest artistic merit receive federal funding. . . . While I cannot assure this subcommittee

that there is never a case in which an Endowment supported project is actually offensive to a minority or ethnic group, I do believe with great personal conviction that such instances are rare enough out of the more than 7,000 grants we make each year, that we as a nation are better served by retaining the present system which permits the occasional offensive grant than we would be to dramatically alter the system and impose undefinable government standards on all that we do. The fact is that art involves risk if it is to succeed and grow. I would respectfully urge this subcommittee to continue the climate of freedom in which this agency has operated for 20 years and ask that our authorizing language on this subject be left unchanged.[17]

The Endowment won this time; Biaggi's amendment was not adopted. Another, more serious problem akin to the recent troubles happened in 1985, during reauthorization. As Kevin V. Mulcahy and Harold F. Kendrick note, "These periodic reviews allow the authorizing committees, the agencies in their orbits, and the interest groups that revolve around them to gather for the purpose of examining a public policy's performance"[18]—so reauthorization has often been a time when congressional suspicion is at its height. In 1985, three Republican representatives from Texas (Dick Armey, Thomas D. DeLay, and Steve Bartlett) attacked the NEA in the House for having made grants for poetry that they considered pornographic. Armey was the primary spokesman for the trio: "I sat in my office with seven young, virile men, and not one of us could read several of these poems aloud, they were that bad."[19] Frank Hodsoll, testifying and defending the agency, said: "We must ask ourselves which danger is greater: running the risk of speaking 'offensively' to some, or running the risk of censorship of freedom of expression, and tyranny which would logically ensue from such a course."[20]

The Texans introduced an amendment to H.R. 3248 (the reauthorization measure) that would limit funding only to projects that have "significant literary, scholarly, cultural or artistic merit; are reflective of exceptional talent; and foster excellence." DeLay offered an amendment that limited reauthorization to only two years, in order to "send a clear message . . . that we in Congress do not want [the NEA] to continue with a business-as-usual type attitude."[21] Both amendments passed the House. Representative Armey concluded, "When it comes to using the American taxpayers' hard-earned dollars to subsidize and promote a particular work of art, I believe that Congress, acting as

elected representatives of the people, has a right to determine what type of art we should be funding."[22]

Meanwhile, the Senate had passed a bill reauthorizing for five years (the usual term). It became necessary, during the fall of 1985, for both houses of Congress to negotiate the terms of a final reauthorization. Just before Christmas, both houses passed bills reauthorizing for five years; providing $167,060,000 for FY 1986, $170,200,000 for FY 1987, $177,010,000 for FY 1988, and "such sums as may be necessary" for FY 1989 and FY 1990; and also ordering twenty rules—among them that the NEA chair be called "chairperson," that the NEA and NEH conduct a study of arts and humanities education, that there be a Poet Laureate within the Library of Congress, and that at both endowments, panels recommend for funding only projects that have "significant literary, scholarly, cultural, or artistic merit; are reflective of exceptional talent; and foster excellence."[23] This last was hardly threatening; no one was opposed to "significant merit" being the standard, and this rule simply confirmed the Endowment's quality emphasis. Still, Representative Armey had the last word and made it clear that the battle would continue: "Although we won't have the opportunity to reauthorize the endowments for five years, we will be able to revisit these programs at the appropriations process. And be assured, those of us who have concerns about certain activities at the National Endowment for the Arts will be following closely the progress the NEA makes in addressing these problems."[24] Looking back on 1985, Montana Congressman Pat Williams says:

> The 1985 anti-NEA effort took two paths: one policy, the other political.... Politically, the far right ... realized that they had an issue that would appeal to hundreds of thousands if not millions of Americans. On the policy side, Congressman Armey and others were coming at the issue not only from a standpoint of requiring that only "works of artistic merit" be funded; they were also beginning to question whether the federal government should be involved at all in funding.[25]

Despite these problems, Hodsoll led the Endowment through relatively steady years. Quantitatively, the Endowment could point to extraordinary growth in the numbers of arts institutions; since 1965,

symphony orchestras had grown from 58 to more than 225, opera companies from 27 to 120, dance companies from 37 to 250, and theater companies from 23 to 420. Audiences, too, had grown substantially:

Performing Arts Attendance (in millions)*

	1965	1988
Symphony orchestras	9	24
Dance companies	1	16
Theater companies	1	15
Opera companies	3	18

In FY 1989, the funds awarded by NEA supported $1.4 billion in arts projects and attracted $1.25 billion in nonfederal funds. In the last full year before the crisis, FY 1988, the agency had more than $150 million to give, which it divided up as follows:

	FY 1988 Funds
Total Appropriation	$167,731,000
Administration	-17,140,000
Grantable Funds	150,591,000
Grants to Arts Managers, Education, International, Local Arts Agencies, Research, Special Constituencies, State Arts Agencies and Regional Organizations	-34,034,000
Available for Institutions and Individuals	116,557,000
Grants to Individuals	- 8,585,000
Available for Institutions	$107,972,000

The grantable funds are the core money of NEA. They amounted to 68 cents per taxpayer (which makes the American federal government much more stingy and less supportive in direct funding than governments in Western Europe, which often provide twenty to forty dollars

* The growth between 1965 and 1988 in each category is the significant part of this. It is unlikely that the four audiences now add up to seventy-three million people total. There is considerable crossover among the four: people who attend more than one art form. Still, the overall audience was at least five times in 1988 what is was in 1965.

per citizen to their arts). In FY 1988, 7 percent of available money went to individuals, and 93 percent to institutions; the institutions' share was matched by about eleven dollars from the private sector for every dollar given by NEA. Quantitatively, the Endowment was a very good buy.

Trends of the 1980s

Three other developments in the 1980s affected the NEA and forecast future problems. The first of these was a "philosophy of entitlement" that took hold in the nation. Ever since the New Deal addressed the crisis of the Depression, Americans had increasingly come to expect that government should provide for the basic needs of its citizens. In the 1987 *Random House Dictionary*, "entitlement" is defined as "the right to guaranteed benefits under a government program." By FY 1993, $717 billion or 48.6 percent of the federal budget was being spent on entitlements (Social Security, Medicare, Medicaid, unemployment, welfare, and federal retirement), and it was estimated that in FY 1997 they would claim $868 billion or 51.8 percent. The rights movements of the 1960s and 1970s—for minorities, feminists, the imprisoned, and the gay—introduced a new assertiveness that was attractive to and comfortable for artists as well. The arts community came to believe that federal, state, and local governments owed it something. By the late 1980s, arts institutions and especially individual artists were ruled by what critic Hilton Kramer calls "the idea that if you received a grant in the past, you have an entitlement to it in the future."[26]

The second development had been there from the beginning but was more pronounced in the 1980s: the proclivity of the Endowment to fund the new and innovative, and so a tendency to behave like a foundation. This tendency flowed partly from the brightness of NEA program directors—people that Fannie Taylor and Anthony L. Barresi call "unusual, capable, brilliant, and occasionally distinctly oddball."[27] Russell Lynes, in an article in *Harper's* in 1969, noted that "The National Council on the Arts has acted as though it were a private foundation, giving grants to institutions and to individual artists and writers in much the same way that the Ford Foundation has."[28] Michael Straight, in *Twigs for an Eagle's Nest*, tells a poignant story: "It seemed clear that many of the Endowment's actions were more appropriate for a private foundation than for a government agency. 'How do you distinguish between the role of the Endowment and the role of private

foundations?' I asked Mr. [Roger] Stevens. He answered: 'We do more daring things than they can do.' "[29]

In 1969, the federal government clamped down on foundations, requiring them to pay taxes on their investment earnings and narrowing their freedom to make grants, especially to individuals. After 1969, the foundation community became more conservative in its giving to individual artists because of the government's change in attitude. It may be that the federal government, having legislated these changes and having forced this adversarial mood, moved to take the place of foundations in agencies like NEA.

Saying that the Endowment has had a tendency to behave like a foundation should not be taken to mean that it is really one; there are big differences between the two forms. A foundation is the essence of the *private sector*, its governance in a small and usually elite board. Any federal government agency has a much more diffuse constituency, because it is part of the *public sector*, and its governance rests in a wide variety of groups (the president, Congress, its beneficiaries, interest groups, and the public at large). The NEA is not at all like a foundation structurally; but it is very like one psychologically, in how its people (staff and panels) behave.

Because of the intelligence of its program directors, and advisory panels that include cutting-edge artists and critics, the NEA has always (and particularly in the 1980s) concentrated on the new and innovative. Its 1980s chair, Frank Hodsoll, turned out to be (somewhat surprisingly) a champion of the experimental; he believed that, like the National Science Foundation, the NEA should be on the cutting edge of new developments. Programs like Inter-Arts (now Presenting and Commissioning) and Visual Arts have been examples of experimentation; and while the bulk of Endowment dollars still go to traditional Western European primary arts institutions, there has been a bias, among staff and panels, for the more experimental and exotic. As novelist John Updike says, "Now that the government no longer has to prop up wheat prices, it has become the last great underwriter of the avant-garde."[30]

The National Endowment has not been a predictable, dull, automatic provider of funding from the federal government to the arts; it has been, itself, on the cutting edge, taking chances. For example, in the 1980s there were subtle shifts in the Theatre Program, from traditional to more innovative companies. From 1978 to 1988 funding for ten traditional companies was more than halved, from 37.7 to 17.9 percent of program funds, while ten experimental companies went up by more

than 50 percent, from 4.2 to 6.4 percent of funds.* (Of course, in terms of total dollars, the traditional theaters continued to get the bulk of the money.) For example, the Yale Repertory Theatre went from a $244,000 grant in 1978 to only $170,000 in 1988, while Indiana Repertory Theatre also dropped from $37,250 to $7,500. The experimental Mabou Mines, on the other hand, jumped from $21,000 in 1978 to $107,500 in 1988 and The Ridiculous Theatre Company had similar growth from $16,000 to $67,500.

The tendency to behave like a private foundation, and the parallel funding of experimental art, has allowed the NEA to be on the cutting edge and sometimes a real force for change in the arts; as Paul DiMaggio notes, "Endowment programs have often been creative in identifying and meeting needs in their fields."[31] But this tendency can also breed suspicion. As 1981 Task Force cochair Charlton Heston said (in 1985): "To say that the NEA should be preoccupied with subsidizing the leading edge of the arts is, I think, a highly suspect position. The leading edge of creativity in any field is always thin, sharp, and liable to get nicked."[32]

The third development in the 1980s was a change in giving to the arts by corporations, foundations, and individuals (the private sector). Despite the vast attention given to it by the media in the last two decades, federal government support of traditional or mainstream art in America has been very small compared to all other sources. The NEA admits this, and is justifiably proud of its impact on the growth of private-sector giving: "In the decade prior to the Endowment, private giving grew from $199 million to $205 million—an increase of less than 3 percent. In the 25 years since the Endowment's creation, the annual private charitable giving grew to a spectacular $6.8 billion—an increase of more than 30-fold."[33]

Giving USA, published by the American Association of Fund-Raising Counsel, tracks philanthropy in the private sector (excluding government). This chart shows the history of private support of the arts/culture/humanities from the year before the creation of the

* The ten traditional companies are Arena Stage; Alley Theatre; Guthrie Theater; Hartford Stage Company; Indiana Repertory Theatre; Long Wharf Theatre; Mark Taper Forum; NY Shakespeare Festival; Seattle Repertory Theatre; and Yale Repertory Theatre. The experimental companies are At the Foot of the Mountain; Ensemble Studio; Independent Eye; La Mama ETC; Mabou Mines; Playwrights Horizons; Ridiculous Theatre Company; Theatre X; Victory Gardens Theater; and The Wooster Group.

Endowments through 1991 (and also the percentage of the whole that A/C/H represents):[34]

	Total Giving in 1991 (in billions)	A/C/H Giving	A/C/H %
1964	$65.07	$2.06	3.2%
1970	80.17	2.53	3.2%
1976	84.07	5.97	7.1%
1982	94.99	6.86*	7.2%
1988	118.56	7.86	6.6%
1991	124.77	8.81	7.1%

These figures show that there was phenomenal growth in private sector giving to the arts since the creation of the National Endowment (328 percent, 1964–1991), which can be interpreted as partly NEA-stimulated; and that the biggest growth was during the Hanks years, 1970 to 1976.

To the $8.81 billion given by the private sector to arts/culture/humanities in 1991, we should add another $1 billion from federal, state, and local governments; so total giving to arts/culture/humanities in 1991, from private and public sectors, was $9.81 billion. Of this total, the three levels of government accounted for only 10 percent; and NEA, with $96,700,000 in support of arts institutions in 1991, for only 1 percent: further proof of the NEA being a tiny player in the total funding mix.

The Association of Art Museum Directors survey of 180 museums confirms these figures: their 1991 NEA funding was 1.06 percent of all funding. But three performing arts service organizations show different and higher percentages. Dance USA says that in FY 1990, American dance companies received 6.6 percent of their funding from NEA; Theatre Communications Group says that in 1992, 6.77 percent of all giving to theaters came from NEA; and The American Symphony Orchestra League reports that, in FY 1992, 3.47 percent of all orchestra funding came from the NEA. It should also be noted that Giving USA's $8.81 billion is a lot higher than estimates by other researchers. For one

* This figure is actually $7.86 billion, the same as 1988's. But in 1982, the Getty Foundation gave an unusually large amount, $1 billion. So the figure here has been changed to $6.86 billion, taking out Getty, in order to show more natural growth over the years.

thing, that $8.81 billion includes capital giving (for buildings); it goes way beyond *annual support*. Dick Netzer, head of the Wagner School of Public Service at NYU (and author of *The Subsidized Muse*, a 1978 Twentieth Century Fund study of government and the arts), maintains that 1985 annual support of the "arts and culture subsector" was $2.001 billion from the private sector and $729 million from government,[35] or a total of $2.73 billion (and so, we might suppose, $3.5 billion in 1991). At this rate, NEA's 1991 contribution was 2.76 percent of the whole. Given all these various opinions and statistics, and especially given the fact that service organizations do not count the hundreds of nonprofit arts organizations that get no NEA funding, it is probably fairest to say that the National Endowment for the Arts, in FY 1991, provided no more than 3 percent of all annual giving to all American arts institutions: still a very very minimal share.

Whether we use *Giving USA*'s $8.81 billion or the adjusted $3.5 billion from Netzer, the vast majority of private sector money in the arts, culture, and humanities goes to traditional, Western European establishment institutions. On November 3, 1992, the *Chronicle of Philanthropy* published a list of what it called the "Philanthropy 400," those institutions that received the most money from the private sector in FY 1991 or FY 1992. Thirteen arts institutions are on that list:[36]

	Private Support	Total Income (in thousands)	Private %
Metropolitan Museum, New York	$71,463	$183,042	39%
Metropolitan Opera, New York	46,201	117,709	39%
Museum of Fine Arts, Boston	32,735	100,958	32%
National Gallery of Art, Washington, D.C.	25,727	86,455	30%
Art Institute of Chicago	23,551	100,455	23%
Los Angeles County Museum of Art	22,277	39,233	57%
Lincoln Center, New York	20,903	50,602	41%
Music Center of Los Angeles County	19,288	19,763	98%

	Private Support	Total Income (in thousands)	Private %
Kennedy Center, Washington, D.C.	18,894	89,380	21%
Museum of Modern Art, New York	17,601	41,409	43%
Indianapolis Museum of Art	14,432	31,015	47%
New York City Ballet	14,092	18,424	76%
Chicago Symphony Orchestra	12,936	35,173	37%

Altogether, these thirteen institutions raised about $340 million from the private sector—more than three-and-a-half times the amount that NEA had to give in FY 1991 to *all* the arts institutions of America—another fact that underscores the small role of the NEA in the total arts funding mix.

The 1980s brought changes to private sector giving. Corporations expanded their contributions to the arts in a big way over a twenty-one year period, from 1967 to 1988:

Corporate Giving to the Arts[37]

1967	$22 million	1982	506
1970	68	1985	698
1976	221	1988	634

The National Endowment's "seal of approval" helped to fuel this expansion; many corporations looked to NEA as both justifier and sometimes collaborator in funding arts activities in their market areas. They generally gave 10 to 12 percent of their contributions to the arts. Corporate funding peaked in the mid-1980s; after that, mergers and acquisitions started to reduce the number of corporate givers and the recession cut down on available funds. Corporations started giving less, and less frequently. As reported in the *Chronicle of Philanthropy*, "Companies gave 18 percent less to the arts in 1991 than in 1988. . . . Businesses gave about $518 million to arts and cultural groups in 1991 . . . But the amount of money given by those companies declined from $634 million [in 1988]."[38]

Foundations, in the early 1960s, were giving about 5 percent of their grant money to the arts; by 1980, they were giving a total of $161 million and by 1984 $229 million, equaling about 14 percent of grant funds. The NEA "seal of approval" was a factor here, too. But by the end of the 1980s, foundations were starting to turn away from the arts, concentrating more on other issues like poverty and social causes. The "golden days" of Ford-Rockefeller foundation largess were gone (for instance, Ford gave almost $185 million in the first twelve years of its arts program, 1957–1969); only the Getty and Pew Trusts and the Wallace *Reader's Digest* Fund continued consistently to support the arts in a big way.

Individuals, fortunately, have not turned away from the arts. In fact, the development of individual giving (many people giving every year) has been a major achievement of the arts in America in the last quarter century. In 1991, the $7.29 billion in arts giving by individuals was 82.7 percent of the $8.81 billion given to the arts by the private sector. (*Giving USA* says that nearly 90 percent of private-sector giving comes from individuals and bequests, but their figures include giving to religion, which accounts for half of all philanthropy.) Government agencies (and corporations) often need quantifiable reasons for their giving; an individual does not. A dowager or robber baron can give to whomever they please, whoever pleases them. There is nothing official about a person's gift; it can be an act of love.

It is true, though, that individual giving has greatly favored the classical, Western European arts provided by establishment institutions. As Paul DiMaggio says, "Private patronage as a rule is less supportive of the value of innovation. . . . less likely to help the nontraditional, experimental, or neighborhood-based arts organizations."[39] Such *alternative* groups have a hard time lining up dowagers and robber barons.

The essence of individual giving was captured by *The New York Times* when it reported on the ninetieth birthday of Alice Tully:

> Miss Tully . . . has had a significant effect on the mainstream of musical performance. In her philanthropic involvement with the Chamber Music Society and other organizations, including the New York Philharmonic, the Metropolitan Opera, Juilliard, the Pierpont Morgan Library, the Alliance Francaise and the Institute of Fine Arts at New York University, she has demonstrated how private patrons with great fortunes and trained tastes can make a

considerable difference in an artistic era dominated by institutions. She has treated patronage not as a hobby, but as an art.[40]

With the shifting of other funding sources, holding on to people like Alice Tully is of primary importance to arts institutions. They, not the government, are the main benefactors.

FIVE

The Crisis Starts

WHEN FRANK HODSOLL left the NEA chair in early 1989, Hugh Southern, deputy for programs, became acting chair and served through that summer. In July, George Bush announced his choice of John Frohnmayer, who was approved by the Senate on September 29. Frohnmayer was an attorney in Portland, Oregon; a past member and chair of the Oregon Arts Commission (the state arts council); a 1982 to 1983 member of the NEA Opera/Musical Theater panel; and an avocational singer who had appeared in recitals and musicals. He did not come from the arts; he was basically a member of the audience. He was also the first chair to come to the job from west of the Mississippi River.

Because of their overall work experience, the first four NEA chairs were connected to the hold on the arts that the Boston-to-Washington corridor has always had. That region, too, has some of this country's most respected museums, orchestras, theaters, and dance companies. For instance, in 1981, at the time of the Reagan Administration attack, New York City institutions were getting 15 percent of all NEA money:

much higher than the city's percentage of the entire U.S. population (though probably close to the percentage of U.S. artists that live there). Of the thirteen institutions listed in the *Chronicle of Philanthropy*'s "Philanthropy 400," eight are in the Boston-to-Washington corridor, and they raised 73 percent of the $340 million donated to these institutions from the private sector. That is real cultural power!

In coming out of the West, John Frohnmayer simply lacked any connection to this power base. He was an "innocent" in the world of the Metropolitan Opera, the National Gallery, the Boston Symphony, and the Philadelphia Museum of Art. Despite the growth and development of the arts throughout the country, institutions like these still dominate the arts in America; it is their world that one must have mastered if one is to speak for the country's arts. John Frohnmayer was probably doomed to failure from the beginning, because of his innocence.

Even more damning than the innocence, though, was Frohnmayer's lack of Washington experience and Washington connections. All four previous chairs were masters of politics. While least experienced in the nation's capital, Nancy Hanks was a political genius; Stevens had raised money for the Democrats; Biddle had been a Senate staffer and part of the Senate club; and Hodsoll had been a career public servant. These people came to the job with the political judgment that can come only from having lived a political life. Frohnmayer had not lived that life and had none of that judgment. As he now admits, "It never occurred to me in my wildest dreams that I could not do this job brilliantly and gracefully. I fully expected to be Washington's darling—loved, respected, and sought out. I was in la-la land."[1]

Besides being both innocent and politically inexperienced, Frohnmayer did not take advantage of Washington resources and connections. As Hugh Southern recalls: "He came in quite unaware of how difficult the job was going to be. Also, he did not prepare himself properly. For example, we took the trouble to prepare a very user-friendly and informative briefing book, and produced three or four copies for him and his senior staff. And to my certain knowledge, none of them ever read it."[2] Livingston Biddle says, "I called him. And I said, 'I'm here, and I'm available if you want to talk. . . . ' So we went out and had dinner, and we spent about two and a half hours discussing what my interpretation of the Endowment was. And its history. And his reaction was, 'Well now, Livvy, I'm going to set aside two days next week. Please come. I'll call you. . . . ' That was the last I heard. I never got a call."[3] In Frohnmayer, the Endowment got a chair who was a foreigner in

America's primary arts and an innocent in the ways of Washington: two gaps that would spell doom in the crisis.

The crisis started in a small and hardly noticeable way. In 1987, Andres Serrano, a black, lapsed Catholic artist in Brooklyn, created a photograph of a plastic crucifix submerged in his urine. His point was twofold: first to comment on the commercialization and cheapening of religion, and second to work with bodily fluids and the Catholic imagery of transmogrification and sharing in the "body and blood" of Christ. The golden fluid in which the crucifix was placed was identified as urine by the title of the piece: *Piss Christ*. Serrano said of it, "I think it's charged with electricity visually. It's a very spiritually . . . comforting image, not unlike the icons we see in church. . . . At the same time, it's meant to question the whole notion of what is acceptable and unacceptable. There's a duality here, of good and evil, life and death."[4] Later in 1987, Serrano was one of ten artists chosen by the Southeastern Center for Contemporary Art (SECCA) in Winston-Salem, North Carolina, to receive a visual-arts award. Each of the artists received a grant of $15,000, and a tour was arranged for their works to three cities: Los Angeles, Pittsburgh, and Richmond. Funding for SECCA's Artists in the Visual Arts program came jointly from a foundation, a corporation, and a government agency: the Rockefeller Foundation, Equitable Life, and the NEA.

Serrano's *Piss Christ*, with works by the other artists, went to Los Angeles and Pittsburgh and caused no fuss. Then it went to Richmond. One Saturday in early 1989, it happened to be seen by Philip L. Smith, a designer of computers, who was outraged by it. Smith wrote a letter to *The Richmond Times–Dispatch*:

> During a recent visit to the Virginia Museum of Fine Arts, I was appalled to find a very large, vivid photograph of a crucifix submerged in urine. The work was given prominent placement among other offensive works
>
> The Virginia Museum should not be in the business of promoting and subsidizing hatred and intolerance. Would they pay the KKK to do a work defaming blacks? Would they display a Jewish symbol under urine? Has Christianity become fair game in our society for any kind of blasphemy and slander?
>
> It is this mentality that led to the unspeakable atrocities of the Holocaust. In view of what happened to the Jews in the highly cultured German society, it is disquieting to have the tax-supported

Andres Serrano standing in front of his "Piss Christ." *David Walters, courtesy of the* Miami Herald.

arbiters of our culture justifying the desecration of a symbol so precious to so many of our citizens.[5]

Smith's letter was read by a Richmond resident who was a follower of the Reverend Donald Wildmon, a fundamentalist preacher and head of the American Family Association (AFA) in Tupelo, Mississippi. With more than 500 local chapters, a budget of $5 million per year, and a mailing list of over 400,000, the AFA had led the attempted boycott of Martin Scorcese's film *The Last Temptation of Christ* in 1988 and had also forced Pepsi-Cola to cancel a $5 million dollar advertising contract with Madonna because of her "blatantly offensive" music video *Like a Prayer*. When Wildmon heard from his Richmond follower about *Piss Christ*, he unleashed his vast and formidable public opinion artillery against it. He sent out a letter to his supporters:

We should have known it would come to this. In a recent art exhibition displayed in several museums throughout the country, one "work of art" was a very large, vivid photograph of a crucifix submerged in urine. The work, by Andres Serrano, was titled "Piss Christ." When asked, since he had worked with urine, what could be

expected next, Mr. Serrano said, "Semen." And, of course, defecation will follow that. The bias and bigotry against Christians, which has dominated television and the movies for the past decade or more, has now moved over to the art museums.

We Christians must, in my opinion, accept part of the responsibility that such has come to pass. For various and sundry reasons, most of us have refused to publicly respond to the anti-Christian bias and bigotry found in various parts of our society, especially in the media. . . .

As a young child growing up, I would never, ever have dreamed that I would live to see such demeaning disrespect and desecration of Christ in our country that is present today. Maybe, before the physical persecution of Christians begins, we will gain the courage to stand against such bigotry. I hope so.[6]

Wildmon's letter was sent out on April 5, 1989. That same month, he also sent a letter of protest to every member of Congress, with a copy of *Piss Christ* enclosed.

Representative Richard Armey of Texas, who had led the criticism of NEA in 1985, spoke in the House about Serrano and NEA's support of him; but it was mostly Senator Alphonse D'Amato (R-NY) who led the charge: he rose in the Senate on May 18, ripped up a Serrano catalog, threw it on the floor, stomped on it, and then made a speech:

Mr. President, several weeks ago, I began to receive a number of letters, phone calls, and postcards from constituents throughout the State concerning an art work by Andres Serrano. They express a feeling of shock, of outrage, and anger.

They said, "How dare you spend our taxpayers' money on this trash?". . . . This so-called piece of art is a deplorable, despicable display of vulgarity. The art work in question is a photograph of the crucifix submerged in the artist's urine.

This artist received $15,000 for his work from the National Endowment for the Arts, through the Southeastern Center for Contemporary Art.*

* A key point. Serrano did not receive a grant directly from NEA; he received a subgrant: money from an organization (SECCA) that received an NEA grant to enable it to make grants to individual artists. So technically NEA was not supporting Serrano himself.

Well, if this is what contemporary art has sunk to, this level, this outrage, this indignity—some may want to sanction that, and that is fine. But not with the use of taxpayers' money. If we allow this group of so-called art experts to get away with this, to defame us and to use our money, well, then we do not deserve to be in office.

That is why, Mr. President, I am proud of the Members, who in literally a matter of minutes—over 20 about 25—joined me in signing a strong letter of protest to the Endowment.[7]

D'Amato was joined by Jesse Helms, Republican Senator from North Carolina (the leader of the protest against Erica Jong's *Fear of Flying*), who also spoke that day:

> What this Serrano fellow did, he filled a bottle with his own urine and then stuck a crucifix down there—Jesus Christ on a cross. He set it up on a table and took a picture of it.
>
> For that, the National Endowment for the Arts gave him $15,000, to honor him as an artist.* . . . That is all right for him to be a jerk but let him be a jerk on his own time and with his own resources. Do not dishonor our Lord. . . .
>
> I have sent word to the Endowment that I want them to review their funding criteria to ensure abuses such as this never happen again. The preliminary report we got from one person with whom we talked was sort of "Down, boy, we know what we are doing."
>
> Well, they do not know what they are doing. They are insulting the very fundamental basis of this country.[8]

D'Amato and Helms led their fellow senators in sending a letter of protest to Hugh Southern, acting chair of the NEA:

> We recently learned of the Endowment's support of a so-called "work of art" by Andres Serrano entitled "Piss Christ." . . . This work is shocking, abhorrent and completely undeserving of any recognition whatsoever. Millions of taxpayers are rightfully incensed that their hard-earned dollars were used to honor and support Serrano's work. . . .

* Unlike D'Amato, Helms (wrongly) suggested that Serrano was funded directly by NEA, not as part of a subgranting program.

After the artist was selected and honored for his "contributions" to the field of art, his work was exhibited at government expense and with the imprimatur of the Endowment. . . .

This matter does not involve freedom of artistic expression—it does involve the question whether American taxpayers should be forced to support such trash.

. . . We urge the Endowment to comprehensively review its procedures and determine what steps will be taken to prevent such abuses from recurring in the future.[9]

The senators who signed this letter were not all rabid rightists; some of them are moderates, including John Kerrey, Dennis DeConcini, Pete Wilson, Wendell Ford, Tom Harkin, and Arlen Specter. The letter was a fairly broad and inclusive protest. Hugh Southern remembers the mood in the Senate:

Everybody was panicked about this—even people who should have known better. I had a very long meeting with Claiborne Pell, at which Pell simply denounced the agency for supporting anything of this kind. The Senators were angry, and they didn't know where the next blow was coming from. . . . So it was easy to sign the letter without really agreeing with it. . . . Many people voting one way are confident that it will disappear under subsequent amendments or in conference or somewhere else; so a vote, which may please some conservative constituents, doesn't have to have a practical effect. And they know when they're voting that it won't. I talked to many people on Senate staffs; they said that the Senators felt that they had to do this.[10]

The second incident at the start of the crisis was much more visible: the cancellation by Washington's Corcoran Gallery of "The Perfect Moment," a 150-piece exhibition of photographs by Robert Mapplethorpe. The exhibition had been put together by the University of Pennsylvania's Institute of Contemporary Art, using a $30,000 NEA grant; it had already been shown in Philadelphia and Chicago without incident and was scheduled to be seen after Washington in Hartford, Berkeley, and Boston. It showed a wide range of work by Mapplethorpe: photos of flowers, scenes, and people, some of them celebrities; but a few of the photographs were homoerotic, showing naked men and rough

Christopher Holly, 1980. This was one of the photos shown in
Mapplethorpe's exhibit "The Perfect Moment." *Robert Mapplethorpe,
© 1980, the Estate of Robert Mapplethorpe.*

gay activity. (Mapplethorpe was homosexual and died of AIDS in
March 1989).

The Corcoran canceled the Mapplethorpe show on June 12 out of
fear that it might cause a firestorm on Capitol Hill. Director Christina
Orr-Cahall said that the Gallery could be "embroiled in a political battle
over federal funding of artistic work that may offend."[11] There was fear,
too, that mounting the show might threaten the Corcoran's funding by
the NEA and by the National Capital Arts and Cultural Affairs Pro-
gram (NCACAP), another federal program supporting Washington's
cultural institutions. (The Corcoran had received $292,000 and
$330,000, respectively, from these sources in 1988.) It could also jeopar-
dize the Corcoran's campaign to expand its endowment from $2 million
to $12.5 million. Orr-Cahall was fully supported in her decision by the
Corcoran Board of Trustees; as the board's president and chair, Freeborn
G. Jewett, Jr., and David Lloyd Kreeger, said in the *Washington Post*, "It

is indeed our function to ensure that the Corcoran does not damage itself or the NEA and the greater arts community. Weighing these considerations, and being fully aware of the public controversy . . . the director and the board of trustees on June 26 reaffirmed the Corcoran's withdrawal from the tour of the Mapplethorpe exhibition as the prudent and wise course of action at this time."[12] Former NEA chair Livingston Biddle called the decision a "wise one."[13] One of the few naysayers was Mrs. Sidney Yates (wife of the Illinois congressman), who quit the Corcoran board.*

The Corcoran's action, though, did not prevent a firestorm on Capitol Hill. One hundred and five House members joined Dick Armey and Carroll Hubbard in sending a letter to Hugh Southern at NEA: "We realize that the interpretation of art is a subjective evaluation, but there is a very clear and unambiguous line that exists between what can be classified as art and what must be called morally reprehensible trash. We want to know what steps you and NEA will be taking to . . . put an end to this horrible abuse of tax dollars. If the NEA has enough money to fund this type of project, then perhaps the NEA has too much money to handle responsibly."[14]

And the heat on the Hill was more than matched by the heat in the arts community. The Washington Project for the Arts, an alternative gallery down the street from the Corcoran, arranged to show "The Perfect Moment"; it opened there on July 20, was seen by nearly 50,000 people, and brought in $40,000 in donations toward an $80,000 cost. There was a passionate and furious reaction to the Corcoran cancellation within the broader arts community. Artist Lowell Nesbitt changed his will to cancel a $1 million gift of art to the Corcoran, giving it instead to the Phillips Collection. Annette Lemieux and other artists withdrew their work from upcoming Corcoran shows, forcing their cancellation. The National Committee Against Censorship in the Arts circulated petitions of protest at other Washington art galleries. Charlotte Murphy, executive director of the National Association of Artists' Organizations, wrote in the *Washington Post*: "In canceling the show, the Corcoran may have escaped immediate financial repercussions. . . . However, it has betrayed all who believe in democracy and the right to freedom of expression. It has weakened all of our efforts to withstand the bullying of a vocal few."[15]

* By October, the Corcoran had lost almost 10 percent of its members. On December 18, Christina Orr-Cahall resigned, taking with her a severance-settlement of $180,000.

The arts community equated the cancellation of the Mapplethorpe show with censorship, and the Corcoran with villainy. One spokesperson for the arts was Robert Brustein, critic and artistic director of the American Repertory Theatre, who said in his article "Don't Punish the Arts" in *The New York Times* on June 23, 1989, "It is on the basis of quality, not morality, that posterity judges art. While awaiting that verdict, arts organizations must not cave in to political intimidation for fear of losing grants. . . . Once subsidized artistic activity becomes subject to Government manipulation, we resemble the official culture of Stalinist Russia."[16] But nine days later, critic Hilton Kramer in the same newspaper wrote for the other side: "We are being told . . . that no one outside the professional art establishment has a right to question or oppose the exhibition of Mapplethorpe's work even when it is being shown at the Government's expense. . . . If the arts community is not prepared to correct the outrages committed in its name, there will be no shortage of other elements in our society ready and eager to impose drastic remedies. This is a problem that the art world has brought upon itself."[17]

The Religious Right

By July 1989, the contenders in the crisis had been identified: the National Endowment for the Arts; the arts community of institutions and individual artists; Congress; the media; and the religious right. The last of these groups was among the most vicious: for the right, the NEA was a target that could replace communism (removed by the end of the Cold War). Donald Wildmon, who started the right's assault with his *Piss Christ* mailings in April 1989, explained the reasons for the vehemence of their attacks: "What we are up against is not dirty words and dirty pictures. It is a philosophy of life which seeks to remove the influence of Christians and Christianity from our society. Pornography is not the disease, but merely a visible symptom. It springs from a moral cancer in our society, and it will lead us to destruction if we are unable to stop it."[18]

The religious right is centered in several organizations: Wildmon's American Family Association; Pat Robertson's Christian Coalition, with 450,000 members; Concerned Women for America, with 500,000 members; Phyllis Schafly's Eagle Forum, with 75,000 members; and Focus on the Family, with more than 100,000 members. In total, the American religious right probably numbers several million people—

John Frohnmayer, left, with Donald Wildmon of the American Family Association, appearing on CNN. *Glenn Stubh, courtesy of the Washington Times.*

fewer than America's overall arts constituency (including artists and audiences). So the attack was being mounted by a group smaller than the targeted community. The problem was that, while the arts were very unorganized, and so not easily able to fight, the religious right was highly organized and able to stage a major assault.

By the time that the religious right mounted its campaign against the NEA and individual artists, Robert Mapplethorpe had already died. Another NEA-supported artist, David Wojnarowicz, also gay and doing "homoerotic" work, was attacked by the right, making his work a "cause celebre" in the arts community. (Wojnarowicz would also die of AIDS during the crisis.) In March 1990, Wildmon sent another mailing to members of Congress pointing out NEA support of "pornographic" art, enclosing a copy of David Wojnarowicz's work, showing Jesus with a drug needle in his arm. The next month he sent still another mailing, again featuring Wojnarowicz and urging Congress to "clean up the NEA or abolish the agency." In May, Wojnarowicz sued the American Family Association for copyright violation (because they reproduced a portion of his art in their mailings without his permission) and

for defamation of character; in June, the U.S. District Court in New York issued an injunction against AFA's pamphlet "Your Tax Dollars Helped Pay for These Works of Art," which featured Wojnarowicz's work. In August 1990, the U.S. District Court ordered AFA to revise the "Tax Dollars" pamphlet, but awarded Wojnarowicz only $1 in damages, saying that he had not proved financial loss. AFA revised the pamphlet and reissued it in October.

Meanwhile, Pat Robertson's Christian Coalition was mounting a $200,000 national advertising campaign, with ads in major newspapers and on radio and television, hoping to reach 50 million households. Later, in June 1991, the Southern Baptist Convention called on President George Bush to fire John Frohnmayer.

Congressional Maneuvers and the Helms Amendment

Following the letters to acting chair Hugh Southern from the Senate (May 18) and the House (June 8), things moved swiftly in the Congress. The 1989 appropriations process (for FY 1990) was coming up in the late spring, which made the matter all the more urgent. Representative Sidney Yates of Illinois, long the best friend of the arts in the House, proposed on June 20 an amendment to the appropriations bill that would prohibit subgranting by the NEA. Yates recalls the rationale for his amendments: "It seemed to me that there was a responsibility for the National Endowment to oversee [how grant money was spent]. And I thought that it was avoiding its responsibility when it gave grants to sub-grantors."[19] In proposing the amendment, Yates was trying to restore the balance that is essential in all federal granting: the balance between freedom on one side and oversight on the other. He was also seeking to clarify accountability in granting: by removing subgranting, perhaps Serrano-like situations could be avoided. The amendment idea was praised by Yates's fellow House members, most notably Dick Armey, who said, "I think it's a really good first step. . . . Unfortunately, we've seen congressional action in the past that didn't translate into behavioral change by the endowment."[20]

Reaction to Yates's idea within the Endowment, though, was much less sanguine; staffers pointed out that ending subgranting might seriously imperil some programs like Folk Arts and Education. Acting Chair Hugh Southern insisted to Yates that the Endowment had to have subgranting power; and so Yates changed his mind. He took to the Appropriations Committee a revised proposal: that subgrantee organi-

zations only recommend specific awards, leaving final approval to the Endowment. This new proposal greatly softened the subgrant prohibition, and the Committee approved it on June 29.

On July 12, the House rejected a proposal by Representative Dana Rohrabacher (R-CA) to eliminate the NEA, and passed instead an appropriations bill introduced by Yates. The vote was overwhelmingly positive: 361 in favor and 65 against. The bill contained a cut of $45,000 from the NEA budget, the total amount that had been spent on Serrano ($15,000) and Mapplethorpe ($30,000). Less than two weeks later (July 25), the Senate Appropriations Committee voted to accept the $45,000 cut; to transfer $400,000 from the NEA Visual Arts Program (which had supported both Mapplethorpe and Serrano, though neither directly), to Folk Arts and Locals; and to impose a five-year ban on NEA grants to both SECCA and the Institute of Contemporary Art (sponsors of Serrano and Mapplethorpe).

A day later, Jesse Helms struck. Late at night on July 26, when almost no one else was in the Senate chamber, Helms introduced Amendment 420, which came to be known as the "Helms Amendment":

> None of the funds authorized to be appropriated pursuant to this Act may be used to promote, disseminate, or produce (1) obscene or indecent materials, including but not limited to depictions of sadomasochism, homoeroticism, the exploitation of children, or individuals engaged in sex acts; and (2) material which denigrates the objects or beliefs of the adherents of a particular religion or non-religion; or (3) material which denigrates, debases, or reviles a person, group, or class of citizens on the basis of race, creed, sex, handicap, age, or national origin.[21]

Helms offered his reasons: "A difference exists between an artist's right to free expression, and his right to have the Government, that is to say the taxpayers, pay him for his work. . . . There is a fundamental difference between government censorship, the preemption of publication or production, and government's refusal to pay for such publication and production."[22] Discussion followed, and there were eloquent disagreements from Senators Edward Kennedy, Timothy Wirth, Claiborne Pell, and Daniel Patrick Moynihan; but in the end, a voice vote of the few Senators in the room passed the Helms Amendment and added it to the bill.

It is fascinating to go back to 1985 and look at how the Helms Amendment paralleled what happened then. In 1985, the compromise between the Texans (Dick Armey and others) and Pat Williams (Montana Congressman and Postsecondary Education Subcommittee chair) put into the reauthorization bill a provision that NEA should fund only projects that have "significant literary, scholarly, cultural or artistic merit; are reflective of exceptional talent; and foster excellence." They told the Endowment to fund only works of merit—something it had always done, and wanted to do anyway—and the panels, Council, and chair would be the judges of merit. The 1985 compromise told the NEA what it *should fund*. Helms in 1989 was telling the NEA what it *should not fund*. Helms's amendment *seemed* more extreme because he was discussing things (sadomasochism and homoeroticism) that are rarely mentioned in the Senate chamber. The 1985 amendment happened to match the Endowment's original purpose (to support "quality" art); unlike it, Helms's amendment was alarmist. But both amendments strove to control how and why the Endowment gives away its money.

Through the summer of 1989, there was haggling between the House and the Senate on the various amendments in the appropriations bills. On September 13, again by a lopsided 264 to 53, the House passed its appropriations bill and rejected the Helms Amendment. The Senate followed on September 28, also refusing Helms, 62-35. Early in October, both houses approved a FY 1990 appropriation of $171,255,000, up more than $2 million from 1989's $169,090,000, despite all the controversy!

Public Law 101-121

On October 28, the Congress passed Public Law 101-121, a follow-up to the summer's controversy and to Yates's and Helms's amendments. This law specified that "prior to the award of any direct grant to . . . SECCA . . . or for the Institute of Contemporary Art at the University of Pennsylvania, the National Endowment for the Arts shall submit to the Committees on Appropriations of the House and Senate a notification of its intent to make such an award . . . that such notification shall delineate the purposes of the award which is proposed to be made and the specific criteria used by the Endowment . . ."[23] This was Congress' way of punishing the two institutions that had supported Serrano and Mapplethorpe, and of keeping watch over future subgranting. Law 101-121 also addressed the Helms controversy, making this stipulation:

None of the funds . . . may be used to promote, disseminate, or produce materials which . . . may be considered obscene, including but not limited to, depictions of sadomasochism, homoeroticism, the sexual exploitation of children, or individuals engaged in sex acts and which, when taken as a whole, do not have serious literary, artistic, political, or scientific value.[24]

The bill came out of a congressional decision (as proposed by Sidney Yates) that all questions of obscenity be decided on the basis of *Miller v. California*, a 1973 Supreme Court landmark decision that defined obscene art as works that: (1) an average person, applying community standards, finds appealing to prurient interests; (2) depict or describe sexual conduct in a patently offensive way; and (3) taken as a whole, lack serious literary, artistic, political, or scientific value. Sidney Yates points out that "What I did was to propose bringing the Miller case out from the wings and into the forefront. I was changing nothing in the law itself. All I was saying was 'There's no need for anything else; this is the law, and we will go by the law.' That was the reason for bringing the Miller case into the settlement. To show that the Helms stuff wasn't needed."[25] Congress assumed that the Endowment could live comfortably with its Miller definition.

Like the Helms amendment, Law 101-121 went beyond the *Miller v. California* obscenity test, in specifying certain acts (sadomasochism and homoeroticism) as "obscene" that are not necessarily so. On the other hand, the bill did not deal with another Miller stipulation, that the work in question must appeal to prurient interests to be obscene. Still, as Edward deGrazia points out in his book *Girls Lean Back Everywhere*, Law 101-121 did obligate the NEA "to administratively censor artists by rejecting arts projects considered *by the NEA* to come within the *Miller* definition of the obscene."[26] Perhaps most significantly, the law also switched the determination of obscenity from the *judicial* branch of government (the courts) to the *executive* branch (a government agency). All told, while his amendment was rejected, Jesse Helms had won: he had convinced his fellow Congress members to pass a law encouraging the NEA to act as a censor.

The Call to Advocacy

It is strange that with all the controversy through the summer of 1989, the arts-advocacy forces that lobby the government were rather quiet.

Perhaps they were just stunned by the assault from the religious right, and assumed that this too would "blow over" as other controversies had in the past. But this was not to be: a new and different national mood, fanned by the media, was changing the context. The old rules, and so the old techniques, were no longer relevant or useful; and the arts-advocacy forces either did not realize this or could not face it. In the wake of the Corcoran cancellation, the voices of protest were often limited to the more extreme spokespeople for the arts, like poet Allen Ginsburg, who started and ended a letter this way:

> This arts censorship rot gut originated in the beer-soaked bucks of Joseph Coors, was moonshined in Heritage Foundation think-tanks, and is peddled nationwide by notorious tobacco-cult Senator Jesse Helms. These alcohol-nicotine kingpins have the insolence to appoint themselves arbiters of Public Morality. . . . These hypocrite scoundrels have muscled their way into museums already, and plan to extend their own control-addiction to arts councils, humanities programs, universities. How long will Congress, the Public and Arts be held hostage to this cultural Mafia?[27]

The power structure, inside and outside Congress, could easily disregard such rantings.

The commentary, even in the establishment press, was not always pro-NEA. Helen Frankenthaler, a major painter and then-member of the National Council on the Arts, wrote in July 1989 in *The New York Times*:

> We must not smother expression of art. . . . But there are other issues. . . . As a painter on the council I find myself in a bind: Congress in a censoring uproar on one hand and, alas, a mediocre art enterprise on the other! Sad, indeed.
>
> By "mediocre art enterprise" I mean: Has the council run its course in terms of doing a necessary quality job? Should it change its course from within? Is it possible? I myself find the council—the recommendations of the panels and the grants given—of increasingly dubious quality. Is the council, once a helping hand, now beginning to spawn an art monster? Do we lose art along the way, in the guise of endorsing experimentation? . . . Quality control is the issue. Raise the level.[28]

It is very very difficult for any industry or community to fight for its future when its best people are in doubt and are joining the assault against it.

The arts advocates finally got their act together in the spring of 1990, a full year after the crisis started. As *The New York Times* reported on May 12:

> One year after attacks on the National Endowment for the Arts began, the members of the National Council on the Arts . . . gathered . . . to determine how to respond to their opponents. . . . Said Anne Murphy, head of the American Arts Alliance, "A lot of people who support the endowment are grappling with how to handle the situation. Fifteen or twenty ideas are floating around on Capitol Hill—none of them formulated. Everyone is asking a lot of questions."[29]

The advocacy effort in the spring of 1990 centered on the reauthorization of the NEA. In March, the American Council for the Arts' Cultural Advocacy Day attracted hundreds to Washington, where they lobbied Congress and held a rally on the Capitol steps. April saw the formation of the National Campaign for Freedom of Expression, an organization of individual artists that immediately set out to unseat Jesse Helms in the fall 1990 elections. In May, the directors of the seven museums showing Mapplethorpe's "The Perfect Moment" met at the Washington Project for the Arts with NEA staffers and House members and the press, and issued a statement that "the right of freedom of expression must never give way to censors."[30] On June 7, hundreds of arts institutions across the country staged protests on Arts Day USA. In mid-May, Sidney Yates turned his Post-Secondary Education Subcommittee hearings over to a parade of artists to testify*; Jessica Tandy's testimony was especially swaying:

> I am not a businesswoman. I am not a politician. I am an actor. I have sought to be an artist. I can only speak today from an artist's perspective.
>
> In 1987, *Driving Miss Daisy* was an Off-Broadway play supported by an NEA grant. In 1989, *Driving Miss Daisy* became a movie, in which I was fortunate to have appeared. It received four Academy

* Including Yo-Yo Ma, Ruby Dee, Jane Alexander, Jessica Tandy, Bella Lewitzky, Joseph Papp, Robert Rauschenberg, Roy Lichtenstein, and George Plimpton.

Five Hollywood actors lead a rally in support of the NEA in front of the U.S. Capitol. L to r: Alec Baldwin, Ron Silver, Stephen Collins, Susan Sarandon, Christopher Reeve. *Courtesy of the* Newark Star Ledger.

ARTS DAY, U.S.A., Thursday, June 7, 1990, was the Ninety-fourth Annual Meeting of the Association of Art Museum Directors (AAMD) at the Art Institute of Chicago. *Thomas Cinoman, © 1993, the Art Institute of Chicago. All rights reserved.*

Awards. Twenty-one million people have seen this film. Through videotape, hundreds of millions more will see it. The NEA made that possible.

I am here because I believe in the wisdom of Congress in starting and supporting the Arts Endowment, and I applaud President Bush's wisdom in calling for an unfettered and uncensored Endowment. Our government's support of free expression is one of the triumphs of our democracy.[31]

Just as during the 1981 Stockman-OMB assault, the advocacy effort was led by the American Arts Alliance, the Washington-based association of major arts institutions nationwide. AAA was aided and abetted by the American Council for the Arts and by service organizations like American Symphony Orchestra League, Theatre Communications Group, Dance USA, OPERA America, and the American Association of Museums. These organizations encouraged a grassroots effort to send letters to Congress from citizens nationwide, and the citizens responded. Whereas most letters were from the religious right in 1989, by the summer of 1990 that had changed, and more letters came from arts partisans. The arts advocacy forces woke up in 1990.

SIX

The Battle for Freedom of Speech

THE FIRST TEN months of 1990 brought the climax of the crisis, when Congress was considering reauthorizing the NEA; as I have shown, reauthorization has traditionally been a time of conflict. In those ten months, censorship was a raging issue throughout American society. This battle played itself out not only in the debate over the NEA, but also in the courts, where lawsuits were filed alleging that heavy-metal lyrics had influenced young Americans to commit suicide, as well as in the ratings of films and in the funding of public television. Even flag burning, an act of civil disobedience, became part of the censorship debate in the overheated atmosphere. The Bush-Quayle emphasis on "family values" tended to promote these attacks on free speech.

More Conflict in Congress

The NEA was an easy target in this new emphasis on family values. Conservatives could pick and choose among the small number of outra-

geous grants to make their point that the NEA was out of touch with "mainstream" America, sometimes distorting the truth in the process. On February 5, Dana Rohrabacher (R-CA) sent this "Dear Colleague" letter to his fellow Congress members:

> Does the following performance sound like an appropriate use of tax dollars to you?
>
> Star of 150 explicit, XXX-rated videos, Annie Sprinkle takes to the stage and . . .
> - Masturbates with various "sex toys" until she experiences orgasm.
> - Performs oral sex with rubber penises, inviting the audience to massage her breasts.
> - To conclude her performance, she opens her vaginal canal with a gynecological tool known as a speculum and invites audience members to the stage to inspect her. . . .
>
> The New York Council for the Arts receives $500,000 in unrestricted funds from the National Endowment for the Arts every year. In turn, the Council chose to spend $25,000 on a performance series at the Kitchen Theatre in New York. "Annie Sprinkle: Porn Modernist Manifesto" was performed twelve times during that series. . . .
>
> Mr. John Frohnmayer, the Chairman of the NEA, defended the grant, saying "The point is that we are not the moral arbiter of this country. We're not going to run around and respond just because something happened somewhere that someone didn't like."
>
> Let's remind Mr. Frohnmayer he is dealing with taxpayer funds and is accountable for how they are spent, just like every other head of every other federal agency. If the NEA can't hold itself responsible to the US taxpayer, it's our job to make them responsible.[1]

Pat Williams (D-MT), chair of the House subcommittee overseeing reauthorization, answered Rohrabacher in another "Dear Colleague" letter on February 12:

> Recently you received what may be the Congress's first X-rated "Dear Colleague" letter. The letter depicted in graphic detail a pornographic performance in New York City which supposedly was funded by the taxpayers through the National Endowment for the Arts.
>
> Titillating, perhaps, but not true.

The truth is, that performance didn't receive one penny of funding from the National Endowment for the Arts, nor, for that matter, from the New York Council for the Arts. . . .

Such "Dear Colleague" letters are part of an organized attack on the Arts Endowment. Certain individuals and groups have set out to destroy the Endowment, and they apparently don't let the facts get in their way. Their purpose is obvious. to make the American public believe that the Endowment has deliberately set out to fund works that are offensive to the average American, and that a vote by members of Congress to support funding for the Endowment is a vote to support pornography and obscenity. . . . The work of the Subcommittee . . . as it weighs these issues will be made exceedingly difficult in this atmosphere of demagoguery, untruths, and half truths. And an agency which has enriched the cultural lives of Americans in every state and territory of this nation may very well be in jeopardy because of it.[2]

Rohrabacher continued his attack. On February 20, he issued another "Dear Colleague" letter, this time criticizing NEA support of David Wojnarowicz's *Tongues of Flame* exhibition in Illinois; on March 3, he proposed a House amendment to end all NEA funding; and on March 12 he sent a third letter criticizing NEA funding of the *Modern Primitives* exhibition in San Francisco. Philip Crane (R-IL) introduced a "Privatization of Art Act" on May 10, another attempt to abolish the NEA. Paul Henry (R-MI) presented legislation in June banning funding of works of art that attack "the cultural heritage of the United States, its religious tradition, or racial or ethnic groups"; and Senator Orrin Hatch (R-UT) offered an amendment to the reauthorization bill that would prohibit for ten years grants to artists who created "obscene" works. None of these measures was passed.

Jesse Helms spent the spring of 1990 trying to get the federal General Accounting Office (GAO) to indict the NEA. In March, he formally requested a full investigation of NEA by GAO; he sent to GAO samples of controversial art funded by the Endowment, suggesting that "great care be taken to assure that your women associates not be exposed to the material."[3] John Frohnmayer says that Helms "was using the GAO as a bludgeon, as an instrument of harassment."[4] In June, the General Accounting Office issued its report, saying that the Endowment had not violated any federal laws by funding what other people called "sexually explicit" or "sacrilegious" art; GAO said that NEA had

simply not considered the art to be that. Again, Helms was technically defeated.

Other Free Speech Issues

The censorship debate in Congress spilled over into the courts and the media in the first months of 1990. Censorship had been present at other times in the twentieth century: *Lady Chatterly's Lover*, *Tropic of Cancer*, and *Ulysses* were all initially thought to be obscene. In the mid-1960s, comedian Lenny Bruce was arrested for giving an "obscene" performance at the Cafe A-Go-Go in Greenwich Village; as Gerald Harris notes in his 1990 article "My Brief on Lenny Bruce," the routine:

> was a brilliant and witty exposé of the follies and foibles of self-righteous institutions: the press, the justice system, the political establishment. . . . Bruce was convicted by a divided court, couldn't get work, sank deeper in drugs and depression and was dead before an appellate court reversed his conviction. . . . It's too bad today's prosecutors never had the opportunity to look into Bruce's sad and knowing eyes; the country might have been spared this latest moral roundup.[5]

In 1990, 2 Live Crew, a Miami rap group whose album *As Nasty as They Wanna Be* featured sexually explicit lyrics, were arrested and prosecuted for obscenity. As *The New York Times*'s pop music critic Jon Pareles reported, "The 2 Live Crew are like adolescents who have just discovered the idea of sex; they can't stop spouting dirty words, although their idea of sex doesn't go much further than repeating those words with a salacious chuckle. . . . For the 2 Live Crew, sex is a big, stupid, slapstick joke: out of the locker room and, soon, into the courts."[6]

As Nasty as They Wanna Be was the first recording ever declared obscene by a Federal district court; sale of it was banned on March 15, 1990 in Fort Lauderdale. A record store owner was arrested for selling it, and two members of 2 Live Crew were arrested for performing one of the album's songs at an adults-only concert. Both owner and performers went on trial in early July, but were acquitted in October.

In Louisiana, the State Senate passed a bill requiring warning labels on record albums with lyrics promoting "rape, incest, bestiality, sadomasochism, prostitution, homicide, unlawful ritualistic acts, suicide." The bill, passed in mid-July, amazed the music industry. As Jon Pareles wrote: "A music lover can only wonder how such legislation could come

out of Louisiana—a wellspring of American music that was never much concerned with propriety. In passing its labeling law, the State Legislature has shown its willingness to toss out, or at least render inaccessible, a large part of a great heritage."[7] On July 25, Governor Buddy Roemer vetoed the bill, citing the potential economic hardship that a ban would bring.

In Reno in July, members of the heavy-metal band Judas Priest were tried on charges of leading two young men to commit suicide, who were supposedly inspired to take their own lives through repeated listening to the band's album, *Stained Class*. This suit paralleled others in California, Georgia, and New Jersey, where others had killed themselves after listening to the song "Suicide Solution" by hard-rock singer Ozzy Ozbourne. In Reno, Judas Priest was charged with liability in making and marketing a faulty product, and with negligence and reckless misconduct. The judge ruled that the subliminal messages in the *Stained Class* lyrics (like "Do it" and "Let's be dead") were not forms of speech and therefore not protected by the First Amendment. Bill Curbiohley, the manager of Judas Priest, said, "I don't know what subliminals are, but I do know there's nothing like that in this music. If we were going to do that, I'd be saying, 'Buy seven copies,' not telling a couple of screwed-up kids to kill themselves."[8] In the end, the band members were freed.

These controversies and trials, though, led the recording industry to start to police itself, instituting a rating system like the one for movies. On July 1, record companies started affixing labels to albums that read "Parental Advisory—Explicit Lyrics."*

The film-rating system also faced challenges during 1990. Pedro Almodovar's film *Tie Me Up! Tie Me Down!* received an X rating, and Almodovar and his distributor, Miramax Films, filed suit in May seeking to overturn it. Judge Charles Ramos of the New York Supreme Court upheld the X rating, but found fault with the entire Motion Picture Association of America rating system: "The manner in which the M.P.A.A. rates all films, not just *Tie Me Up! Tie Me Down!*, causes this Court to question the integrity of the present rating system,"[9] he said. The *Tie Me Up! Tie Me Down!* controversy led the Motion Picture

* Tipper (Mrs. Al) Gore, as president of the Parents' Music Resource Center, had been calling in the late 1980s for warning labels on records with suggestive lyrics. Some saw her calls as censorship; but the same media that attacked Dan Quayle for his "Murphy Brown" campaign let Tipper off.

Association to develop a new rating, NC-17, for frank and explicit adult films that are not pornographic.

There was also controversy in the visual arts.* Most heated was the case of photographer Jock Sturges in San Francisco, whose nude photos of children were seized by the FBI in May. San Francisco's Board of Supervisors (the city's governors) rallied to Sturges's defense, with Supervisor Terence Hallinan calling the FBI seizure "part of a nationwide attempt through restriction of culture to bring about a more conservative state."[11] Arts authorities throughout the country called the case an attack on the First Amendment. Charges against Sturges were eventually dropped.

Another major issue in freedom of expression in 1990 was the conservative attack on the Corporation for Public Broadcasting (CPB). As Dick Netzer has noted, "At least half of total CPB funding should be considered support of the arts,"[12] so what affects the CPB will affect the arts in America.

The CPB is a private corporation begun by the federal government in the late 1960s as a way to fund public television and radio. It grew out of a long history of government involvement in these media. In the beginning, before there was television, the Department of Commerce handled licensing of radio stations. In 1927, the Dill-White Bill became law, and it carried three key provisions:

1. The government would control all channels but not own any.

2. Licenses or transfers were to depend on stations serving the public interest, convenience, and necessity.

3. The government could not censor the content of particular programs, but "obscene, indecent or profane language" could be censored.[13]

* Before the NEA crisis, the most heated visual arts controversy of the 1980s was the case of Richard Serra's *Tilted Arc*, a minimalist sculpture in Manhattan's Federal Plaza. People objected to *Tilted Arc* because its massive size prevented easy walking through the plaza. The General Services Administration started proceedings in 1985 to remove the *Arc*, and Serra sued, charging that his artist's rights were being violated. It took four years of wrangling (with the NEA advising against its removal), before the piece was removed in 1989. Writing about the *Tilted Arc* controversy in the *Journal of Arts Management and Law*, Judith Balfe and Margaret Wyszomirski said, "Direct federal involvement in artistic creativity and ongoing responsibility for artistic products is an invitation to controversy. Such controversy generally works to the detriment of all . . . interests—artist, public, and government."[10]

In 1934, the Federal Communications Commission (FCC) came into existence. It controls the universe that CPB joined in 1967.

Funding for CPB has grown enormously, from $5 million in 1969 to $103 million in 1977. In FY 1986 it was $130 million. Then Congress changed to three-year funding authorizations (based on their trust of CPB); and by 1992, it was authorizing more than $1 billion for FY 1994 to 1996.

The CPB though, has been even more than NEA a political football: "There is no escaping the fact that CPB depends for its existence on the funds provided by the U.S. Congress, and members of Congress serve their constituents—who do not hesitate to tell their Congressmen what they want. Therefore, Congress does end up telling CPB what to do."[14] When Congress passed reauthorization in 1992 and gave CPB $1.1 billion for FY 1994 to 1996, it included in the legislation an amendment by Senator Robert Byrd (D-WV) that bans indecent programming on public radio and television in prime time. The American Civil Liberties Union sent a letter to Congress saying that the indecent language provision "violates the First Amendment's guarantee of freedom of speech," but Congress passed the bill anyway.

Congress's 1992 ban on indecent programming flowed from a controversy that reached its climax in 1990. As reported by *The New York Times* on July 13, 1990:

> The Federal Communications Commission made a new effort today to impose a complete ban on what it considers indecent radio and television broadcasts.
>
> "Parents feel beleaguered in their efforts to instill proper values," said Ervin Duggan, one of the commissioners.
>
> F.C.C. officials also said that they had received 92,500 letters from the public in favor of a 24-hour ban, support they cited as additional evidence of a compelling national interest.
>
> Virtually the entire broadcasting industry opposes the complete ban.
>
> Congress ordered the F.C.C. to develop regulations for a 24-hour ban in September, 1988.
>
> All five commissioners made clear today that they strongly supported Congress's original instructions. "There has been not only a Congressional outcry but a public outcry against indecency and obscenity," said Commissioner James Quello.[15]

On July 31, 1990, WGBH, the public television station in Boston, showed on a newscast some of the sexually explicit photographs in Mapplethorpe's "The Perfect Moment" exhibit, which was opening the next day at the Boston Institute of Contemporary Art. Donald Wildmon of the American Family Association sent a videotape of the broadcast to the FCC, calling it "nothing more than the sensational presentation of potentially obscene material."[16] A WGBH spokesperson said, "We wanted to let the public know what the controversy was about and let them decide for themselves."[17] Again, nothing much came of the Wildmon-WGBH contretemps.*

Another free-speech controversy erupted in 1989 and 1990 over the issue of the right of Americans to burn or desecrate the nation's flag. During his 1988 campaign against Michael Dukakis, George Bush had made a big issue of Dukakis's failure to require teachers to lead the pledge of allegiance in public schools; he had even visited a flag factory in Bloomfield, New Jersey to show his support for this national symbol. Obviously, his campaign strategists recognized the flag as a "hot-button" issue for conservative voters. When a group of protesters decided to burn the flag as a symbolic act in late 1988, it was natural for Bush and conservatives to seize on this as an important issue.

The House acted first, enacting a law on January 27, 1989, stating that the flag should be treated with due respect, and that public desecration of the United States flag is not considered symbolic speech under the First Amendment to the Constitution. Voting to protect the flag was easy for most representatives, about as dangerous as coming out in support of mom and apple pie.

Surprisingly, the conservative Supreme Court overturned this law on June 21, 1989, upholding the right of citizens to desecrate the flag as protected free speech. Led by President Bush, conservatives quickly responded to this decision by calling on June 30 for a constitutional amendment to prohibit flag burning.

The flag frenzy reached ludicrous heights with the Senate's Flag Protection Act of 1989, enacted on July 18. This overturned the Supreme Court ruling, and Bush happily signed it into law. Then, on

* But the controversy continued. In 1991, the PBS broadcast of Marlon Riggs's film about black gay men, *Tongues Untied* (also supported, through a production grant, by the NEA) brought attacks from the American Family Association and Pat Robertson's Christian Broadcasting Network. In 1992, *Masterpiece Theater*'s "Portrait of a Marriage," about a homosexual-lesbian marriage, was kept off the air in North Dakota.

October 19, the Senate contradicted its own Flag Protection Act, by turning down the Bush-backed constitutional amendment outlawing desecration of the flag.

On June 11, 1990, the Supreme Court again ruled that desecrating the flag is free speech protected by the First Amendment, overturning the Senate's Flag Protection Act. This was followed by a second move for a constitutional amendment, originating in the House Judiciary Committee. Obviously, things were simply a mess in Washington: Congress was at war with the Supreme Court, and the Senate was at war with itself (countering the Court in July and agreeing with it in October).

The flag issue bled over into the world of the arts when an art student at the Chicago Arts Institute displayed an American flag mounted on the floor in front of his final project. In order to look at his painting on the wall, a viewer was required to step on the flag, symbolically and literally. Outraged conservatives had a field day attacking the exhibit as yet another example of the art world's disrespect for American values.

The flag desecration controversy was another example of how savvy politicians exploited emotional issues for their own ends. President Bush could easily portray flag desecraters as a "lunatic fringe." Sadly, artists were often dumped into this same category, so that, in the public mind at least, art was equated with so-called anti-American acts and values.

Mapplethorpe at Cincinnati's Contemporary Art Center

Of all the free speech and First Amendment controversies in 1990, the most significant was the obscenity trial against Cincinnati's Contemporary Art Center (CAC) and its director, Dennis Barrie.

The Center was scheduled to start showing Mapplethorpe's "The Perfect Moment" in April. Things started happening in March. Citizens for Community Values, a right-wing religious organization in the city, sent to its 16,000 members and to 18,000 other Cincinnatians a letter telling how to stop the exhibition. The Center withdrew from the 1990 campaign of the local Fine Arts Fund (a united arts fund) because of fears that the exhibit would hurt that effort; and Chad Wick resigned as the chair of the board of the Art Center when his bank was boycotted by religious fundamentalists.

Still, the Art Center stood its ground and proceeded to open the show on April 7.* (However, they restricted attendance to people over

* The show attracted 81,302 visitors, more than any other in CAC's history.

age eighteen, and doubled admission rates.) In the first day's audience were nine members of a grand jury, and also Hamilton County sheriff's deputies, who shut down the CAC and videotaped the exhibition. Later, the Art Center and Barrie were indicted on obscenity charges, making CAC the first American museum or gallery to be prosecuted for the work it showed. Commenting from Washington, John Frohnmayer ducked the issue when he blandly said, "Obscenity is a local issue, and they will make their decision based on community standards."[18] A poll conducted by the University of Cincinnati found that 59 percent of the public favored allowing the exhibition to be shown, while 38 percent were opposed. The city of Cincinnati was turned upside down by the trial.

Eight jurors were chosen, and they were not sophisticated art lovers:

> Of the eight men and women questioned [for jury duty] . . . only three had ever been to an art museum. Others said they had gone to other types of museums, but only on field trips from school. One man in his 50's said he had never been to any kind of museum. The man said he could not relate either to art or its enthusiasts. "They're into that type of stuff," he said during questioning by a defense lawyer. . . . "These people are in a different class. Evidently they get some type of satisfaction looking at it. I don't understand art work. That stuff never interested me."[19]

Given the lack of arts awareness in the jury, the American arts community watched the Cincinnati trial with trepidation. Everyone expected a major disaster: that Barrie and the CAC would be found guilty, and that First Amendment rights would be brutalized.

On October 5, 1990, the jury, after less than two hours of deliberation, gave their verdict: not guilty! Barrie and the Art Center were exonerated. The eight jurors, none experienced in the arts, had decided that Mapplethorpe was a legitimate artist and that CAC had every right to exhibit his work. (It was also true that the defense had provided convincing witnesses, while the prosecution had not.) The verdict was hailed by arts supporters and First Amendment advocates as a ringing victory for free speech. As he left the courtroom, Dennis Barrie told *The New York Times*, "This was a major battle for art and for creativity in this country. Mapplethorpe was an important artist. It was a beautiful show. It should never have been in court."[20] (Within two years, Barrie, like

Christina Orr-Cahall at the Corcoran, was gone; he resigned following a dispute with his board over program and exhibit expansion.)

NASAA's Betrayal

The most heinous act of the crisis took place on May 12, 1990: the recommendation by the National Assembly of State Arts Agencies (NASAA) that 60 percent of NEA program funds (up from 20 percent) be given to state arts councils.

As legislated in 1973, 20 percent of the NEA's program funds went to state arts councils. In FY 1990, for instance, $21,683,000 went from NEA to the states in basic grants, and the total states allocation was $26,090,000. The development of state arts agencies (councils) was a major success of the NEA years. In 1965, when the Endowment started, there were only eighteen state arts councils, but soon all fifty states and three territories had created them (largely because the NEA in its first years provided start-up money to any state wishing to create a council). In FY 1966, combined state appropriations were only $2,664,640; by FY 1976, they had grown to $61,017,945. In FY 1986, state appropriations ($195.6 million) exceeded federal ($158.8 million) for the first time; and by 1990 they had reached $292 million, or 70 percent more than NEA's money that year. So the states became a major force in the arts community, and NASAA, their service organization, a force to contend with.

There was always tension between NEA and the state arts agencies; Michael Straight points out in his biography *Nancy Hanks*, "As the state agencies gained in size and in stature, their attitude toward the National Endowment was transformed. They had started as wards of the Endowment; they wanted to be accepted as partners. The Endowment, in its turn, acknowledged the rhetoric of partnership, but not the reality. That created a growing sense of resentment in the states."[21]

The question lingered: Exactly how much money should go from NEA to the states? In the early years, Russell Lynes (in his article "After Hours: How to Make Politics from Art, and Vice Versa") in *Harper's* of August 1969, said, "I would like to see the budget of the Endowment expended entirely on the promotion of state arts councils."[22] In 1981, the year of the Reagan assault, James Backas, in an article in *American Arts* magazine, wrote, "The other half of the . . . proposal . . . is to send half of the federal agency's funds to the fifty-six states and territorial arts agencies. This would be a real boon for the states, and I believe they

would spend the money in a responsible and fruitful manner."[23] Even Joseph Papp, in the wake of the Stockman-OMB 50 percent cut proposal, made a radical suggestion: he "called . . . for the abolition of the National Endowment for the Arts. Mr. Papp proposed that Federal money for the arts be channeled instead to state arts councils to administer the funds."[24] So there had been quite a lot of talk through the years about doing things through the states.

NASAA's proposal was reported in *The New York Times* of May 16:

> [NASAA] has proposed privately to members of Congress that 60 percent of all endowment money be given directly to the state agencies instead of the current 20 percent. Supporters of the endowment say the move would virtually disenfranchise it. . . .
>
> Jonathan Katz, the executive director of the states' group, said, "We think it's a good idea for N.E.A. to disperse funds to a greater extent through state arts councils." He said the state councils could distribute the money more effectively than the national endowment. This change, he said, would take pressure off the national endowment.[25]

Reaction to the proposal was swift and vitriolic. Many in the arts world blamed NASAA for a vicious attempt to take over the Endowment. Jonathan Katz now maintains that the subject was introduced by members of Congress: "The issue of controversial art was not raised in any of the conversation that members of Congress initiated with us regarding shifts of funding. . . . The topic was considered by NASAA board members under direct request from members of Congress and with their assurance that, without our input, a similar or more extreme restructuring would be submitted as legislation."[26] Montana Democrat Pat Williams says: "I remember some of the proponents of the 60 percent [proposal saying] . . . that some members of Congress had come to them asking for this. . . . I recall no members of my committee that were in support of the 60 percent. . . . because they realized that to support it would so divide the arts community that we would probably not get the reauthorization passed."[27] At the time of the NASAA proposal, in 1990, Williams made a statement that suggests that it was not Congress that instigated the idea: "The American art community has assurance from me that the House will not be slam-dunked into making major structural changes in the NEA. This whole thing is disappointing. We now not only have controversy surrounding the

content of works funded, but also differences about the very structure of the endowment itself."[28]

Peter Zeisler, director of Theatre Communications Group, wrote an impassioned editorial against NASAA's move in TCG's *American Theatre* magazine:

> The recent exhibition of opportunism demonstrated by the leadership of the National Association [sic] of State Arts Agencies, the umbrella organization for arts-funding agencies of state and territorial governments, is an example of what happens when bureaucrats confuse serving art with serving themselves. The chaos that NASAA created, based on totally erroneous assumptions, will float for years in the subconscious of Congress (and the arts community). One hopes that the arts world has learned once and for all that it cannot delegate primary responsibility to bureaucrats; artists must take it upon themselves to control their own destiny.[29]

It is impossible to know exactly where the idea started; but if Katz is right and it started with Congress, then NASAA certainly did not tell Congress to drop it; they plunged right in and capitalized on a chance to get most of the money shifted to themselves. As Hugh Southern says, "Maybe when the devil presents you with such opportunities, you don't resist them."[30]

NASAA chair Mary Hays (executive director of the New York State Council on the Arts) announced that the NASAA board decision was unanimous; but not all state arts councils agreed. Anthony J. Radich, executive director of the Missouri Arts Council, spoke for the dissenters:

> The proposal put forth . . . for the restructuring of the National Endowment for the Arts is not supported by the Missouri Arts Council. The NASAA proposal was put forward with neither the advice nor the agreement of the Council or its staff.
>
> The NASAA proposal is unacceptable for a number of reasons:
>
> a. The proposal will result in fewer state and federal funds being available to Missouri's arts efforts than are presently allocated by the Endowment and the Arts Council combined.
>
> b. The proposal will effectively eliminate national policy making in the arts.

c. The proposal will encourage those who oppose public funding for the arts to target individual states for the elimination of public arts funding efforts.

d. The NASAA proposal for funding is similar to the funding structure of the former Federal Revenue Sharing Program. When Federal funds became scarce, the revenue sharing program was terminated. This also could happen to federal arts funds under this program.

e. If this proposal is implemented, many states will be unable to convince their legislatures that the federal funds allocated to the states do not represent an actual increase in dollars to the arts. As a result, some states will experience reductions in state arts funding.

f. This proposal ignores the fact that many states are not equipped to manage additional federal funds placed in their care.

Because the actions of NASAA are not helpful to the work so many have put forth to secure reauthorization of the Endowment, I will recommend to the Council that it suspend its membership in this organization.

This well-intentioned but misguided proposal should be put behind us as soon as possible. All arts people should unite in support of the National Endowment for the Arts and prevent the Endowment from becoming a victim of the present censorship hysteria. When the public is educated to the false basis for this hysteria, it will support the Endowment. Educating the public and Congress is the job we have before us.[31]

The uproar made the NASAA board retract; they announced that they no longer supported their own proposal. But executive director Katz had already discussed it with several members of Congress, most notably E. Thomas Coleman (R-MO) and Steve Gunderson (R-WI), who grabbed hold of the idea and within days were proposing to the House a 60 percent allotment of NEA funds to the states. So it hardly mattered that NASAA had retracted the idea; their introducing it assured that it would become a major factor in any reauthorization.

NASAA's proposal was a betrayal of the NEA by the states. It showed that people in the arts were their own and each other's worst enemies, and that if they could not stand together, they would fall.

The United Arts Group

Early in 1990, President George Bush agreed to support legislation that would reauthorize the NEA for the usual five years without any content restrictions. His primary ally was Democrat Pat Williams of Montana, chair of the House Postsecondary Education Subcommittee which had authority over the agency; Williams had also been Frank Hodsoll's ally in the 1985 face-off with the Texans. Williams introduced the reauthorization legislation on May 15. There was a violent reaction to this bill from the American Family Association, which proposed to send homoerotic photographs to 1600 churches in Montana.* Tim Wildmon, Donald's son and associate director of AFA, said, "Except for Williams, I haven't heard anything of people taking the cheerleaders' position for the continuation of N.E.A. without any restrictions. How do you defend one man urinating in another man's mouth, like in the Mapplethorpe? . . . Even if [legislators] are pro-N.E.A., they're not going to stick their political neck out to fund this kind of stuff."[33] In the wake of this reaction, Williams withdrew the reauthorization legislation and canceled a subcommittee vote on it. He explained that "There was, last week, an appearance that the arts community was itself divided."[34]

But, because he was a prime friend of the arts and wanted to find a way to new and positive legislation, Williams convened in Washington a special group to formulate it. Called the United Arts Group, it included four individuals (artists Dana Broussard and Billy Taylor and citizens Val Beck-Sena and Faith Evans), and representatives of numerous organizations oriented to the arts and free expression.** This was an awesomely diverse group, ranging from those with the highest establishment credentials and political connections through the academic to the entitlement-directed individual artists' groups. Rarely or never had these

* Pat Williams says, "Rev. Wildmon's group and others did send copies of the [photographs] to churches in Montana. . . . They did a very clever thing: they put the photos in brown paper envelopes, warning people that the contents might be troubling to the viewer. Which I'm sure was a way to get everyone to open the envelope!"[32]

** The American Arts Alliance; American Association of Museums; American Council for the Arts; American Council for the Traditional Arts; Association of American Cultures; AFL-CIO Department of Professional Employees; Coalition of Writers' Organizations; Creative Coalition; Independent Committee on Arts Policy; National Alliance of Media Arts Centers; National Artists' Equity Association; National Assembly of Local Arts Agencies; National Assembly of State Arts Agencies; National Campaign for Freedom of Expression; and the National Coalition for Education in the Arts.

organizations worked together or even spoken in unison or to each other; now they were being asked to forge a solution.

It took three long days behind closed doors to get the United Arts Group to come to a unanimous conclusion; but finally they issued a statement affirming the call for a five-year reauthorization without content restrictions, and calling for court determination of obscenity:

> A profound chilling effect now afflicts the arts and the exchange between artists, arts organizations, audiences and their congressional representatives. This must stop. . . .
>
> In the heat of this debate we have all, to some degree, lost sight of the fundamental consensus that underlies a free and civilized society: that freedom of expression is among our most important and cherished rights and that accountability in the expenditure of public funds is essential to the democratic process.
>
> In this spirit we call upon the arts community, the Members of Congress and all concerned Americans to work together to uphold these principles in a spirit of good faith and shared purpose so that we may honor both the right of free expression and public accountability.[35]

The United Arts Group rejected the NASAA proposal to give 60 percent of NEA funds to the states, and recommended instead a continuation of the 20 percent state funding system. It also agreed to the idea of an Independent Commission to study NEA accountability, an idea that had been brewing in Congress. In calling for both "the right of free expression" and "public accountability," the group was striving to balance the needs of artists versus government's responsibility to its constituents. The United Arts Group showed that the arts community could be newly united when pressed to the wall. Pat Williams remembers: "Artists . . . are a diffuse bunch. . . . [T]hey find it difficult to present a united front in favor of or against any single piece of legislation, even the reauthorization of the NEA. And so the United Arts Group became extraordinarily important. I was frankly somewhat surprised that they were able to pull it off with the unanimity that they achieved. Surprised and delighted."[36] Now Williams could negotiate with Representative Thomas Coleman, who was spearheading the NASAA 60 percent proposal; and acknowledging that chances of passage without restrictions were less than even, Williams was now willing to propose a three-year bill. Meanwhile, the White House was suggest-

ing a one-year reauthorization, "to let the noise level die down . . . let the commission do its work . . . and revisit this next year."[37]

The insane complexity of Congressional operations, the contradictions inherent in what Congress does, and the internecine warfare inherent in the process are all evident in what happened in June and July 1990 in the House. Pat Williams realized that he did not have support for the original five year legislation, so he chose to bypass subcommittee markup and sent the bill directly to the House Education and Labor Committee. That committee, though, being unable to agree, voted to send the bill directly to the full House for consideration. When it arrived there in late July, there were already twenty-six amendments that had been submitted to the House Rules Committee, which led Speaker Thomas S. Foley (D-WA) to postpone consideration until after recess in September!

Theatre Communications Group, in its magazine *American Theatre* of September 1990, provided a listing of the major pieces of legislation pending in July 1990:

> The original Administration bill, proposed by Williams, which calls for a five-year re-authorization of the agency without content restrictions. Williams added an amendment to re-authorize the Endowment for a period of three years instead of five, and another . . . that would bar grant recipients from receiving further NEA grants for up to one year if they knowingly produced materials under an NEA grant that a court, after all appeals, found "obscene."
>
> A revised bill proposed by House Republicans E. Thomas Coleman of Missouri and Steve Gunderson of Wisconsin that would dramatically change the agency by channeling 60 percent of NEA funds to the states. . . .
>
> An amendment drafted by Rep. Paul Henry (R-MI), with White House support, that extends the assurance . . . to include a ban on works that also violate prevailing standards of "decency."
>
> A bill proposed by Rep. Philip M. Crane (R-IL) to abolish the NEA entirely.
>
> A bill proposed by Rep. Dana Rohrabacher (R-CA) that includes . . . a condition that NEA-funded work may not "depict or describe, in a patently offensive way, human sexual or excretory activities or organs," and a ban against desecration of the American flag in works funded by the agency.[38]

The Senate, too, was having problems coming up with a reauthorization bill. Claiborne Pell's Education, Arts, and Humanities Subcommittee voted unanimously on June 13 to submit a five-year bill without restrictions to the Labor and Human Resources Committee, but that committee was unable to mark up a bill by the end of July. Senators Pell and Orrin Hatch (R-UT), Nancy Kassebaum (R-KS), and Edward Kennedy (D-MA) worked through the summer to forge a consensus.

At long last, the National Endowment for the Arts had won the attention of the Congress—and was obsessing it!

SEVEN

The Loyalty Oath and the NEA Four

JOHN FROHNMAYER'S LACK of understanding of Washington and of the arts world brought the NEA crisis to a head in late 1989 and early 1990. His failure to understand the system led him to overreact to Congressional moves, while at the same time he underestimated the anger in the arts world at the NEA's refusal to support cutting-edge works. The upshot was the famous "loyalty oath" that Frohnmayer inserted into all grant papers, making artists pledge not to create obscene work. This inflamed artists while failing to assuage the conservatives. Frohnmayer's later waffling on the issue only made matters worse and inspired a group of artists, known as the "NEA Four," to sue the Endowment when Frohnmayer overturned peer panel recommendations to fund their works.

When Frohnmayer was first appointed, he seemed to have won the hearts of conservative critics. Even Jesse Helms apparently thought well of him, and Frohnmayer returned the Southerner's praise. He said of Helms, "I found him to be an extremely fine, gentlemanly person."[1]

Helms, in the Senate on October 7, said, "I met at some length with John Frohnmayer, the new Chairman of the National Endowment for the Arts. . . . He is a delightful man, and not only did he tell me then, but he called later to reiterate that on his watch things like Mapplethorpe and Serrano will not happen again. And I believe that."[2]

The civility, though, would not last. In October 1989, Congress passed Law 101-121, stipulating that no NEA funds could be used for "materials which in the judgment of the National Endowment for the Arts . . . may be considered obscene." Frohnmayer responded to this by deliberately repeating the law's provision in the November 1989 General Information and Guidance for Grant Recipients:

> *Restriction on use of FY 1990 Appropriated Funds.*
> Public Law 101-121 requires that:
> None of the funds authorized to be appropriated for the National Endowment for the Arts . . . may be used to promote, disseminate, or produce materials which in the judgment of the National Endowment for the Arts . . . may be considered obscene, including but not limited to, depictions of sadomasochism, homoeroticism, the sexual exploitation of children, or individuals engaged in sex acts and which, when taken as a whole, do not have serious literary, artistic, political or scientific value.[3]

With this clause inserted in the terms and conditions sent to each grantee with the notice of a grant, the grantee's later signing of a certification meant that the so-called loyalty oath was being accepted as binding. Apparently Frohnmayer knew exactly what he was doing and wanted to do it; he writes, "I purposely inserted these words, verbatim, in the terms and conditions of NEA grants. . . . I did so to assure Congress that it had gotten our attention and to make our applicants aware of the law so they would not inadvertently run afoul of it."[4] He also was trying to force a court case: including the prohibition "was an invitation to a lawsuit, which I hoped would lead to a finding that the language was unconstitutional. If I simply buried the language, we would have it forever; if we shined a light on it, perhaps someone would sue us and the law would be invalidated."[5]

These moves were Frohnmayer's way of dealing with 101-121 and *Miller v. California*. Sidney Yates believes that "NEA overreacted. And I wrote to Frohnmayer and told him 'I think that's wrong. That isn't contemplated by the bill.' But he held onto it, as a bomb-shelter. As if to

say, 'I've done my part to observe your mandate.' I think he was torn both ways, by having to deal with very conservative attitudes. And that was one of the ways he sought to protect himself."[6]

Over twenty-five years, there had really been very little controversy about NEA grants, very few times when the chair disagreed with peer panels or with the National Council on the Arts. Frank Hodsoll had clashed more with panels than had previous chairs, but only one-tenth of 1 percent of the time did he reverse their decisions (thirty five reversals of 33,700 grant recommendations between 1982 and 1989). Things would be very different with John Frohnmayer. For one thing, Frohnmayer's coming brought a return of indecisiveness to the chair in its management of the National Council. Unlike Hanks and Hodsoll, Frohnmayer did not take control of the Council, as the law provided; and so the Council was again restive and suspicious, both of the process and of Frohnmayer himself. The standoff between Frohnmayer and the Council was another example of his inexperience in dealing with the Washington establishment. As he says, "The Congress, the press, and the art world were so different from the Oregon legislature, the Oregon press, and the Oregon art community that I might as well have been in a different galaxy."[7]

A month after beginning the job, and sixteen days after passage of Law 101-121, Frohnmayer had his first run-in with the arts community. Artists Space, an alternative gallery in the TriBeCa neighborhood of Manhattan, had used a $10,000 NEA grant to help mount "Witnesses: Against Our Vanishing," a show featuring the work of twenty-three artists that dealt with AIDS and included depictions of homosexual activity. Director Susan Wyatt deliberately informed the new NEA chair of the show: "I was concerned that the Endowment not be blindsided in case there might be some controversy on this show."[8]

On November 8, 1989, Frohnmayer suspended the $10,000 grant and asked that NEA not be listed as an exhibit sponsor. He gave as his reason what he considered to be the "political" nature of the show:

> I think it's essential that we remove politics from grants and must do
> so if the endowment is to remain credible to the American people
> and to the Congress. Obviously, there are lots of great works of art
> that are political. Picasso's "Guernica" and the plays of Bertolt Brecht
> are strongly political. But the question is, Should the endowment be
> funding art whose primary intent is political? The N.E.A. has always
> steered clear of that.[9]

Jesse Helms was delighted. His spokesman John Mashburn said, "Senator Helms said he was much more pleased by this than he was by the NEA's reaction under the former acting chairman to the Mapplethorpe exhibition."[10] And conservative commentator William Buckley wrote, "Mr. Frohnmayer is off to a good start. There remain public representatives who don't believe in the copulative imperative, that art and sex necessarily merit public support."[11] But the arts community was up in arms. Joseph Papp, head of the New York Shakespeare Festival, commented, "Everyone should be upset about this. . . . There is no question that this will have a widespread impact on all the arts." Ted Potter, Director of SECCA, said, "We could see immediately that the compromise arts funding bill passed by Congress was a hunting license for the ultra-conservatives, but we didn't expect the first shot to be fired by the NEA." And Anne Murphy of the American Arts Alliance chimed in: "The decisions of the endowment must be based on artistic quality, not content."[12]

In an effort to control the outrage in the arts community, Frohnmayer announced, on the day after the suspension, that the real reasons for it were "artistic" rather than "political." Confirming his inexperience with both Washington politics and the Eastern arts establishment, he said:

> The word "political," I'm coming to see, means something different in Portland, Oregon than it does in Washington, D.C. . . . It has sounded like I was saying you look at the political content and you decide whether or not you like it. What I meant to say was you look at the *artistic* quality and you decide on that. . . . In looking at the [Artists Space] application and then in looking at what was actually happening in the show, there was a substantial shift and, in my view, an erosion of the artistic focus. I described that with the "P" word, and it was taken by the arts community as a suggestion that I had been influenced by political pressure, or that it wasn't all right for artists to make . . . a political statement.[13]

With this statement, Frohnmayer destroyed his credibility among both politicians and artists!

Especially disturbing to the new chair was an essay in the "Witnesses" catalogue by artist David Wojnarowicz, in which he told of his "rage" at having AIDS and watching others die of the disease, and fantasized

about setting Jesse Helms on fire. He also attacked Senator D'Amato of New York, New York City Mayor Edward Koch, and New York Catholic Cardinal John O'Connor (the last for having "kept safer-sex information off the local television stations and mass transit advertising spaces . . . thereby helping thousands and thousands to their unnecessary deaths").[14] It was the catalogue that Frohnmayer saw and that led to the suspension of the $10,000 grant on November 8. After the controversy first broke, Frohnmayer hurried to New York to visit Artists Space (on November 15); he then announced that he was reversing the suspension, allowing Artists Space to keep the money for use on the exhibition only, and not the catalogue. (Artists Space received a grant from the Robert Mapplethorpe Foundation to pay for the catalogue.) Frohnmayer sought to explain his actions: "I did act precipitously. I made a mistake and I moved . . . to rectify that. . . . It may be as long as I exist on this earth that will be what people remember. As in all mistakes, I certainly hope I've learned from that one."[15]

In two weeks of November 1989, the new chair of the Endowment had alienated both politicians and artists, both right and left. The Visual Arts Panel was horrified and upset with the original suspension, while Jesse Helms said, "I do hope that Mr. Frohnmayer is not retreating from his voluntary commitment to me [to refuse to fund controversial art]."[16] In a detailed analysis of the entire Artists Space controversy ("Arts Chief's Potholed Path to a Grants Decision," *The New York Times*, November 20), William H. Honan noted that Frohnmayer's "unfamiliarity with the sometimes arcane procedures of Washington and the art world led him to misread important signals at critical moments."[17] His outsider status was already limiting his ability to placate the warring groups; and given his own poor relationship with the National Council, they were not standing behind him.

Congress's passage of Law 101-121, which led the NEA to censor controversial artworks, guaranteed that the crisis would continue. When Congressman Pat Williams began the reauthorization process in late 1989, he said, "It may well be that in responding to recent Congressional language the NEA has begun to have a chilling effect on art in the United States."[18]

John Frohnmayer appeared to be comfortable with the new Congressional rules. Ever the lawyer, he was being an advocate, trying to please both sides, and not being a political broker. For the next two years, 1990 and 1991, Frohnmayer was caught in the middle of the crisis, making decisions and then contradicting them, shilly-shallying on key issues.

There was no decisiveness at the top of NEA. As Livingston Biddle points out, "Frohnmayer made the mistake of changing his mind, several times. And that is equated in Washington with vacillation; vacillation means weakness; and weakness means vulnerability."[19] Frightened, the chair sided with the safe and predictable, leaving the experimental disenfranchised. As the *New Art Examiner* noted in an October 1990 editorial, "NEA program priorities could be written to swing the majority of agency support to these safe and predictable programs, leaving the emerging, controversial, and experimental artists and alternative spaces only a few token crumbs."[20]

The NEA Four

The censorship issue was most prominent in the case of the "NEA Four"—Karen Finley, John Fleck, Holly Hughes, and Tim Miller—individual performance artists whose funding Frohnmayer stopped in 1990. All four had previously received small NEA grants—Finley had received the most, three grants totaling $22,000—but the radicalism of their art made continued support problematic.

Karen Finley's case was the most colorful. Brought up in Evanston, Illinois, Finley was the daughter of a jazz drummer who killed himself in 1977. This affected her deeply: "I thought of how unhappy he must have been in order to take his life. His invisible emotions are what I wanted to start working with."[21] She moved to New York and began appearing in East Village clubs in one-woman shows about violence and the mistreatment of women. In these shows, Finley was often naked and howled and shrieked while smearing herself with chocolate (to simulate human excrement). In January 1990, the Walker Art Center in Minneapolis presented Finley's new piece, *We Keep Our Victims Ready*, as part of a series called "Cultural Infidels." Critic Mike Steele reviewed it in the Minneapolis *Tribune*: "Instead of banning Karen Finley, governments might be well-advised to hire her in the name of community health. She's a release valve for the alienated, an exorcist of sexual demons . . . a primal scream arising from the eerie quiet of denial."[22] Martha Wilson, director of the Franklin Furnace in New York (a frequent Finley presenter) called her "one of the best artists in America. She's an extremely moral person who is against the degradation of women. That's the opposite of pornography."[23] In the world of "underground" culture, Karen Finley was a darling: admired by the cognoscenti, and unnoticed by the wider public.

Then suddenly, she was famous. Columnists Rowland Evans and Robert Novak published an article mentioning Finley ("The NEA's Suicide Charge") in the *Washington Post* of May 11, 1990:

> Only a few exhibits up for approval inhabit the shadowy realm of controversy about true artistic merit. NEA Chairman John Frohnmayer has been advised to veto them, including the performance of a nude, chocolate-smeared young woman in what an NEA memorandum calls a "solo theater piece" and what the artist herself, Karen Finley, describes as "triggering emotional and taboo events." An administration insider calls the exhibit "outrageous." . . .
>
> Insiders in the sometimes-elitist world of the arts say privately it is inconceivable that the 24-member council would risk the outrage of arts intellectuals by imposing a veto on any of the recommended exhibits. . . .
>
> Thus Frohnmayer is the lonely custodian of the veto. . . . he was said by White House sources to be adamant against disapproving any of the recommended exhibits. If so, the small first step taken by Congress last October to end NEA grants for what was vaguely called "obscene" art will be dwarfed by a new congressional attack on taxpayer-financed art. That will squeeze Bush into an uncomfortable corner: side with Congress and the voters or be swayed by the spurious charge of betraying freedom of the arts.[24]

The closed meeting of the National Council on the Arts, held in Winston-Salem immediately after the Evans-Novak article appeared, was difficult and painful. For one thing, the NASAA proposal to redirect 60 percent of NEA funding to the states had just come out and was causing consternation throughout the arts community. The Council took two drastic actions: first, it voted to deny two of three grants to the Institute of Contemporary Art at the University of Pennsylvania (which had mounted the Mapplethorpe show), an action that Council member Jacob Neusner attributed to fear of challenging Congress (which had voted that it had to be informed of any future grants to ICA); and second, the Council voted to defer until its August meeting the eighteen grants to performance artists (including Finley, Fleck, Hughes, and Miller) that had been recommended by the Theatre panel.

After this meeting, Frohnmayer had what must have been the worst month of his life; as he remembers, "I looked forward to my nightmares, compared to what was happening during the day."[25] In Seattle in June,

he announced to arts professionals that "political realities" might require vetoing some grants recommended by panels, a statement that sent shivers of dismay through the arts community. On June 29, he announced that fourteen of the eighteen grants deferred to August would be sent up for approval, following a phone survey of Council members. The four artists to be denied their panel-recommended grants came to be known as the "NEA Four": Karen Finley, John Fleck, Holly Hughes, and Tim Miller. Holly Hughes reacted: "I think the reason my work was overturned is because it is chock-full of good old feminist satire and secondly, I am openly lesbian." Tim Miller said, "My work explores my identity as a gay person and as a person dealing with the AIDS crisis in an active, political way. So much of this is a homophobic attack on gay people and the visibility of gay people." But Congress was pleased: Representative Dana Rohrabacher said, "It was clear this decision was arrived at after a great deal of painstaking thought on the part of the endowment leadership. It shouldn't have been that difficult to reject sacrilegious and pornographic art. It is time we set some standards."[26]

The National Council meeting on August 3 to 5 in Washington would be very different. For one thing, after a suit by four newspapers (*The New York Times*, *Washington Post*, *Philadelphia Inquirer*, and *Los Angeles Times*), the Endowment decided to meet in open session for the first time. As John Frohnmayer remembers, "All three television networks, CNN, and forty reporters had declared their intent to attend. It promised to be a zoo."[27]

House members Williams and Regula came to warn the Council that reauthorization looked impossible without content restrictions. The Council voted seventeen to two to urge that the "loyalty oath" be put aside, but Frohnmayer (ever the lawyer) refused to do so until a federal court ruled on its constitutionality: "Congress had put the law there and Congress could take it away, but only a court, by declaring it constitutionally infirm, could get it out of our hair permanently. I was prepared to continue to take the heat on that one."[28] Surprisingly, at Frohnmayer's urging, the Council voted to reverse its May rejection of the two grants to the Institute of Contemporary Art. On the final day of the meeting, the Council voted down Jacob Neusner's proposal to prohibit funding for "work that denigrates the beliefs of a particular religion or advocates a particular program of social action or change," but approved Frohnmayer's statement that the Council favored "responsibility, accountability and sensitivity to bring quality art to the American people, fair procedures, and a case-by-case careful analysis of each grant pro-

posal."[29] In his memoirs, Frohnmayer says that his resolution "reiterated that the council unequivocally opposed obscenity, a litany that, in those intimidating days of summer, had to be repeated daily. It was meaningless, and I proposed it only so Neusner and the press couldn't say that the council refused to oppose obscenity. The council adopted it immediately."[30]

Frohnmayer's equivocation continued throughout 1990 and 1991, as he first sent strong signals that he would support controversial art and then, strangely, reversed himself. At the August Council meeting, he commented to one reporter that "before approving [future] grants, he would have to consider 'how it's going to play with the audience.'"[31] On August 24, he reiterated his support for the antiobscenity pledge, and the NEA announced that it was "creating a panel to investigate complaints from 'any reliable source' that grant recipients are violating the law by using Federal money to produce obscene art."[32]

Frohnmayer's hardline against "obscene" art continued throughout the fall. He repeated his support for the "loyalty oath" in September, saying that: "Taxpayers really do own the NEA, and if we do not speak to the people of this country, then we will have failed our mission. . . . I think we can support art that is absolutely on the cutting edge and still be sensitive to the public's reactions."[33] On October 23, Frohnmayer reversed the Visual Arts panel's recommendation for a $40,000 grant to the Boston Institute of Contemporary Art (which had also mounted the Mapplethorpe show) for an exhibition by Mike Kelley.[34] He went even further on November 17, overturning a decision by a panel (that was also approved by the National Council at its August meeting) for funding to experimental artist Mel Chin: the first time he had vetoed both advisory groups.[35] (This was another example of the continuing tension between Frohnmayer and the Council; if he and these twenty-six advisors could not get along, then there was no way for the NEA to function, let alone thrive.)

By December 15, the National Council on the Arts and the NEA were already backtracking on their tough stand. By a unanimous vote, the Council rejected the idea of panelists being given a "standard of decency" on which to base their decisions on grant proposals. The Council stated that panelists needed no extra guidance on matters of "decency" because "by virtue of your backgrounds and diversity you represent general standards of decency—you bring that with you."[36] At the end of the year, funding was approved by the NEA for Holly Hughes and Tim Miller, two of the four artists who had earlier been

denied support, perhaps bowing to the pressure of their threatened lawsuits.[37]

Frohnmayer's equivocation brought massive disaffection with him and with the agency inside the arts community. Joseph Papp, of the New York Shakespeare Festival, wrote a letter to the editor of *The New York Times*: "Senator Jesse Helms ... is now joined by his apprentice, John E. Frohnmayer, the endowment's chairman, to bring forth the inevitable malignant offspring of censorship—the informer. . . . Here's to the National Endowment for the Arts, the new cultural Federal Bureau of Investigation."[38] And Anne Murphy, executive director of the American Arts Alliance, said, "The endowment is bleeding to death."[39]

For the NEA Four, feeling entitled to receive NEA support was a major factor in their dismay when Frohnmayer vetoed their grants. These people were acclaimed and celebrated in the arts underground; they and their champions felt that the National Endowment, having received the panels' recommendations, simply owed them support. There was an assumption that grants would be forthcoming; when they were denied, it was seen as a personal attack on creativity. Karen Finley spoke for the whole group when she said:

> I didn't want to have happen [to me] what happened to [Lenny Bruce]. Which is stopping my ability to create. It's the biggest form of censorship, where you question yourself. When people are attacked it stops the creativity from growing. . . . If you come from a working-class background, like me, if I hadn't got that first NEA grant I just wouldn't be here. That's how it is. I wouldn't have gone to art school if I didn't get a grant. That's what I'm mostly fighting for, the right of people to become the artists that they want to be.[40]

The NEA Four assumed that, because they were working, and because the panel had chosen them for funding, the government was obligated to provide them with continuing support. This is the essence of a sense of entitlement.

Refusals of Grants by Artists and Arts Institutions

John Frohnmayer was chair of the NEA from the fall of 1989 to the spring of 1992. The American arts community found constant fault with him as a leader. He quietly, in a lawyerly way, sought to have the obscenity pledge, the "loyalty oath," removed; but he was castigated by

arts leaders for keeping it in place, even when the National Council (in August 1990) urged him to put it aside. Artists and arts institutions also faulted him for treating the NEA Four like sacrificial lambs and accused him of homophobia and cowardliness.

The years 1990 and 1991 also brought refusals by artists and arts institutions to accept NEA funding and commendations. It started in November 1989, when composer and conductor Leonard Bernstein declined a National Medal of the Arts (the award was presented by the president and administered by the Endowment). Bernstein refused the medal because of the cancellation of the grant to Artists Space. In 1992, Stephen Sondheim, another composer, frequent NEA panelist, and Bernstein's collaborator on *West Side Story*, would also refuse the medal, saying of the Endowment:

> In the last few years . . . it has become a victim of its own and others's political infighting, and is rapidly being transformed into a conduit, and a symbol, of censorship and repression rather than encouragement and support. For me to accept an award from the NEA in this particular climate and from an Administration that seems to approve of the transformation would be an act of the utmost hypocrisy, and I must therefore respectfully decline your invitation.[41]

Despite being horrified by the Endowment's handling of the issues in 1990, most arts organizations happily and gratefully accepted NEA funding; a small number, though, did refuse it, citing the "loyalty oath" as unconstitutional and an infringement of their First Amendment rights. These organizations refused a total of nearly half a million dollars. Here is a list of the organizations, along with the amount of money in grant-dollars that they refused:

American Poetry Review	$10,000
Bella Lewitzky Dance Company	72,000
Cornerstone Theater Company	7,500
Gettysburg Review	4,550
Lehman College Art Gallery	15,000
New School for Social Research	45,000
New York Shakespeare Festival	50,000
Newport Harbor Art Museum	100,000

Northern California Grantmakers	$75,000
Oregon Shakespeare Festival	49,500
Paris Review	10,000
Penn State Center for Performing Arts	5,000
Theatre for the New City	25,000
Time and Space Limited	10,000
University of Iowa Press	12,000
Total	$490,550

In refusing the $50,000 New York Shakespeare Festival grant, Joseph Papp said, "I cannot in all good conscience accept any money from the NEA as long as the Helms-inspired amendment on obscenity is part of our agreement."[42] He then raised $60,000 from *The New York Times* and TV producer Mark Goodson, $10,000 more than the original NEA support!

After their rejection by Frohnmayer in 1990, the NEA Four joined with the National Campaign for Freedom of Expression, the ACLU, and the Center for Constitutional Rights to sue the Endowment. Center attorney David Cole told the *Washington Post* that "The fundamental issue is that Frohnmayer rejected these artists not on artistic grounds, but because of their works. This is an impermissible reason for nonfunding, under both the NEA statute and the First Amendment."[43] Three of the refusing organizations—the Bella Lewitzky Dance Company, New School for Social Research, and Newport Harbor Art Museum—also sued, charging that the obscenity pledge violated freedom of speech and due process. Frohnmayer was at last getting the lawsuits that he had hoped for when he inserted the "loyalty oath" language into the guidelines in November 1989.

Both Theatre Communications Group and the Rockefeller Foundation filed friend-of-the-court briefs on behalf of the suits; Rockefeller's statement pointed out that the obscenity pledge might end up jeopardizing private support too: "Although the NEA budget may appear small, because of the closely integrated structure of public and private support which drives the art world, NEA funding decisions and NEA policy exercise a most powerful influence—an influence far beyond the dollar amounts involved."[44] The three institutional suits challenged the Endowment's right (in the wake of Law 101-121) to play the censor. Attorney Barbara Hoffman described the issue:

When we talk about constitutionality, we're focusing primarily on the First Amendment. . . . While government doesn't have any obligation whatsoever to fund the NEA, once it does commit to funding, it cannot impose conditions that suppress any particular kind of free speech. . . . The real issue is . . . whether a non-court body [like the NEA] can determine what is and what is not obscene.[45]

Not only was the NEA requiring the "loyalty oath" to be signed, but it also required certain organizations (like the Kitchen and Franklin Furnace in New York) to specify their programming in order to receive money. On July 23, the Endowment asked Franklin Furnace to provide "identification of the artists involved and the nature of the work to be performed" at their facility so that there could be a "final determination" on grants.[46] On July 11, the NEA published new guidelines on what constituted obscenity, in an attempt to comply with *Miller v. California*. Attorney Floyd Abrams pointed out that the new rules mandating the obscenity pledge meant that grantees were "asked to sign language which says one thing and simultaneously told that it means something else,"[47] further evidence of the total confusion at the agency.

When FY 1990 ended on September 30, Public Law 101-121 expired, because it was related only to that fiscal year. When Congress reauthorized the Endowment in October, it replaced the obscenity pledge with a milder requirement that "general standards of decency" be taken into account when grants were awarded. Frohnmayer used the expiration of 101-121 as an excuse to lift the "loyalty oath," and the obscenity pledge was dropped in the fall of 1990. It had never been required by law anyway; it was only the Endowment's assumption that it must "behave" that had led it to put the oath into the guidelines for FY 1990. Then, in January 1991, John Davies, a federal judge in Los Angeles, ruled that the oath was unconstitutional! In Davies's judgment, "The government may well be able to put restrictions on who it subsidizes, and how it subsidizes, but once the government moves to subsidize, it cannot do so in a manner that carries with it a level of vagueness that violates the First and Fifth Amendments."[48]

Edward deGrazia, in *Girls Lean Back Everywhere*, says:

At bottom, the issue was the profoundly distressing one of whether Congress might be bulldozed into passing a new law that would allow presidentially appointed government officials like John Frohnmayer, popularly elected politicians like Jesse Helms, and self-

appointed religious leaders like Donald Wildmon to control the images that American artists and arts institutions communicate.[49]

I think it is striking that, almost always during the crisis, free speech and the First Amendment triumphed. Two Live Crew in Florida, Judas Priest in Nevada, Jock Sturges in San Francisco, WGBH in Boston, the Contemporary Art Center in Cincinnati, and the NEA Four and the three suing organizations all won their free-speech cases. (A primary casualty was the Corporation for Public Broadcasting, whose 1992 reauthorization carried a ban on "indecent" programming in prime time.) Despite the importuning of Jesse Helms and the hysterical tirades of the religious right, the American courts upheld the right of the American people to say whatever they wanted. The system worked.

The Media as Villain

A major villain in the crisis was the media. Almost every day, there was a big article in the press about the controversy. The news media seemed driven by the shock value of Mapplethorpe and Serrano, the bigotry of Jesse Helms, the prejudice of Donald Wildmon, and the confusion of John Frohnmayer. It made little effort to understand or convey the complexity of the issues, and instead concentrated on sensationalizing them: life as *People* magazine. As Leonard Garment said, "Looming over the resulting clashes was a media machine avid for the sort of titillating material that usually lay at the heart of these disputes."[50]

In the nation's capital, *The Washington Times* was especially inflammatory. Pat Buchanan wrote for this conservative newspaper, and he spent much of 1989 dwelling on the crisis. Reflecting on the Reagan/Bush years, he stated: "While the right has been busy winning primaries and elections . . . the left has been quietly seizing all the commanding heights of American art and culture."[51] Buchanan reflected the stereotypical view of American culture as out-of-touch with the taste of the "common man":

> What's to be done? We can defund the poisoners of culture, the polluters of art; we can sweep up the debris that passes for modern art outside so many public buildings; we can discredit self-anointed critics who have forfeited our trust.[52]

He characterized the arts community as petty individuals who were against any criticism or control:

> What does the "arts community" want? . . . To be honored and subsidized by a society they appear to loathe. Like spoiled children, our artists rant and rail at us; then cry "repression" and "censorship" when we threaten their allowance.[53]

At the height of the reauthorization controversy in the summer of 1990, *The New York Times* was packed with coverage. In a six-month period from May to October, dozens of articles, editorials, letters to the editor, and op-ed pieces appeared there. Some examples are:

May 17	"America's Art, Smeared" (editorial)
June 6	"Abolish the Arts Agency" (op-ed piece)
June 13	"Compromise on Endowment Sought"
June 20	"Arts Endowment's Fate Is Left Up to Full House"
June 29	"Disapproval of Grants is Forecast"
July 6	"Arts Panel Seeks Review For Four Rejected Grants"
July 12	"Arts Figures Denounce Endowment on Grants"
July 18	"Subsidies for Artists: Is Denying a Grant Really Censorship?"
July 25	"Debate on the Fate of Arts Endowment Is Postponed"
July 28	"Homophobia at the N.E.A." (op-ed piece)
July 31	"Frohnmayer Concedes Arts Agency Faces a Lag in Public Confidence"
August 4	"Council Opposes Making Artists Sign a Pledge"
September 3	"Endowment Prepares to Shortchange Artists" (letter to the editor)
September 28	"4 Performance Artists Sue National Arts Endowment"
October 10	"House Ready to Take Up Arts Endowment Fight"
October 18	"Supporters Vow to Save Compromise on Arts Endowment"
October 23	"Helms Vows to Fight on Arts Funds"

In the week that Nelson Mandela came to the United States, *Newsweek* magazine gave its cover story to the NEA crisis. Conservative and

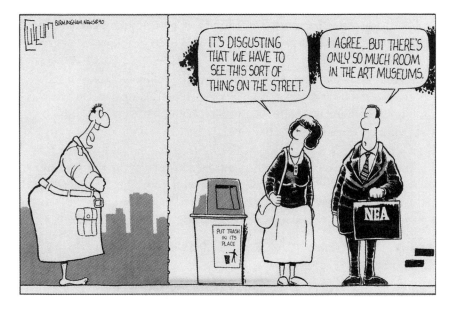

Many editorial cartoonists throughout the country commented on the NEA crisis. This one is by Mark Cullum of the Birmingham, Alabama *News*. *Courtesy of the Birmingham* News, ©*1990*.

liberal columnists including William Buckley, Tom Wicker, Russell Baker, and William Safire devoted many column inches to it. At the height of the Artists Space controversy, John Frohnmayer acknowledged the media's influence on the situation: "I am hopeful that some resolution of this matter can happen. We were attempting to do that but the story broke precipitously, and forced, I think, decisions to be made on a very rapid basis. I hope we will not have to respond on the press's schedule."[54] And in his memoirs, Frohnmayer says of the Artists Space incident, "In my wildest imagination I did not believe that suspending this grant would be front-page news. I was stunned and bewildered by the intensity of press interest."[55]

The almost daily coverage in major newspapers was completely out of proportion to NEA's minuscule 3 percent share of arts funding to institutions; the coverage made it look like the Endowment was providing 75 to 80 percent. In 1990, the media was indulging itself, and us, in the NEA crisis.

Of course, attention in the media led to instant celebrity for some. Karen Finley became a sudden star, and the price of a Mapplethorpe photograph shot past $50,000. The Robert Mapplethorpe Foundation,

which controlled all rights to the artist's work after his death in 1989, used its new-found income to give $5 million to the Guggenheim Museum in 1992 and announced that 20 percent of all its revenues would be given for three years to AmFAR, the American Foundation for AIDS Research.

Much attention in the media was given to surveys of public attitudes toward government funding of the arts and individual artists. Through the years, the main researcher in this field had been Louis Harris, who conducted six studies between 1973 and 1992.* Harris's surveys were suspect to many people in the arts (one person said that a typical Harris question was "If the government delivered a symphony orchestra to perform on your front lawn, would you listen?"); but they did build sympathy for the arts in the public consciousness. Over the years, the surveys showed significant change in attitudes:

	1975	1980	1984	1987	1992
Federal Government should support arts	39%	50%	55%	59%	60%
Federal Government should help individual artists	29%	35%	40%	47%	52%
Willing to pay extra $10 in taxes to support the arts	51%	65%	66%	70%	64%

Only in 1992 did Harris ask whether the government should try to control artists' work; in that year, 75 percent said that government should not.

In both 1989 and 1990, *Newsweek* magazine commissioned polls from the Gallup Organization. Gallup found the following:[56]
Should federal funds be used to encourage and support the arts?

	1989	1990
Yes	35%	42%
No	47%	50%

* In 1975 for the National Committee for Cultural Resources, and in 1973, 1980, 1984, 1987, and 1992 for the American Council for the Arts.

Should federal officials exercise more control to ensure that works of art don't offend? Or should these judgments be left to independent panels?

	1989	1990
Official control	22%	30%
Panels judge	58%	63%

Other public surveys were made by the Thomas Jefferson Center for the Protection of Free Expression, People for the American Way, the *Los Angeles Times*, and the University of Cincinnati during the Contemporary Art Center's Mapplethorpe exhibition. But the surveys were mostly the arts community talking to itself. As Gladys Engel Lang and Kurt Lang point out in their article "Public Opinion and the Helms Amendment" in the *Journal of Arts Management and Law*:

> Federal funding for the arts is of direct concern to only a minority [of Americans]. Not many people feel vitally affected and/or greatly aroused over the issue. . . . By neglecting to marshal an effective response, the cultural lobby let the opponents define the terms on which the issue was debated. . . . The public-at-large was neither so outraged nor as bent on abolishing the agency as some media reports might have suggested. . . . Even as late as March 14, 1990, no more than 27 percent of those queried were either "very familiar" or "somewhat familiar" with "the controversies surrounding the NEA" and fully 40 percent still had heard nothing about it. . . . The poll did reveal . . . a public fundamentally well disposed toward the NEA and ready to take its side in the impending showdown. . . . For all that, throughout the long congressional debate . . . there was little evidence of an outraged public. . . . They were little more than "bystanders."[57]

With its growth-oriented bias, the NEA has been telling us for years that the arts public is huge and deeply committed. But when the chips were down, that public really did not care very much. The arts community was left to fight its battles mostly by itself.

EIGHT

Meeting "General Standards of Decency"

Reauthorization and Its Aftermath

BEDEVILED BY DOUBT, Congress in Public Law 101-121 in October 1989 had provided for "a temporary Independent Commission for the purpose of (a) reviewing the National Endowment for the Arts grant making procedures, including . . . its panel system; and (b) considering whether the standard for publicly funded art should be different than the standard for privately funded art."[1] Four members of the twelve-person body were to be chosen by the President; four by the president pro tempore of the Senate; and four by the Speaker of the House. It took more than six months after passage of 101-121 to put the commission into place; but by late spring of 1990, while Congress wrestled with reauthorization, it was ready to conduct its study. Typically, one-third of the members were from New York (including Kitty Carlisle Hart, chair of the New York State Council on the Arts); but the others were drawn from California, Illinois, Kansas, New Mexico, and West Virginia. Two men with long histories of arts involvement were chosen to be cochairs: John Brademas, president of New York University and a champion of

the arts in his days as an Indiana congressman; and Leonard Garment, a Washington lawyer who, as arts adviser to Richard Nixon, had been Nancy Hanks's primary collaborator. The Independent Commission, unlike the 1981 Task Force, was not only a "blue-ribbon" group; as Sam Hope points out, "Neither the White House nor the two branches of Congress found it important to have as a member of the Commission anyone with high credentials as a currently practicing professional artist, critic, or historian. . . . This was truly a citizens's panel."[2]

The staff director of the commission was Margaret Wyszomirski, a social scientist who had written extensively on the Endowment and on arts policy (and who would later become director of policy, planning and research at NEA); there were seven other professionals on the staff. The cost of the commission's work was $250,000; this sum was specially appropriated by Congress, which also asked NEA to be the fiscal agent (ie., to pay the bills). As Leonard Garment says, "The whole thing was an afterthought; Congress didn't want to create another organization, more structure, more administrative costs. Why not let an existing organization do it? There wasn't anything much to it: staff salaries mostly, and a few sandwiches."[3] Still, no one seemed bothered by the fact that the cost of the study was being technically borne by the agency being studied!

The Commission had been charged by Congress to finish its work by September 1990—so that its findings could be of help in the reauthorization process. Testimony was received from former National Council members, from former chairs Biddle and Hodsoll, and from other key players. There were four hearings, all held in Washington, on June 6 and 25; July 23, 24, and 31; and August 1. At the final hearing, the Commission heard from various legal authorities on constitutional issues regarding the loyalty oath; and they also heard from John Frohnmayer, who said that if a project is "so offensive that it simply leads to confrontation and solidification of positions . . . that would not be appropriate for public funding. We cannot look strictly at artistic excellence in a vacuum. We have to look at how it's going to play in an audience that we are charged with serving, which is the people."[4]

The Commission finished its work on time; in September, it submitted *A Report to Congress on the National Endowment for the Arts*, a ninety-four page document with many unanimous recommendations. At a joint press conference, Brademas and Garment said:

The Endowment is charged with one of the most complex and delicate tasks that an agency of government can perform in a democracy. On the one hand, it must seek to offer a spacious sense of freedom to the artists and the arts institutions it assists. . . . At the same time, the NEA must, if it is to maintain public confidence in its stewardship of public funds, be accountable to all of the American people.[5]

This general statement reiterates the need for the NEA to strike an essential balance between supporting artistic freedom and the need for governmental accountability.

Major findings of the Commission were as follows:

Freedom of speech is essential to the arts

Obscenity is not protected speech, and therefore the NEA should not fund it

The NEA is not an appropriate body to determine obscenity

The NEA should cancel its obscenity pledge

There should be no legislated restrictions on the content of art

Artistic excellence should remain the primary standard in grant making

The authority of the NEA chair should be strengthened

Panels should be broadened and should include lay (non-arts-professional) people

Panels should be one of several sources of advice to the chair

Procedures for evaluation of grant applications should be reformed

The 20 percent allocation to state arts councils should be maintained

NEA Council meetings should be open to the public

As later pointed out by Staff Director Wyszomirski, "The political task of such a commission is to develop a compromise position that can be acceptable to a broad coalition of interests";[6] or as John Frohnmayer writes, "Like myself and Congress, the commission was trying to have it both ways—to support free speech and at the same time not to offend anyone."[7] This of course is another way of calling for balance, and of admitting that, like all "blue-ribbon panels," the Independent Commission tended to beg certain questions. Striving for unanimity, they

hedged: "The NEA must not operate solely in the interest of its direct beneficiaries.... To support art from public funds entails considerations that go beyond artistic excellence."[8]

While the commission said that the Endowment should not determine obscenity and should not require grantees to sign a loyalty oath or obscenity pledge, it also said that the Endowment must behave responsibly. On pages 60 and 61 of the report, the Commission recommended additions in the Congressional Declaration of Purpose for the NEA:

> 1. that the arts and humanities belong to all the people of the United States ...
> 4. that it is necessary and appropriate for the Federal Government to complement, assist, and add to programs for the advancement of the humanities and the arts by local, state, regional, and private agencies and their organizations; and that, in doing so, it must be sensitive to the nature of public sponsorship ...
> 9. that the arts and the humanities reflect the high place accorded by the American people to the nation's rich cultural heritage and to the fostering of mutual respect for the diverse beliefs and values of all persons and groups.

The first of these—that the arts belong to the people—was the core point. This same point concluded Lyndon Johnson's remarks on September 29, 1965, when he signed the NEA legislation: "The arts and humanities belong to the people, for it is, after all, the people who create them."[9] The commission's call for a return to this "people's property" priority was an acknowledgement of the political basis of federal support and the need to protect the people's rights. Critic Hilton Kramer, in the *New York Observer*, emphasized that: "This point about 'the arts [belonging] to all the American people' ... completely changes the nature of the debate ... It means that the special interests of grant recipients must no longer be given priority over the public interest.... to implement such recommendations would require nothing less than a complete overhaul of entrenched practices."[10]

The Independent Commission was a very important part of the reauthorization process. As Leonard Garment says, "For it to be effective, it had to be a unanimous report.... We were able to transcend a lot of ideology.... What came out of it was like the work of a jury: not so much wisdom as common sense, the collective product of compromise and experience."[11] The Independent Commission enabled Congress to

pass a reauthorization of NEA. It restored reason and some balance to the debate. But it also did something very significant: it changed the NEA's ultimate authority, *from* artists and arts institutions *to* the people of the country: "the standard for publicly funded art must go beyond the standard for privately funded art. . . . The Endowment serves all of the people rather than artists and arts institutions alone."[12]

It is fascinating to compare the deliberations and findings of the 1981 Task Force and the 1990 Independent Commission. Both examined the NEA in depth, and considered whether it should continue. Both concluded that it should. But in 1981, the key question was *how* to fund the arts: "What are the respective responsibilities of the public and private sectors?" In 1990, the key question was *what* to fund: "What are the public sector's rights and responsibilities in funding the arts?" Calling for significant shifts in public-sector standards, the Independent Commission also proposed significant revisions in the panel system, whereas the Task Force had merely endorsed it. The Task Force was only a blue-ribbon committee; the Independent Commission was also a people's panel: it stood up for the people's rights.

The Reauthorization

At the beginning of 1990, George Bush was in favor of a five-year reauthorization of the NEA with no content restrictions; this fit his patrician, moderate, Eastern establishment background. At a March 23 press conference, he said, "I am against censorship, but I will try to convince those who feel differently . . . that we will do everything in our power to stop pure blasphemy. . . . Having said that, I don't know of anybody in the government or a government agency that should . . . censor what you write, or what you paint, or how you express yourself."[13] Despite these official positive words, though, Bush was not paying much attention to the issue or working very hard on it. As Pat Williams says, "He wasn't pulling his end of the load, with any great exertion. . . . To the president's credit, he did not do an about-face; he did not change his position; but neither was he willing to put his shoulder to the wheel. And so it was left for legislators to do so."[14]

By June, Bush was already starting to hedge. When the Independent Commission got going, the White House suggested that the NEA be reauthorized for only one year, to give the commission time to examine the NEA's granting processes, and presumably come up with new procedures. White House spokesperson Alixe Glen explained: "The White

House is open to suggestions from the Hill as long as they don't gut NEA. . . . The Administration, as much as anybody, wants to be sure grants are made appropriately. . . . If Congress is able to come up with a reasonable and limited approach that no grant go to anything obscene, that is acceptable, but we don't think that art should be censored by statute."[15] E. Thomas Coleman, the Missouri Republican shepherding the NASAA 60-percent proposal, objected to the one-year idea: "The White House has been careening from goal to goal. A one-year extension simply puts this issue back on the floor during the appropriations process, in the same situation we faced last year. . . . I think this is the wrong proposal at the wrong time."[16]

Various committees in both houses tried to formulate ways to reauthorize the NEA through the summer 1990. There was much delay, and much back-and-forthing and disagreeing between the two bodies. The House, with Pat Williams still taking the lead, made the clearest progress; and on October 11, a compromise put together by Williams and Coleman passed the House, 382 to 42. This piece of legislation reauthorized the Endowment for three years and left obscenity judgments to the courts. With 90 percent of all voting members in favor, it was a major achievement for arts advocates. After the vote, Williams said, "I was surprised with the depth of support for protecting pluralism in America and avoiding the diminution of artistic freedom of expression. This is a terrific vote for those Americans who were concerned with the creeping threat of censorship."[17]

There were big problems in the Senate. On September 12, the Labor and Human Resources Committee passed a five-year extension without restrictions, the result of joint efforts over the summer by Senators Pell, Hatch, Kassebaum, and Kennedy. This measure echoed many of the Independent Commission's recommendations for changes in NEA procedures, including opening up meetings of the National Council to the public.

The Senate Appropriations Committee met in October. In an effort to placate Jesse Helms (then facing a tough reelection battle in North Carolina), they decided to reinstate the antiobscenity provisions, and to go for only a one-year reauthorization. As E. Thomas Coleman said, "The Appropriations Committee took a step backward in trying to resolve this issue."[18]

The House and Senate were at loggerheads. Both called for changes in NEA procedures and for artists to repay their grants if the courts found their work to be obscene; but the House wanted a three-year

reauthorization and all obscenity issues decided by the courts, while the Senate wanted one year and a continuation of NEA's role as a judge of obscenity. Any hope of reconciling these differences seemed slender at best. Pat Williams recalls the mess:

> To reach unanimity and clarity and singleness of purpose required, first, a rough-and-tumble, roll-up-your-sleeves attitude that was willing to accept the liability of bruised knuckles and scraped knees. House members are more likely to do that in our legislative pursuits than are the Senators; and so it was not unusual that we achieved the clarity of purpose prior to the Senate doing so. In fact, what we went through in the House made what the Senate went through look like a Saturday afternoon picnic. . . . I often wonder what Madison and Jefferson would have thought had they been around during the NEA crisis and had they witnessed the more politically vulnerable House willing to go first and go it alone, and the Senate literally hiding in the shadows until the dirty work was done.[19]

Finally, though, the Senate did come round. It rejected Helms's efforts to reestablish the antiobscenity provision (the loyalty oath). On October 27, both houses passed legislation reauthorizing the Endowment for three years. The main provisions were as follows:

- Grants shall have no content restrictions
- Questions of obscenity must be determined by the courts
- Artists whose work is found to be obscene by the courts must return funding to the Endowment
- NEA panels must be opened up to be more diverse and conflict-free
- There must be expanded reporting requirements for all grants
- The chair must be given more authority in grant making
- Funds to State Arts Agencies must be increased to 30 percent of NEA funds in FY 1991, and 35 percent in FY 1993
- Half of all NEA funds over $175 million must go to efforts in arts education
- All grantees must consider "general standards of decency and respect for the diverse beliefs and values of the American people"

This last provision was Congress's way of somehow dealing with the obscenity issue. It was a slippery provision: "general standards of decency" would be almost impossible to enforce, even if it could be understood! As noted by Peter Kyros, cultural adviser to Jimmy Carter and an Independent Commission member, "What Congress has done is craft a content restriction that doesn't look like one. It's very subtle." John Frohnmayer expressed relief, calling the legislation "far better than what we expected only a few weeks ago. . . . The language 'general standards of decency' is less restrictive than decency as defined by a specific case in law. But since we just got the legislation we have to figure out what it means and draft regulations based on it."[20]

The Endowment came through the reauthorization process luckier and better off than it might have expected in the spring and summer of 1990. It was not destroyed. The *Washington Post* summed it up:

> In the next several months, the focus will be shifted away from the Hill to the NEA. Congressional supporters like [Pat] Williams and [Sidney] Yates acknowledge that the bitter struggle on the Hill has taken its toll on the agency. Frohnmayer has vetoed several potentially controversial grants and many arts groups contend that the endowment has been muzzled even without explicit content restrictions.
>
> "Whether or not the NEA now survives and prospers is a question that's going to be answered only by the endowment itself," Williams said.[21]

More Money for the States

The 1990 law's stipulation that the state funding percentage be increased meant that each state would receive $90,000 more from the federal government in FY 1991. This was not a very big increase, given that state funding had started exceeding federal levels five years earlier. Some in the arts community worried that more money from the feds going to the states could lead some state governments to reduce their own funding. Bennett Tarleton, executive director of the Tennessee Arts Commission, spoke for the state arts councils when he said, "I doubt that state legislators will look at a $90,000 increase as a real boon. If it were $900,000, that might be something, but nobody here is going to say we got rich all of a sudden because we got an extra $90,000."[22] The real impact of the new arrangement was felt at the Endowment itself,

where the rise in state funding as mandated by Congress forced an almost $12 million reduction in program monies for FY 1991. Money and percentage reductions were:

Program	$ Reduction	% Reduction
Dance	$1,005,000	10.5%
Design	465,000	11.2%
Expansion Arts	585,000	9.0%
Folk Arts	500,000	15.2%
Inter-Arts	580,000	13.0%
Literature	565,000	11.3%
Media	1,730,000	12.8%
Museums	1,764,000	13.7%
Music	1,938,000	12.0%
Opera/Musical Theater	745,000	11.0%
Theater	1,200,000	11.1%
Visual Arts	775,000	12.7%

The average cut was about 11 percent. Folk Arts's 15.2% was the highest, but that program also received an extra $863,000 to give to state agencies as part of the "Under-Served Communities Set-Aside," Congress's new requirement that 5 percent of NEA program monies in FY 1991 be devoted to projects in inner city, rural, and other underserved areas. Expansion Arts was awarded $397,000 for this program, which, combined with its lowest 9 percent reduction, meant that this program fared best of all. (Expansion Arts had been cut through the 1980s more than other programs, so perhaps it was being favored this time round.)

The Endowment had very painful months after the 1990 reauthorization. In February 1991, Frohnmayer testified to a House subcommittee that to return Endowment grants to their earlier levels would require additional funding of $57 million.[23] Tellingly, the Bush Administration was "freezing" the NEA: in the new FY 1992 budget, its money stayed the same as in 1991, while the National Endowment for the Humanities rose almost 5 percent, to $178.2 million. (NEA, historically, had always received a little more than NEH; but when the crisis came, that situation was reversed, with the Humanities Endowment

getting more than the Arts. The NEH was also helped at this time by being headed by a popular Republican, Lynne Cheney, wife of Bush's secretary of defense.)

The Firing of Frohnmayer

George Bush's support of the Endowment wavered early. He had started in favor of a five-year reauthorization without content restrictions; by June 1990, he was already having second thoughts. He sent a delegation that month to discuss the issue with House Republican leaders and announced his support of a one-year reauthorization (to allow the Independent Commission time to reconsider all issues). An August 3 response from the White House to a citizen's query gave Bush's viewpoint:

> While the President supports the statutory purpose of the NEA, he believes that Federal funds should not be used to support the production or display of obscene material. . . . President Bush will continue to work with Congress and its bipartisan Commission on the NEA to find an appropriate policy balance that ensures that needed Federal support for the arts continues, while avoiding activities that clearly do not warrant taxpayer support.[24]

The problem for Bush was the growing right-wing backlash against the Endowment. Politically a moderate, Bush had been courting the conservatives, believing that he needed their support for reelection; to have an issue on which he disagreed with them could be an embarrassment. Federal funding of the arts was not important enough to George Bush to risk losing a big constituency. *The New York Times* said in an editorial, "Mr. Bush has left his appointee, Mr. Frohnmayer, alone on the tightrope. If the President would take a position against censorship, that would take Mr. Frohnmayer off the tightrope and put the endowment on firmer ground."[25] But Paul B. Weyrich, head of the conservative Free Congress Foundation, noted that "Bush understands that while he may not like it, just as he didn't like the Willie Horton stuff, if it means the difference between victory and defeat, he'll do it. But I don't think he's terribly comfortable with these sorts of things, which are not the sorts of things you care to deal with in the circles he has traveled all his life."[26] Obviously, in the summer of 1990 George Bush was betraying his own patrician past.

John Frohnmayer was a friend of George Bush, but key White House assistants were unimpressed by his leadership of NEA. Tensions between the Endowment and the White House continued through 1991. Bill Lichtenstein, in a major article in the *Village Voice* ("The Secret Battle for the NEA," March 10, 1992), described the attempts of John Sununu (then White House chief of staff) to keep Frohnmayer under control: "Sununu told Frohnmayer that the chairman's vision of the agency's mission conflicted with the administration's determination not to fund homoerotic and politically objectionable art. . . . He also told the NEA head to 'stay away from Capitol Hill' and the controversy over the Jesse Helms amendment to the NEA's appropriations bill."[27]

Frohnmayer was really alone; not only abandoned by his president, he was an arts executive without the support of his "board," given the standoff between him and the National Council. As he admits in his memoir *Leaving Town Alive*, "I was becoming increasingly isolated."[28]

On January 31 and February 1, 1992, the National Council met in Washington. Among the grants recommended by the Visual Arts panel were two involving controversial artists: a $5,000 award to the Highways Gallery of Los Angeles for a project by Tim Miller (of the NEA Four), and $25,000 to Franklin Furnace of New York for its performance series. Both applications included visuals: slides from Highways, and slides and a video from Franklin Furnace. All were very raw, depicting sexual activities. Frohnmayer said to the Council that all the visuals had to be considered in evaluating the applications and panel recommendations. Both the Highways Gallery's slides and Franklin Furnace's slides and video were shown to the Council. One Council member (James Wood) suggested that the Franklin Furnace application be sent back to the panel for reconsideration; but Frohnmayer vetoed that, and kept insisting that a decision be made, based on the materials submitted by both applicants. In the ensuing discussion, it was revealed that the Visual Arts panel had seen only two minutes of the hour-long Franklin Furnace video, featuring performance artist Scarlet O, before concluding that as a performance it was irrelevant to a visual arts application.

The Council did reach decisions, as evidenced by this very revealing passage in the minutes of the meeting:

> [M. Ray] Kingston saw no artistic merit in the Scarlet O video. [Jocelyn L.] Straus remained concerned about the applicant's intent that the video be seen. Also decrying the quality of the work before

them, [Sally] Bliss mentioned the political jeopardy facing the Endowment. [William E.] Strickland expressed a similar concern.

[Donald] Hall implored his colleagues not to vote out of fear of criticism, a theme [Harvey] Lichtenstein expanded upon vis-a-vis upholding the grant review process, retaining respect in the artistic community, and the continuation of the Endowment. [Peter] Hero maintained that Council members who might vote against funding this application were not motivated out of fear; they would be deciding on artistic merit in accord with their mandated role in the process. [Roy] Goodman also held this position.

Not deeming what she had seen to be art, [Ardis] Krainik worried about being set up, as [James] Wood suggested earlier. Mr. Wood said he had not wanted to let the panel off the hook, but he no longer believed the Endowment had the time to send the matter back. The Council should act out of artistic conviction—artists were not monolithic in their understanding of these issues and their reactions need not be feared.

Mr. Lichtenstein moved the Council endorse the panel's recommendation to award a grant to Highways. The motion was defeated 10 to 7, with Ms. Krainik abstaining.

Mr. Lichtenstein moved the Franklin Furnace Archive application be returned to the panel for reconsideration, including the problematic video. The motion was defeated 11 to 5. Mr. Kingston's motion to reject the panel recommendation to fund the application passed 17 to 1.

The Council then voted unanimously to recommend the remaining proposed grants and rejections.[29]

Council member Wendy Luers later offered a reason for the rejection: "I'm a champion of the avant-garde . . . but the tape had no artistic merit. . . . I had no choice other than to vote against it."[30] (Like other institutions that either were denied funding or rejected it, Franklin Furnace obtained a grant, $25,000 from the Peter Norton Foundation of Los Angeles, to replace NEA's funding.)

Franklin Furnace ended up much better off than did John Frohnmayer. Things came to a head early in the 1992 reelection campaign. Pat Buchanan was challenging Bush in the early primaries, embarrassing the president with his strength and sounding like Pat Robertson. Buchanan was attacking the Endowment on the campaign trail. During the Southern primaries, he ran ads showing excerpts from

Marlon Riggs's *Tongues Untied*, a film about black gay men that had had NEA funding. On February 21 (again in *The Washington Times*) he called the Endowment an "upholstered playpen of the arts and crafts auxiliary of the Eastern liberal establishment. They have been subsidizing both filthy and blasphemous art."[31]

That same day, George Bush fired John Frohnmayer. An aide to the president said, "We had to wipe away at least one of Pat's points in advance. Dumping John was craven, but it was just politics."[32]

The reaction within the arts community was cool and dispassionate, because Frohnmayer, with his wishy-washy support of the Endowment's programs, had alienated that community. David Mendoza, executive director of the National Campaign for Freedom of Expression, said, "There is nothing to celebrate. . . . His lack of courageous leadership in defense of freedom of expression has given license to those who would enforce morality through restrictions on public support for the arts." Harvey Lichtenstein, president of the Brooklyn Academy of Music and a member of the National Council on the Arts, said, "I fear for the future of the NEA. For a while it looked like we would weather the storm. Now I'm not so sure." And Andres Serrano, whose "Piss Christ" had started the crisis, said, "The problem with John Frohnmayer was that he tried to please everyone and fell flat on his face. The question now is who will replace him—someone better or worse? And does anyone care anymore?"[33]

Frohnmayer's primary problem was that it was impossible to know exactly where he stood. While the right attacked him for being permissive, the left accused him of embracing conservative prejudices. It was even hard to know what he would do next: "I'm hopeful to find a foundation to head, to write and speak, and perhaps look for another career. . . . It's very difficult to go back to the private sector and simply deal with individual problems. I am too invested in what we have been through in the last three years to simply say, 'That was a segment of my life,' and just go back to what I'd been doing before."[34] Strangely, after losing his job, Frohnmayer came out as an old-fashioned champion of freedom of expression, although he had previously taken a much more conservative stance. One month after his ouster, Frohnmayer gave a speech, "Talking Points," at the National Press Club in Washington: "The answer of how to save the Arts Endowment is very simple. . . . It is to read, believe, and embrace the First Amendment . . . To kill the Endowment because of a few disturbing lines or images poses a far greater threat to this nation than anything that has ever been funded. It

would be a craven admission that we are not strong enough to let all voices be heard."[35] After questions and answers, Frohnmayer, the amateur singer, agreed to offer a song. He chose "Simple Gifts," a Shaker hymn, the same song he had sung to his staff on the day after his dismissal.

A New Acting Chair and New Problems

With Frohnmayer gone, Anne-Imelda Radice was named acting chair. Because it was already an election year, there was no attention given by the administration to nominating a new chair; that could wait until after the voting in November. Originally from Buffalo, Radice had been director of the National Museum of Women in the Arts and had also spent fifteen years working for the federal government: in a congressional office; as assistant curator in the National Gallery's Education Department; as architectural historian and curator for the Architect of the United States Capitol; and as chief of the Creative Arts Division of the U.S. Information Agency. She had come to the NEA as deputy chair in 1991, and many said that she was put there by John Sununu, the conservative White House chief of staff, to watch over John Frohnmayer.

Anne-Imelda Radice led her first National Council meeting on May 1 and 2, 1992. She made this fairly benign initial statement of her view of the Endowment's role:

> We must ensure that the Endowment does its job superbly, because it is an important job—to make the best investment in the best of our artistic resources. These sound investments support those projects which represent the highest quality, promote the widest access of Americans to excellent arts, and contribute most to American and world cultures.[36]

A few days later, she testified on the FY 1993 appropriation to the House Subcommittee on Interior and Related Agencies. When asked by Sidney Yates if excellence should continue to be the primary criterion for NEA grants, she responded, "Excellence is more than technical ability or trendiness or expression of social concerns. There are the concerns of the taxpayer, the concerns of Congress as well. . . . If we find a proposal that does not have the widest audience . . . even though it may have been done very sincerely and with the highest intentions, we just

can't afford to fund that."[37] (Citing lack of audience appeal as a reason for not funding something was a major mistake by Radice; after all, some of the best and most legitimate art has small audiences. And the political system is much less concerned with audience size than with whether something is patently offensive—the kind of thing that politicians cannot or will not stand up for on the floors of Congress.) Despite this gaffe, though, Radice was making it very clear that she was going to take a tough approach and would not equivocate as John Frohnmayer had done.

One week after her House testimony, Ms. Radice struck her first blow. The National Council, in its May 1 and 2 meeting, had approved two $10,000 grants: one to the List Visual Arts Center at MIT for "Corporal Punishment," an exhibit featuring sexual organs as well as other body parts; and the other to the Anderson Gallery at Virginia Commonwealth University for "Anonymity and Identity," which included one small photograph of a penis. Radice vetoed both grants on May 12. Supposedly they violated the standards that she had put forward in her House testimony. The Endowment issued a statement explaining the action: "Grant applications are evaluated on the basis of artistic excellence and artistic merit. The List Visual Arts Center and the Anderson Gallery applications, in the opinion of the Acting Chairman, did not measure up to these criteria and, therefore, are unlikely to have the long-term artistic significance necessary to merit Endowment funding."[38]

Reaction to the veto was immediate and intense. The arts community was again up in arms. Beacon Press in Boston announced that it was withdrawing a $39,000 NEA grant request; Murray DePillars, dean of Virginia Commonwealth's School of the Arts, resigned from an NEA panel; several other panels suspended deliberations in protest. Playwright Jon Robin Baitz, who had just gotten a $15,000 Endowment fellowship, gave $7,500 of his own money to each of the two spurned galleries; and the rock group Aerosmith gave $10,000 to the List Center to replace its grant, with rocker Steve Tyler saying, "If someone had closed the doors to the barns, the bars and the frat houses that we played in during the '70s, we would never have had a chance to get our music to people's ears. That's happening to the arts community."[39]

Controversy continued. On June 21, the Brooklyn Museum and the Franklin Furnace collaborated in presenting "Too Shocking to Show," with performances by Scarlet O and Sapphire, and Holly Hughes and Tim Miller of the NEA Four. The poster for the show pointed out that

"Franklin Furnace would also like to thank the Art Dealers Association of America for its support during the current funding crisis. Please note that some of the material in these performances is sexually explicit and may not be suitable for all audiences."[40] Then, on July 1, the National Council met again and Radice approved all 1,167 grants recommended to her, including $15,000 to the Highways Gallery (a grantee that the Council had rejected earlier that year). In November, Radice rejected three grants totaling $17,500 to three gay-lesbian film festivals, saying that the applications did not "demonstrate artistic excellence and artistic merit worthy of support by this agency."[41]

Anne-Imelda Radice's tenure as acting chair lasted less than a year; George Bush's defeat by Bill Clinton meant that she was out. (Like previous presidents, Clinton appeared to be in no hurry to appoint a new chair; when Radice left, the acting chair position went to Ana Steele, the only employee of the Endowment who had been there since the beginning.) The issues continued to swirl.

Continuing Obsession

The NEA issue continued to obsess the Congress. The FY 1992 appropriations legislation went through the two houses in the fall of 1991 with the same vicious battling that had characterized 1989 and 1990. And Jesse Helms found new success. He introduced an amendment to the appropriations bill that would prohibit the Endowment from using funds "to promote, disseminate or produce materials that depict or describe, in a patently offensive way, sexual or excretory activities or organs."[42] The Senate passed this amendment, 68 to 28, on September 19, and the House agreed to it, 286 to 135, on October 16. It was a startling achievement for Helms, and in dramatic contrast to the fate of his amendment in 1989:

		For Helms	Against Helms
September 13, 1989	House	53	264
September 28, 1989	Senate	35	62
September 19, 1991	Senate	68	28
October 16, 1991	House	286	135

Nearly thirty months of haggling had brought most members of Congress to the point where they were simply disgusted, and willing to punish the NEA.

One of the most surprising supporters of the Helms measure was Joseph Kennedy, Robert's son and a Massachusetts Congressman. The *Boston Phoenix* explained:

> Kennedy, usually a strong supporter of public funding for the arts and an opponent of censorship, said in a statement: "I don't think there should be any restrictions on NEA funding. . . . However, the right wing wants to kill the NEA, because it's funded a few projects that would be considered obscene. If we don't at least exclude funding for obscenity as it's been defined by law for two decades, then we jeopardize all federal funding of the arts."

Kennedy's rationale, like his vote, raised some local eyebrows.[43]

Then, the day after the House voted to accept the Helms amendment, Congressional negotiators from both houses voted to reject it! The negotiators' action came to be known as "corn for porn." Western legislators had long been fighting efforts to raise the fees that ranchers paid to graze their cattle and sheep on federal lands. Raising the fees would bring $150 million into the federal treasury, and $150 million was the amount of money that NEA had to award to the arts each year. The Westerners and the pro-arts Easterners got together and forged an agreement: preserve the NEA without Helms's restrictions and postpone higher grazing fees; hence the humorous description "corn for porn." It passed both houses. So in the end, Helms's new amendment was eliminated, again; but the fact of those 68 to 28 and 286 to 135 approvals, by the two houses of Congress, sat indelibly in the *Congressional Record*, haunting both the legislature and the arts community.

Meanwhile, Philip Crane (R-IL) made his annual appeal to wipe out the Endowment completely. Although an enemy of the arts, Crane was awesomely correct in his analysis of the *structure* of arts support in America: "Contrary to popular belief, the NEA is not the cornerstone of American art. That honor rightly belongs to the private sector. Last year alone, American individuals, foundations and bequests spent over $7.5 billion on arts sponsorship. . . . Congress's appropriation of $178.2 million represents only 2 percent of total funding."[44]

Through the crisis, NEA appropriations had grown, if only to account for inflation: from $169,090,000 in FY 1989 to $174,083,000 in

FY 1991, though program funds had stayed constant at around $124 million. There had been no major growth since Nancy Hanks's time; financially, the NEA had stagnated. Rounded off, of the FY 1991 appropriation, $21,600,000 was set aside for administration, leaving $152,500,000 for granting, which the NEA divided up as follows:

	FY 1991 Funds
Total Appropriation	$174,100,000
Administration	-21,600,000
Grantable Funds	$152,500,000
Grants: Arts Administration Fellows, Education, International, Local Arts Agencies, Research, Special Constituencies, State Arts Agencies, Underserved Communities	-47,450,000
Available for Institutions and Individuals	$105,050,000
Grants to Individuals	-8,350,000
Available for Institutions	$96,700,000

The gainers in FY 1991 were the states, who enjoyed a rise in NEA funding, while the losers were art institutions, who lost more than $11 million from their (precrisis) FY 1988 level of funding of $107,972,000.

A New Administration Does Not Deliver

The 1992 presidential election brought sharp differences between the two major parties in their platform stands on the arts:

> REPUBLICAN: We . . . condemn the use of public funds to subsidize obscenity and blasphemy masquerading as art. . . . No artist has an inherent right to claim taxpayer support for his or her private vision of art if that vision mocks the moral and spiritual basis on which our society is founded.
> DEMOCRATIC: We believe in public support of the arts . . . that is free from political manipulation and firmly rooted in the First Amendment's freedom of expression guarantees.[45]

The Republicans were with the conservatives and the religious right, and the Democrats were with the liberals and with artists. The arts community loved being part of Dan Quayle's "Cultural Elite,"* and they supported Bill Clinton, who said, "While I believe that publicly funded projects should strive to reflect the values that most Americans share, I strongly support and will defend freedom of speech and artistic expression."[46] (Cleverly, Clinton seemed to favor the liberal viewpoint, but he was careful not to endorse the NEA specifically.) There was rejoicing throughout the arts community on November 3 when Clinton won. An article in *The New York Times* later that month suggested that the new president might revive the Federal Council on the Arts and Humanities, which "Joan of Art" (Joan Mondale) had used in the late 1970s to promote the arts, and that "Mr. Clinton's arts policy would focus on arts education and making the arts more generally available to the population, a stand likely to rekindle the populism-versus-elitism debate that hounded the cultural leaders of the Carter Administration."[47]

Early in his term, Clinton proposed that donors of works of art should be able to deduct the full value of their gifts (rather than only the purchase price)—a key advantage long sought by museums and so a major boon for the arts. Yet weeks later, he was proposing to slash nonprofit postal subsidies, making it much more expensive for arts groups (and all nonprofits) to do mailings. Meanwhile, the Justice Department seemed to be seeking to restore the NEA's censorship determination function when it appealed Judge A. Wallace Tashima's June 1992 overruling of the 1990 "general standards of decency" provision (Wallace's decision found in favor of the NEA Four, who were later awarded a total settlement of $252,000: $26,000 in restored original grants, $24,000 in compensatory damages, and $202,000 in litigation costs). Most shockingly, in early 1993 Clinton's director of the Office of Management and Budget, Leon Panetta, was suggesting that the Endowment might be "defunded" (canceled) as a way to trim the federal budget! It was amazing: twelve years after Republican David Stockman had proposed halving the Endowment for Reagan, Democrat Leon

* Taking a cue from Spiro Agnew, Dan Quayle got campaign mileage by attacking what he called "The Cultural Elite," those members of the creative community who were supposedly out of touch with mainstream values. However, Quayle did not select a work of art as the brunt of his attack; he focused instead on a popular TV program, *Murphy Brown*, purportedly because it encouraged unwed mothers to raise their children outside the traditional family structure. He might have done better by attacking a radical artist, because *Murphy Brown* fans quickly rallied to the show's defense. The media, too, scorned Quayle for his attack.

Panetta was proposing eliminating it for Clinton. (This proposal did not last; OMB eventually presented a FY 1994 NEA budget close to the year before.) With actions like these, it was as if no one had learned anything. These contradictory and yo-yo actions suggested that there was no overall policy. The lack of any deep or permanent public policy meant that the arts would probably continue to be victims of politics.

The Endowment itself sought to put a positive cast on the changes forced on it during the crisis. The "Year in Review" introduction in the FY 1991 Annual Report said:

> Changes were made in both programs and procedures. . . . Programmatic changes included a new formula, mandated by Congress, increasing by 50 percent the amount of funds allocated by the Endowment to state and regional arts agencies. . . . New grant categories also extended support to under-served rural and inner-city areas. Special emphasis was placed on expanding arts education activities. . . . Among the significant procedural changes, the rules governing potential conflicts of interest of panelists were tightened. Review panels were enlarged to promote their diversity. Panel membership turned over more frequently. Taken as a whole, the procedural reforms made the agency more accountable, responsive and inclusive. Reinvigorated by these changes, the Endowment renewed its efforts to expand arts opportunities for all Americans and to foster support for artistic excellence.[48]

But the crisis was still not over. The year 1993 would bring a need to reauthorize yet again. Early in that year, Donald Wildmon and the American Family Association were spending hundreds of thousands of dollars to take full-page ads in major newspapers that read:

> We Are Outraged! And We're Not Going To Put Up With It Any Longer! We're a group of mothers, fathers, grandparents and other citizens who are outraged at how today's movies, TV programs, music-videos and records are hurting our children, our families and our country. . . . The REASON for all the sex, violence, filth and profanity is with the writers, directors, producers, singers, actors, etc. But THEY can be controlled. All it takes is for the Boards of Directors of their companies to order them to stop! . . . Right now mail the petition on the right. Please enclose a tax-deductible contribution to help pay for another ad like this.[49]

Meanwhile, Representative Philip Crane (R-IL) was offering still another bill to amend the National Foundation on the Arts and Humanities Act of 1965 by abolishing the NEA. Crane's effort was generally scorned; but in July 1993, Cliff Stearns's (R-FL) bill to cut the agency's budget by 5 percent, or $8.7 million, passed the House by a vote of 240 to 184. Congress was ganging up against the NEA.

Changes in Advocacy

Advocacy was a primary casualty of the crisis. As William H. Henry III wrote in *Time* magazine after the Frohnmayer firing, "Artists and administrators who benefit from the NEA's money and imprimatur concede they have blown the political debate."[50] If there had been a massive outpouring of public support in 1989, then the religious right would probably have been unable to wage the attack that became the crisis.

In the 1970s, there was really only one advocate for the arts: Nancy Hanks. She did a brilliant job in enlisting Congressional support and in establishing a nationwide constituency, but her effort was very personal and not part of a movement. In the mid-1970s, there were a couple of structured efforts: the National Committee on Cultural Resources, and Advocates for the Arts within the American Council for the Arts. Then, in 1976 in Santa Fe, the American Arts Alliance was born: a project of the leading service organizations to bind together their major institutions into a lobbying force in Washington. (Nancy Hanks was a major force behind its creation.) Over time, AAA enlisted several hundred institutions (who paid Alliance costs with dues based on budget size). The Alliance became the primary voice of the nonprofit arts community in the nation's capital.

The problem with the American Arts Alliance was that it was not really inclusive. It represented the major *institutions* through their service organizations: American Association of Museums, American Symphony Orchestra League, Dance USA, OPERA America, and Theatre Communications Group. It did not represent state and local arts councils; this lack led other organizations (American Council for the Arts, National Assembly of Local Arts Agencies, National Assembly of State Arts Agencies) to create another group, the National Arts Coalition, to advocate on their side of the arts aisle. So, by the mid-1980s, America had splintered arts advocacy.

Neither the Alliance nor the Coalition reached and involved two important groups: individual artists (more than 1.6 million by 1990),

and especially the public, the millions of people nationwide who were supporting the arts by attending performances, purchasing works of art, and making gifts to arts organizations each year. In the quantitative universe of the NEA, this public constituency was the number-one achievement of the quarter century between 1965 and 1990; but arts advocacy was not connecting to it.

When the crisis came, the advocacy forces did do better than they had done during the Reagan assault of 1981. By 1990, more positive letters came to Congress in support of the arts than negative ones from the religious right. Still, the effort was not what it could have been. There was not the huge swelling of support that could have prevented or quickly ended the crisis. Theatre Communications Group executive director Peter Zeisler, in an *American Theatre* editorial, noted that "The insane scrambling on the part of the NEA and 'arts supporters' to appease our congressional foes has been an unseemly spectacle. . . . the arts community has not demonstrated a sufficiently large and vocal constituency . . . Squeaky hinges *do* get the oil—and political expediency will triumph as long as Congress assumes that the arts are a less cohesive, less outspoken constituency than the religious Right."[51]

The problem was simple unawareness among Americans. Stanley Katz, president of the American Council of Learned Societies, spoke at an American Council for the Arts forum in 1990, about the public's lack of concern for the problems faced by arts groups: "A poll taken this past fall by the *Los Angeles Times* . . . inquired of close to 3,000 people: 'Generally speaking, are you in favor of the government giving money to promote the arts, or are you opposed to that?' . . . In favor was 40 percent; only 21 percent opposed. But 37 percent—nearly as many as in favor—hadn't heard enough to have an opinion."[52] It is hard to fight for something when more than a third of the people don't know enough to say whether they are for or against.

By the end of the crisis, things seemed to be changing at the American Arts Alliance. Director Anne Murphy was ousted, and Judith Golub replaced her as executive director. Golub appeared to favor a more grassroots approach, saying, "We will be developing grassroots packets that will be sent out to Alliance members. . . . I think we have to tell people that art has something to do with them."[53]

The Alliance also started working (in the Arts Working Group) with the American Association of Museums, American Council for the Arts, NALAA, and NASAA to "educate the Congress and the public about the importance of the National Endowment for the Arts. The Working

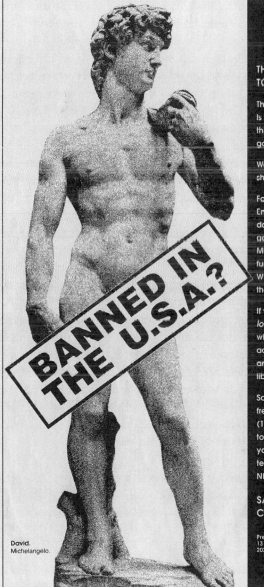

THE EMERGENCY CAMPAIGN
TO SAVE THE ARTS

The National Endowment for the Arts
is under attack from politicians who
think *they* should decide what art is
good for the American people.

We think the American people
should decide that for themselves.

For 25 years, the National
Endowment has made theater and
dance, music and art, come alive
across America. A play called Driving
Miss Daisy got its start from NEA
funding. So did Garrison Keillor. And
Wynton Marsalis. And Alvin Ailey. And
the Vietnam War Memorial.

If we let politicians control what we
look at today, they'll want to control
what we *read* tomorrow. The day we
accept censorship of our museums
and stages is the day we put our
libraries and classrooms at risk.

So if you care about the arts and
free expression, call 1-900-226-ARTS
(1-900-226-2787) and for $4.50, billed
to your phone, we'll send messages to
your Senators and Representative
telling them you support funding of the
NEA without censorship.

SAVE THE ARTS!
Call 1-900-226-ARTS

Prepared by: American Arts Alliance
1319 F Street, NW, Suite 307, Washington, DC 20004
202/737-1727

David.
Michelangelo.

BANNED IN
THE U.S.A.?

This ad, prepared by the American Arts Alliance, appeared in magazines and
newspapers as a part of the arts community's efforts to raise public support
for the NEA. *Courtesy of the American Arts Alliance.*

Group started in June 1992 by taking a two-page ad in the Congressional newspaper *Roll Call*, listing 4,300 1991 NEA grants and saying 'To the members of the United States Congress: thank you for investing in my community through the National Endowment for the Arts.'[54]

Of even greater potential was the new National Cultural Alliance, established by nine arts and humanities organizations* (including all five involved in the Arts Working Group) to create a strong American commitment to the arts and humanities. The NCA fast became a coalition of forty-two national arts and humanities organizations representing over 23,000 cultural institutions in the United States. It announced a $25 million, five-year media campaign to reach the public and gain its support: "This campaign will . . . increase general awareness and understanding of the value of the arts and humanities. . . . If NCA is successful, the rewards are substantial: a responsive national network of committed citizens and institutions; an enriched understanding of the role of arts and humanities in society; and increased financial support from the public and private sectors."[55]

In October 1992, the NCA sponsored a phone survey of 1059 Americans. The survey found that 81 percent of the people consider the arts and humanities "essential to a healthy American society"; that 81 percent believe that they "contribute to the economic health and well-being of society"; that 90 percent believe that they "help people learn about those of different cultural and economic groups"; that 91 percent think that they "represent freedom of expression"; and that more than 50 percent of the people had participated in the arts as audience in the week before they were interviewed.[56] The survey also found that 41 percent had made a contribution to the arts or humanities in the past year.** Clearly, the NCA was working to build a case.

* American Arts Alliance, American Association of Museums, American Council for the Arts, American Council of Learned Societies, Association of American Cultures, Federation of State Humanities Councils, National Assembly of Local Arts Agencies, National Assembly of State Arts Agencies, and National Humanities Alliance.

** NCA's findings may serve political and public relations purposes, but they are not the truth. Eighty to ninety percent of Americans do not favor the arts; it must have been virtually impossible to say "no" to the survey's questions. And the 41 percent who gave must be confused with those who attended. A 1992 Survey of Public Participation in the Arts (SPPA) by the Census Bureau found that 41 percent of Americans attended at least one of seven arts activities in the course of a year (jazz, classical music, opera, musicals, plays, ballet, art museums).[57] The National Cultural Alliance is asking us to believe that as many people *give* to the arts as *go*!

By mounting a massive campaign in newspapers and on radi
television, the NCA would be using for good a force that had been
destructive and harmful during the crisis. The NCA campaign would be
the first time that advocacy reached the people—the audience—and so
it could and probably would make a big difference.

At the end of 1992, the future of arts advocacy looked better than
its past.

The New and Negative Mood

For those willing to believe and trust Louis Harris's surveys, in 1992 60
percent of American adults thought that the federal government should
support the arts; 52 percent believed that the government should fund
individual artists; and 75 percent were against government dictating
what artists do. Harris himself looked on these figures as very positive,
and so did most people in the arts. The mood, though, in the three years
after the 1990 reauthorization, was disquieting; there was what *Variety*
critic David Kissinger called "a poisoned atmosphere, replete with un-
certainty and fear."[58] The Endowment itself may have been permanently
compromised and weakened; as Livingston Biddle says, "Unless it is
resuscitated, revitalized, given a new sense of its mission to support
excellence in the arts, it will be dormant and damaged."[59] And former
acting chair Hugh Southern points out that "The Endowment has been
done serious permanent damage: by the new formula with the states and
the devotion of funds to arts education. What that does is to take away
the case that can be made for the Endowment by its strongest constitu-
ency, which is people in the field. . . . At the program level, we have seen
a political and moral disaster of very great proportions."[60]

Throughout the country, too, among arts institutions, the mood was
depressed; the NEA crisis, combined with recession, succession (finding
new leaders), falloffs in funding and in audiences, inner-city angst, and
demographic shifts brought a new gloom. The funding and financial
situation was dire. State government funding of the arts in 1992 was
down more than 25 percent from its $292 million high in 1990, to $214
million; most believed that this drop was due to fears and suspicions
born of the NEA crisis. James Abruzzo of the A. T. Kearney Company
conducted a survey of 109 directors of the largest art museums in 1991
and found that the recession was having a major negative impact on the
operations of four-fifths of their institutions. Consultant Thomas Wolf,
in 1992, studied 254 of the nation's largest orchestras for the American

Symphony Orchestra League, and found that the combined 1991 deficit was $23.2 million (more than eight times what it had been in 1971), and that the combined deficit would reach $64.1 million in the year 2000. Wolf told the orchestras that the problem was much more than financial, that it related to what they were doing and for whom. "We are overproducing a certain kind of product," he said, "and we must ask ourselves whether we are reaching out effectively to the huge potential audience outside the downtown core."[61]

Theatre Communications Group released its latest annual survey of nonprofit professional theaters, showing a $6.5 million combined deficit for 182 theaters for 1991–1992, more than doubled from 1990–1991's $2.8 million. The TCG study showed federal support dropping almost 8 percent, and state support dropping nearly 14 percent. In its April 1993 "Theatre Facts" report, TCG said: "The erosion of public sector funding in the form of crippling cuts in state and federal government grants, along with a first-time drop in corporate giving, seriously affected the theatres' contributed income outlook. . . . Many theatres were forced to respond . . . by freezing or cutting salaries, furloughing or shrinking full-time staffs, or reducing artistic resources, raising concern over the field's artistic and institutional growth."[62] The National Endowment itself, noting these financial and other factors, said that "The combined weight of these old and new problems is taking its toll in the quality and extent of artistic programming and sometimes in the very survival of arts organizations."[63]

Over three years, 1991 to 1993, there was shocking collapse of scores of arts institutions, which simply threw in the towel and filed for bankruptcy.* Almost every day, the major papers were telling the story of an arts organization closing its doors. As former chief executive of the American Stock Exchange (and new chairman of the Securities and Exchange Commission) Arthur Levitt said, "If events continue to develop as they have in recent years . . . I believe that nearly 40 percent of this country's cultural institutions will not be around at the end of this century."[65]

* Despite collapse, however, the number of organizations kept swelling. The *Chronicle of Philanthrophy* reported in November 5, 1991 that the number of arts, culture, and humanities organizations had grown 16 percent from 1987 to 1990, from 36,102 to 41,878.[64] It is probably likely that at the end of 1993, there were between 43,000 and 44,000 (more than half of which are involved in the NCA).

In the three years after the 1990 reauthorization, people in the arts seemed to have lost their capacity to believe in themselves; and the arts looked like an old and tired industry. Philip Morris, the director of a local arts council in Jamestown, New York, reflected the general mood of disaffection in the arts community when he said, "The problem is that we in the arts have lost our will."[66]

Within days of each other in late February 1992, a television show and a newspaper article underscored the grim mood within the NEA, the arts community, and the nation. On the *This Week with David Brinkley* program of February 23, 1992, this exchange among Brinkley, Sam Donaldson, George Will, and Cokie Roberts showed resolved disgust:

> MR. BRINKLEY: Does anyone feel he's always able to say what is art and what is not? Anyone here willing to make that claim?
>
> MR. DONALDSON: No, no and that's why I don't want the government trying to say what is art and not art, but if it's taxpayer money, I think controls are inevitable.
>
> MR. BRINKLEY: So do we need a National Endowment at all? George?
>
> MR WILL: No.
>
> MR. BRINKLEY: Sam?
>
> MR. DONALDSON: Not with government funding.
>
> MR. BRINKLEY: Cokie?
>
> MS. ROBERTS: Well, I—it is true that we give fewer government dollars to the arts than any other country, but I suppose we don't much need to give any.
>
> MR. BRINKLEY: Well, we survived a long time without it and we may wind up doing so again.[67]

A grim reappraisal of the NEA and its mission was written for the *Washington Post* by Leonard Garment, arts advisor to Richard Nixon and cochair of the Independent Commission; it appeared four days after John Frohnmayer was fired. Garment traced the history of the National Endowment and earlier conflicts, and he ended by expressing a very sobering doubt. Writing about "the immense difficulty of funding private art with public money in a populist culture," he suggested that perhaps government should avoid funding controversial works:

Can the president, Congress and the arts community finally cut through all this baloney and febrile foolishness and redeem the original idea of the arts endowment? I am coming to doubt it. . . . If the Endowment is to survive, we will have to start making legislative distinctions between the preservation and dissemination of time-tested art treasures . . . and contemporary art still in the aesthetic laboratory, which will have to be supported by private foundations and patrons. If private aesthetic tastes run to fecal symbolism, public urination and the politics of contempt, so be it, but not with public funds. And if some arts leaders continue to show disdain for the hard, disciplined, compromise-filled work of sustaining a political consensus for the arts, and continue to act as if shouting "First Amendment!" at every opponent were a persuasive or powerful argument, the federal arts experiment will fade and fall. It will be a sad ending after a happy start, and a loss to the country.[68]

The official reaction to Garment's article was that it appalled the arts community, entitlement devotees, and First Amendment partisans. But he remembers: "I had lots of calls and letters from people who agreed with me. There were also people who criticized the article publicly, but who called me privately and said, 'You're absolutely dead-on right.' "[69]

Eighteen months after cochairing the Independent Commission and so helping to put together a reauthorization, Leonard Garment had come to a very different conclusion: that the NEA could not be sustained as it had operated, and would have to change how it funded the arts. Garment called his piece "The Feds and the Arts: Where It Went Wrong."

NINE

Avant-Garde Blackmail

The Individual Artist's Right to Federal Funding

WITH THE STORY of the NEA crisis told, the remainder of my book will deal with what the story means, and its deeper significance for American life.

The crisis raises four major questions:

1. Is denial of government funding censorship, and is refusal to fund a project a violation of the First Amendment?

2. Should the Endowment fund individuals?

3. Should the Endowment primarily serve the arts, or the people?

4. Is the NEA worth the bother?

I will answer the first three questions in this chapter, and the final one in the last chapter.

151

Is Denial of Government Funding Censorship, and Is Refusal to Fund a Project a Violation of the First Amendment?

By the time of the NEA reauthorization in the fall of 1990, the crisis had become more about protecting First Amendment rights than it was about funding the arts. Artists were saying that their inalienable right to be heard, and to be *funded* to be heard, was being violated; and they blamed the NEA (and its chair, John Frohnmayer) for this violation. Karen Finley summed up this attitude in her statement, "A year ago I was in a country of free expression; now I am not."[1] The media also played up First Amendment issues, because freedom of the press is an integral part of these rights. Therefore, the press is often a partisan for others facing threats to their free-speech rights.

Artists felt that denial of government funding would lead to a denial of private sector support as well; and they were right, because many foundations and corporations tend to follow the NEA lead in grant making. As noted by the late New York Public Library president Timothy Healy, "To deprive an artist of access to . . . subsidy because of the content of his work may well cut him off from all other sources as well. In the real marketplace of art and ideas, private and especially corporate philanthropy tend to follow the federal lead. A rich artist may escape this kind of censorship. A poor one surely won't."[2] The artist who is denied government money is isolated and may be doomed to very little other support.

Of course, it is true that some artists (like Karen Finley) end up not really suffering from the denial of government funding; sometimes the denial makes them celebrities, and they are enriched by their notoriety. In 1993, Finley was named a Guggenheim fellow; in 1990, Richard Bernstein pointed out that "Ms. Finley . . . present[ed] two virtually sold-out shows at Lincoln Center's Serious Fun Festival . . . so she has hardly been silenced."[3] It is also true that there are thousands of artists in America who succeed at their art without a penny of government subsidy; others who are supported by the private sector (especially foundations like Guggenheim, MacArthur, Rockefeller, and Pew); and still others who thrive in the commercial arena. As with total arts funding (of which the NEA provides no more than 3 percent), the total support for individual artists is much larger than simply what the Endowment provides. So the question remains: Is the federal govern-

ment obligated to support individual artists, and especially those whose work might offend taxpayers?

I think that the issue comes down to *entitlement*, that force in modern America that now rules much of our national system and psyche (and half of our federal budget). By the end of the 1980s, many in the arts community—especially individual artists—had come to believe that they were entitled to federal funding: "You, the United States, should be paying for me to create, because I'm here and I'm creating. As an artist, I'm an important member of the society—and so the society should be supporting me."

The NEA, in its first twenty-five years, had perhaps unwittingly fostered and promoted this sense of entitlement. With its quantitative measures and its obsession with growth, the NEA, like other government agencies, had implied to its constituents that they were entitled to federal support. Ronald Berman, a former chair of the NEH, describes how the NEA has come to be viewed in the arts community and in Congress "as a reliable conduit of funds to arts bureaucracies, as a provider of benefits to the maximum number of applicants, and as a visible dispenser of federal funds to all congressional districts."[1]

The tricky thing about entitlement is that it must apply to everyone. If A is entitled to a grant, then so are B through Z. If Karen Finley in New York is entitled, then so is every individual artist throughout the country. If the American Repertory Theatre in Cambridge, Massachusetts, and the Spoleto Festival in Charleston, South Carolina, are entitled to grants, then so are all nonprofit arts institutions everywhere, no matter what they are doing. Entitlement is by definition all-inclusive and for everybody. With entitlement, there can be no discretion, no choosing of some or denying of any. Entitlement is the opposite of grant-making.

In a major article in *The New York Times* in the summer of 1990 ("The Endowment: A Reflective Defense of It and A Show That Tweaks It," August 14), Richard Bernstein discussed the entitlement and free-speech issues with Jacob Epstein, an English professor at Northwestern University, editor of *The American Scholar*, and member of the National Council on the Arts (one of several conservative intellectuals on that body, along with Jacob Neusner and Samuel Lipman). Epstein commented to Bernstein:

"The unfortunate thing about the current flap is that it has forced [us] . . . to operate inside an enemy psychology. . . . There is, for

example, what's called the artistic community. They look at Congressmen and they see the red eyes of repression. They see them in the robes of the Inquisition, flames all around.

"When Congressmen look at the so-called arts community, they see nothing but the most decadent homosexuality, immorality, indolence and incompetence. In the middle of this, somehow all the big questions are lost."

What are those questions? Among those posed to Mr. Epstein were these: How can the arts best be supported? Is it possible to decline to subsidize certain controversial forms and performers without imposing a restrictive sort of officially approved art?

"The N.E.A. is subject to a kind of avant-garde blackmail. . . . [I]f you don't give a grant because you think somebody is pressing a political point of view, then you're stopping them, and very quickly the word McCarthyism comes up, slippery slope and the other cliches of political repression.

"It would be wonderful if the endowment had the flexibility to strengthen those things that are already strong and going well, to keep up its critical guard against those things that are shabby, and not to be blackmailed by the merely innovative and the self-contained avant-garde."[5]

Arts advocates have admitted that denying funding is not repression, but that the economics of life on the fringe make denial *like* censorship.[6] In other words, the American *marketplace* makes saying "no" the same as saying "you may not."

However, I think that there is a vast difference between denial of funding and censorship. I am totally against censorship. It is completely right that the Contemporary Art Center in Cincinnati was found not guilty of obscenity when it displayed Mapplethorpe's photos, and that 2 Live Crew and Judas Priest were allowed to record and perform their songs. Andres Serrano had every right to create *Piss Christ*, and Robert Mapplethorpe had every right to create the photographs gathered in "The Perfect Moment" exhibit. I do not believe that the Corcoran should have canceled his show; but I know that it had as much right to cancel it as the government had to deny support to it. (Neither the Corcoran nor the NEA tried to stop the Washington Project for the Arts from mounting the Mapplethorpe show—nor should they have.) My point is that anything and everything should be *allowed*; nothing should be prohibited. But *allowing* something is very different from

subsidizing it. Allowing is a passive act; subsidizing is active. When a government pays for something that will probably offend many people (who provide that government's funding through taxes), then the government is going against the wishes of the governed; it is upsetting the essential balance.

In a world ruled by entitlement, the denial of a grant is going to be seen by the rejected grantee as censorship or a violation of First Amendment rights. But it is not that; the denial is simply a refusal to pay for something that the funder—the government—believes is inappropriate.

"He who pays the piper calls the tune." Karen Finley, Holly Hughes, John Fleck, and Tim Miller may not like it, but that is the way our arts-funding system has been built, and that is the way it is going to stay. I think that it should stay that way: the giver, not the getter, should be in charge of who gets the gift.

Should the Endowment Fund Individuals?

The NEA crisis centered on individual artists. While Mapplethorpe's work was mounted by the University of Pennsylvania's Institute for Contemporary Art, and Serrano's by the Southeastern Center for Contemporary Art (and while NEA's grants went not to the two men but to those two institutions), the attacks were not focussed on Penn or SECCA. They were attacks on the two artists and others like them whose works offended the religious right and many others. Jesse Helms was against funding the work of Mapplethorpe and Serrano, not really the institutions that exhibited them. (And in fact, both Mapplethorpe and Serrano had been funded directly by the NEA before: Mapplethorpe with a $15,000 fellowship in FY 1984, and Serrano with $5,000 in FY 1986.) As the crisis went on, and especially with the NEA Four (who were funded as individuals), the issues started to revolve increasingly around individual artists.

Institutions have always been the NEA's primary constituency. Created by the "cultural explosion" of the 1960s, the Endowment put most of its money into the major institutions of large cities: the symphony orchestras, opera companies, dance companies, theaters, and, later, museums that bring civic pride to communities. In fact, the Endowment itself led to a massive "institutionalizing" of the arts in America, a formalization of the institutional structure of arts organizations. And the primary quantitative achievement of the NEA in its first quarter-

century was the vast growth in the number of professional arts institutions in the United States, and in their audiences.

Still, while institutions were the Endowment's primary constituency, individuals over the years were becoming an ever-larger group. In 1970, there were 736,960 creative artists in America; by 1980, that number had grown to 1,085,693 (or 1.04 percent of the labor force). By 1984, the number of people identifying themselves as artists had swelled to 1,351,000, and by 1990 to 1,600,000. Many of these people were not professional (they were not supporting themselves from their artistic earnings); Joan Jeffri, of the Research Center for Arts and Culture at Columbia University, conducted a survey of creative artists in the late 1980s and found that more than half of them earned $2,000 or less from their art per year (only 32 percent earned more than $6,000, and only 12 percent more than $20,000).[7]

From its beginnings, the NEA recognized the importance of individual artists to the culture and its responsibility to support them. The original legislation said, "While no government can call a great artist or scholar into existence, it is necessary and appropriate for the Federal Government to help create and sustain not only a climate encouraging freedom of thought, imagination, and inquiry but also the material conditions facilitating the release of this creative talent."[8] The 1965 bill also stipulated that the NEA should provide "grants-in-aid to . . . individuals,"* though it left how to do this up to the chair and the National Council on the Arts.

In the first seven years of the NEA (FY 1966–1972), creative artists received almost 15 percent of all funds granted ($8,967,017 of $61,375,000). Roger Stevens had a passion for the individual creator. But when the time came to reauthorize, in 1968, Republican Congressman William Steiger introduced an amendment prohibiting the Endowment from making grants to individuals. While Steiger's amendment did not survive in the final reauthorization bill, it did pass the House. There was also tension in the late 1960s between new chair Nancy Hanks and the National Council: Hanks favored funding institutions, while the Council wanted more to go to individuals. They compromised, with the Council promising to support groups if Hanks would agree to fund individuals.[9] Forced to compromise, Hanks

* During the reauthorization controversy of 1968, which centered on funding of individuals, the phrase "of exceptional talent" was added after "individuals," in Public Law 90-348 (June 18, 1968).

changed her position and became a partisan of funding individuals. Still, despite her official partisanship, Nancy Hanks's basic affinity for the institution led to a downplaying of support for creative artists through her years as chair. By 1975, the original nearly 15 percent for individuals under Roger Stevens was down to about 5 percent ($3,172,698 of $65,195,600 in discipline program funds). Charles Mark in his *Arts Reporting Service* in 1973 noted that "Aid to the individual creative artist is definitely declining while more money is being granted to the larger establishment arts institutions. . . . The decline in the support of the individual artist in combination with the increased support for major institutions is the clear trend."[10]

Then, after Hanks left, support for the individual creator started to move back up. By 1988, 18 percent of all grants (804 of 4,464) were going to individuals. The percentage of all money in all discipline programs (not counting Challenge or Advancement) that went to individuals almost doubled in fifteen years (1975–1990), though it never again got to Roger Stevens's almost 15 percent:

	Discipline Program Funds	Funding of Individuals	Individual %
1975	$57,789,542	$3,172,898	5.5%
1981	104,079,035	8,909,206	8.6%
1984	85,573,110	7,437,555	8.7%
1988	88,004,785	8,585,329	9.8%
1990	88,189,167	9,435,962	10.7%

Throughout the 1980s, as the Endowment began behaving increasingly like a private foundation, the percentage of support to the individual creator crept up, peaking in FY 1990 (during the crisis). By the early 1990s, there were twenty-three grant categories that provided fellowships or grants to individuals, eight that supported commissions or project grants to artists from organizations, ten supporting artist residencies, and nineteen that reached individuals indirectly via organizations awarding subgrants (the type of grant that got the NEA into trouble with Andres Serrano). Most of this support was in the form of fellowships: grants between $5,000 and $25,000 awarded to actors, administrators, choreographers, dancers, filmmakers, folk artists, museum professionals, musicians, performance artists, playwrights, poets,

video artists, visual artists, and writers. In FY 1991, these artists shared about $8.35 million in federal funds. As former acting chair Hugh Southern says, "The staff always thought that the whole point of making a grant to a young artist, or even to an established artist, was to enable them to experiment with something new, to develop a career. . . . These were fields where the individuals in them were not earning large sums of money; and the relatively small sums afforded by these fellowships were therefore of extraordinary value."[11]

By far the biggest part of individual support at NEA has been in Literature and Visual Arts. In Music, Dance, Theatre, and Museums, the prime constituents have been the major establishment institutions (for instance, New York Philharmonic, San Francisco Ballet, Guthrie Theater, Boston Museum); but in Literature and Visual Arts, which are solitary art forms, the prime constituents have been individuals. These are the differences in FY 1990:

	Program Funds	Grants to Individuals	Individual Percentage
Dance	$8,964,738	$846,000	9.4%
Design Arts	4,240,000	479,971	11.3%
Expansion Arts	6,648,100	-0-	0.0%
Folk Arts	3,429,100	65,000	1.9%
Inter-Arts	4,232,904	-0-	0.0%
Literature	5,007,256	2,489,520	49.7%
Media Arts	11,785,780	1,005,780	8.5%
Museums	11,268,891	110,791	1.0%
Music	12,092,000	875,000	7.2%
Opera-Musical Theater	4,017,915	135,000	3.4%
Theater	10,602,788	504,000	4.8%
Visual Arts	5,899,695	2,925,000	49.6%

Nearly half of all money in 1990 went to individuals in the Literature and Visual Arts categories. While people think that this has always been true, and while it was true in Roger Stevens's years, the fact is that funding of individuals shrank under Hanks and then started building up again steadily in the 1980s:

	Literature Individual Grant Percentage	Visual Arts Individual Grant Percentage
1975	17%	38%
1981	33%	38%
1984	37%	42%
1986	46%	42%
1988	45%	47%

A major factor in granting to individuals (as in all granting) has been the advisory panels: artists and other arts professionals who gather several times each year to choose the applications to fund. Technically, all grant decisions are the National Council's and especially the chair's; but they depend very much on the panels for guidance on artistic value (and have only rarely overruled panel recommendations). All decisions really begin with the panels, and their "peer review" is the way the Endowment funds the arts.

Panels have always been a very important part of the Endowment operation. For one thing, the agency has often chosen new program directors from among the program's panelists. Panelists are on the "inside" of the Endowment, part of the granting process; and so there has always been the assumption that they have an "inside track" to grants themselves. In the early days, the identity of panelists was kept secret; but protests from unsuccessful applicants forced a new policy of revealing panelists's identities. The Endowment was always very careful to make sure that a panelist whose organization was up for a grant left the room while that grant was discussed; but everyone remaining knew who he or she was, the group that he or she represented, and maybe even what he or she wanted. So, the panel system has been both peer review and peerage.

Through the years, there have been various tinkerings with the panel system, often depending on the relationship (and relative strengths) of the chair and council. Livingston Biddle, in 1979, asked Deputy Chair Mary Ann Tighe to conduct a complete study of the panel system; she concluded that panel meetings should remain closed to the public (in other words, secret), but that there should be two kinds of panel for each program: a Grant Panel to decide on applications, and a Policy Panel to revise program guidelines and advise on policies. In the 1979 Annual

Report, Tighe described the panel function: "Panels are constructed to generate passionate discussion. . . . We are engaged in a constant and impossible search for that one more voice that will help us see the arts in this country whole."[12]

As already noted, the Reagan Task Force in 1981 simply endorsed the panel system, paying it little heed. The Independent Commission in 1990, though, concentrated on the panels and said that "In recent years, these grant advisory panels have come to dominate the process of grant making. This development does not satisfy expectations about public accountability nor does it reflect the purposes of Congress when it created the agency."[13] The Commission called for changes, and the NEA followed up on these recommendations in FY 1991* :

1. The number of panels increased 33 percent
2. The number of panelists rose in 1991 to almost 1200, many more than 1979's 500
3. A layperson now sits on each panel, changing the exclusively arts professional character of the group
4. 80 percent of panels turn over annually
5. No panelist can serve longer than three years
6. Ethnic/minority membership is set at a minimum of 30 percent**
7. The number of panelists from New York and California has declined
8. No person may even serve on a panel that will consider his or her organization's application

These changes, as part of the new public-service mandate, may make panels very different in the future. But during the 1980s, before the crisis, the panels were the "closed shops" endorsed by the Reagan Task Force. Because NEA panels have always involved the brightest, most *au courant*, and most adventurous people in American arts, they have always taken a special interest in the experimental; respecting and heeding this interest, the Endowment has increasingly funded the experi-

* The third, fifth, and seventh changes were made even before the work of the Independent Commission, during the 1980s.

** In FY 1992, the ethnic/minority percentage was just under 35 percent, compared to just under 25 percent in the American population.

mental. It is individuals who experiment in the arts, and so to support the experimental one must support individuals; because it supported individuals, the NEA suffered the crisis. If there had been no direct or indirect funding of individuals, there probably would not have been a crisis. The ultimate question, then, is: Should the NEA fund individuals? Does it dare to?

According to Louis Harris, the attitude of the American people has changed significantly over the years. There has been nearly a doubling of support for funding individual artists, from 29 percent in 1975 to 52 percent in 1992; in the latter year, 75 percent said that government should not regulate or interfere with the art produced by individuals. Of course, if slightly more than half the people favor federal support of individual artists, then slightly less than half do not!

The first four NEA chairs all looked favorably on funding individual artists; as Nancy Hanks said, "My gosh, what is art if you don't have an individual somewhere?"[14] Frank Hodsoll later recognized the inherent problems in choosing which individuals to fund:

> There are always problems with a national program of recognition of individuals. You get so many applicants, you choose so few. Obviously we need to nurture individuals, but once you get to the national level and have a thousand people applying for something and can only pick fifty, it gets to be an extraordinarily subjective process. Still, it's absolutely worth pursuing. After all, individuals create art, not institutions.[15]

Even Congressional leaders have spoken up on behalf of support of the individual. Pat Williams notes: "Back in 1986 [we] held an oversight hearing in which we asked a number of artists and museum directors whether federal policy . . . encouraged new exploration, discovery, and invention. [They] responded that with the exception of a very few private foundations, the NEA provided virtually the only support in America for such efforts."[16] And Senator Claiborne Pell is an outspoken supporter of funding individuals: "I'd like to see as much money as possible spent on taking chances on individuals as opposed to institutions."[17]

The NEA insists on the absolute and essential importance of funding individuals. In its most recent document, *The Arts in America 1992*, the NEA announced that individual grants now go to about 500 artists per year (5 percent of the 10,000 applications, and down from the

approximately 800 individuals funded in FY 1988), and stated its case in Reaganesque language:

> The Endowment is the single largest investor in the broadest range of artistic creativity in the nation. . . . Indeed, Arts Endowment support for the work of individual artists can be seen as a supply-side investment strategy expanding the capacity to create new artistic resources. . . . Through its efforts to foster artistic excellence, the Arts Endowment has added significantly to our nation's artistic assets and infrastructure.[18]

This is the "official line." I am struck, however, by the number and vehemence of arguments *against* funding individuals. A major spokesman for this point of view is Michael Straight, who notes in his book *Nancy Hanks*: "It was precisely because grants to individuals placed the Endowment in the position of being the predominant patron that the majority of congressmen voted in 1968 to prohibit them. . . . Of course the individual is the center of creativity. But it does not follow that the government must be the individual artist's direct and predominant patron."[19]

Through the years, the argument against funding individuals has been made by various people. In 1982, Jonathan Yardley, then book critic of the *Washington Post*, wrote an article ("The Case Against") for *American Arts* magazine in which he used the stories of artists before the start of the NEA to make his point:

> For approximately a quarter of a century William Faulkner pursued his vision at tremendous sacrifice. His novels did not sell. He spent much of his time in Hollywood doing hack work, earning the money that would enable him to return to Mississippi for a few months and get back to the creation of the world he called Yoknapatawpha. He complained constantly about the lack of money and lack of recognition, but he didn't quit writing those novels. Neither government nor Guggenheim was necessary to the writing of *Light in August*.
>
> Ditto for Charles Ives and his symphonies; while he wrote them, he earned his living as an insurance executive.
>
> For e.e. cummings and his poems; he lived his entire life on the edge. For Edward Hopper and his paintings; he did magazine illustrations to help pay the rent. . . .

To these people art came first, money second. They were willing to make the sacrifice. They were willing to do work they did not want to do in order to earn the money to support their *real* work; they did not ask Uncle Sam to pamper them. By contrast, many people who call themselves writers and artists now feel that they are owed public support for work that . . . may well prove to have no value. They are wrong.[20]

Yardley's point was that major artists can not only survive but may thrive without government support; those he cited lived and worked before the NEA and before entitlement became a factor. Although all four artists were active when the government was supporting the arts through the WPA, none of them were involved with this program (Ives, in fact, was strongly opposed to the WPA on political grounds).*

Another balance-based argument is about Congress's rights on behalf of taxpayers. Senator Alphonse D'Amato, who had ripped up a Serrano catalogue in the Senate chamber on May 18, 1989, spoke four and a half months later at an ArtTable seminar at the Guggenheim Museum in a much more reasonable and civilized manner:

If we are going to continue spending taxpayer dollars on the arts, then we have to be accountable to those taxpayers. . . . Let's take the work of Andres Serrano. I don't know Mr. Serrano, and I certainly don't want to inhibit him in his creative endeavors. Any work that he wants to put forth is his business. But as it relates to taxpayer dollars, it becomes to some degree the taxpayers' business as well. If the majority of those taxpayers find it unacceptable to fund a photograph of a crucifix submerged in the artist's urine, that decision has to be respected.[21]

Even some individual artists agree with the point that public money necessitates that the artist respect the taxpayers who provide that money.

* Perhaps if Faulkner had received government support he wouldn't have had to waste his time in Hollywood writing movie scripts, and could have produced more classic novels. Yardley implies that there is something noble about the suffering of Faulkner, Ives, et al., where there is no evidence that their art was improved by the lack of government support. Further, there may be other Faulkners and Iveses working today who are totally unknown and, like their famous forebears, are not receiving government support. And, even those lucky few who do receive grants are not receiving enormous sums of money.

Performance artist Laurie Anderson made this statement six and a half years before the crisis began:

> If you are alone in your room making art without support, it's one thing. But as soon as you take public money for it, as soon as you cross that border, there is a responsibility to share it in some way. . . . If, for example, a highly pornographic, deeply insulting tape is made in this tax-supported laboratory, a product that will violate ten FCC regulations if publicly shown, it should be screened within the studio rather than released on the public airwaves. . . . Artists . . . have to be very careful. . . . They have to be aware of when they are no longer making art. Artists who utter polemical statements are, at that moment, polemicists, not artists. . . . I'm talking about judgment. If you know the showing of a certain tape is going to drive people crazy, do you know why you want to show it? Is it for good reasons? Are you just trying to find out how far you can go?[22]

Jesse Helms might well agree with this statement by Laurie Anderson!

Among prominent authors, John Updike is a major voice questioning funding of individuals by government, and in fact all government funding of the arts.* Updike feels strongly that the marketplace, and not government, should determine success or failure of an artist's work: "Government money in the arts, I fear, can only deflect artists from their responsibility to find an authentic market for their products, an actual audience for their performance."[23] As an author himself, Updike opposes receiving government support: "I would rather have as my patron a host of anonymous citizens digging into their own pockets for the price of a book or a magazine than a small body of enlightened and responsible men administering public funds."[24]

Updike also addresses questions of entitlement and implied censorship when government money is withheld from individual artists:

> Once you get Government involved in the arts, then withholding money has a kind of punitive effect. So in this manner I can see a certain number of artists being shaped to please our Government, to please Jesse Helms. A kind of insidious Government control could be exerted.[25]

* Though a major writer, Updike has never served on either the National Council on the Arts or on an NEA panel, perhaps because of the ideas expressed here.

The ancient law that he who pays the piper calls the tune has not been repealed even in this permissive democracy, and the cultural entrepreneurs so eager to welcome NEH and NEA money into the arts may not be aware that they have invited a dog—wooly and winsome but not without teeth and an ugly bark—into their manger.[26]

Leonard Garment's story of his 1989 lunch with John Frohnmayer underscores the complexity of the relationship among the NEA, the government that oversees it, and the artists that it funds:

I tried to explain to him . . . "This is a very parlous zeitgeist. . . . It's an Orwellian world . . . The artists are not your allies but your adversaries. They're not your constituents at all. . . . Your constituency is the country. This is federal money that the Endowment is supposed to use for the benefit of the whole of the country. . . . The artists are the third party beneficiaries of an arrangement whereby money is made available for the arts." He seemed to have a profound problem understanding that whatever you can feasibly give them, artists will want more. And many of them—the most outspoken—will demand things you can't give them and still preserve the Endowment as a viable enterprise in a complex and contentious democratic political system.[27]

Garment was trying to explain to Frohnmayer that it's important that the NEA maintain an essential balance between often warring factions.

I agree with those who are against federal funding of individuals, at least in principle. There are four compelling reasons.

1. *Quantity.* Funding of individuals does not fit the quantitative basis of the Endowment. In any year, only about 500 are going to get grants. We have seen that there are 1.6 million American creative artists; but if only 500 are getting NEA grants in a year, then the Endowment is supporting only three one-hundredths of 1 percent of its constituency: a much smaller percentage than of institutions. Also, it is almost impossible to quantify the effects of grants to individuals, and especially difficult to quantify the audience that individual artists reach. What this means is that supporting the individual artist does not fit the Endowment's need to justify what it does in numerical terms.

2. *Scale.* For the federal government to be providing a small number of its private citizens monies that are apt to be their largest single source of income in a year just feels out of kilter to me. There is a strangeness in the scale of the giver-getter relationship: the gigantic federal government as giver, the single private citizen as getter. Is it really the function of a government to be the subsidizer of .00028 percent of its adult citizens? It is true that the federal government does provide monies to individual citizens: for example, through Social Security, a huge entitlement program. But as an entitlement, Social Security is universal: it goes to everyone who gets old (and who has contributed money to the system over many working years); there is no choosing among citizens to favor some and not others. It is the *choosing* of a small number of individuals that makes the scale feel strange and wrong to me.

3. *100% Individual Funding.* In the same issue of *American Arts* in which Jonathan Yardley gave his argument against funding individuals, James Backas (now executive director of the Maryland State Arts Council) made "The Case For." Backas pointed out that "Grants to individuals do not require matching funds . . . and are not intended to stimulate the marketplace or generate private giving."[28] Yet, this provision was part of the original 1965 NEA legislation and has always been a key part of its mandate. In its funding of institutions, the Endowment has always been rightly proud of the fact that its money is a small part of total funding—that the Endowment is only one player in a panoply of funders, and (as we have seen) that it provides no more than 3 percent of total funding. As Michael Straight has often pointed out, in funding individuals, the NEA is the only funder, providing 100 percent of the money needed for a project. This too is a matter of scale: the gigantic federal government being the only supporter of single citizens. The 100 percent rule tends to contradict the core purposes of the Endowment: "We're here to participate in something larger than just us, to be one of many supporters, and to help build a system for the arts of our country."

Providing 100 percent of funding to individuals may be why the NEA has increasingly looked like a private foundation. Only rarely do foundations collaborate in their granting; they

usually provide all the money for projects. By doing this for individuals, the Endowment has been foundation-like in its operations.

4. *Lack of Improvement in Quality.* Our arts today are not better than they were in the early 1960s, or the 1940s, or the 1920s; art, unlike science, does not progress or improve over time. This is true, too, of creativity; our creative arts today are not better than they used to be. In twenty-eight years of funding individual creators, the NEA has not improved American creativity; it has allowed and enabled more people to create (increased quantity), but it has not made their art better (quality). There is no reason to expect that quality is going to improve just because years pass and the government spends money. Quality is not a function of money. David Mamet, Trisha Brown, Philip Glass, Toni Morrison, and Helen Frankenthaler are exciting artists, but they are neither better nor worse than were Eugene O'Neill, Doris Humphrey, George Gershwin, John Dos Passos, and Mark Rothko. Who would maintain that today's fiction, music, poetry, and art are better than were Faulkner's and Ives's and Cummings's and Hopper's, as described by Jonathan Yardley? No: the Endowment's success and achievement with individual artists has been quantitative, not qualitative.

(In making these arguments against Endowment funding of individuals, I recognize that I will probably be rebuked by many individual artists. Interestingly, though, I am not sure that I will be attacked or faulted by the leaders of arts *institutions*. Throughout this book, I have written about the "arts community," which includes both institutions and individuals; but it should be noted here that individual artists and leaders of institutions reacted differently to the crisis, and that they see NEA's role differently. Individual artists and their organizations were the ones who fought for entitlement rights; the leaders of institutions, while technically supportive of artists' rights, remained interested mostly in what would be best for their institutions. Part of the crisis was a tension and suspicion between individuals and institutions, which made the crisis a kind of civil war within the arts.)

Those who do not agree with me, especially on my point on quality, might argue convincingly about *success*. After all, twenty-eight years is but a moment in time; perhaps we need 150 years of the NEA in order

to measure true success in American creativity and the government's support of it. Those who disagree might also point out that there have been some important successes in NEA funding: for instance, the 1990 Pulitzer Prize winners for drama (August Wilson), fiction (Oscar Hijuelos), music (Mel Powell), and poetry (Charles Simic) all received NEA fellowships in the 1980s.

In conclusion, I have to say that, while I do not favor funding individuals, if I were in charge of the NEA I would not seek to end it. Keeping the essential balance, I think, justifies continuing it. After all, individuals in 1991 took only 8 percent of NEA's available $105 million; 92 percent went to institutions. Those proportions are balanced.

There are two reasons for continuing to fund individuals. First, almost half of all NEA money in Literature and Visual Arts goes to individuals; if there were no funding of individuals, then there would be no way to be involved in direct creativity in these two very important art forms. (The only option would be to create massive subgranting programs in which organizations are funded by NEA to distribute grants to writers and visual artists—and then guarantee that no one in Congress or the country would ever object to a single grant to a person, which is impossible.)

The other reason to continue funding individuals is that it was part of the original legislation: "It is necessary and appropriate for the Federal Government to help create and sustain not only a climate encouraging freedom of thought, imagination, and inquiry but also the material conditions facilitating the release of this creative talent."[29] There were no specifics in the legislation; it was left up to the Council and chair to decide how to help individual artists. My book has traced the pain and discomfort that doing so has caused over the last twenty-eight years; but perhaps the framers of the original legislation knew something that we have forgotten or have failed to achieve. Again, twenty-eight years may be too short a testing time.

The problem is that the "climate" mentioned in the legislation has soured. The crisis has instilled fear, hesitancy, suspicion, and maybe even self-censorship into the arts community; for the rest of the twentieth century, there may be less "freedom of thought, imagination, and inquiry." Some creative artists may have lost (or may be giving up) their capacity to dare. If that is true, then the Jesse Helms who was technically defeated throughout the crisis has ended up winning.

If I were in charge at NEA, I might suggest that we take a "breather"—that for the next seven years, until the twenty-first century

begins, NEA not fund individuals. Let's experiment and see whether an absence of individual funding has any effect, quantitatively or qualitatively. I am sure there would be an effect quantitatively: that there would be fewer artists in America. But I am also sure that an absence of funding would have no effect qualitatively: that if there is a Faulkner, Ives, Cummings, or Hopper out there, he or she will still create art. Creativity is not a function of government.

Should the Endowment Primarily Serve the Arts or the People?

When Lyndon Johnson signed the National Foundation on the Arts and Humanities Act of 1965, he said that "The arts and humanities belong to the people."[30] But when the NEA went to work, it saw its role as one of serving the arts: to expand them, to make them more central in the national life, and to help pay their costs. Arts institutions and individual artists became not only the beneficiaries, but the primary constituents of the NEA; the agency came to be about them.

The panel system of approving grants, which involves arts professionals coming together to judge the work of their peers, has confirmed the closed world of the NEA. The panels made determiners of grantees. Being made up largely of arts professionals, they made the Endowment appear to behave like a foundation. When the NEA crisis came, it was an attack by America on a privileged elite.

Then came the Independent Commission in 1990. It said that "the arts and humanities belong to all the people of the United States," and that "the standard for publicly funded art must go beyond the standard for privately funded art. . . . [that] the Endowment serves all of the people rather than artists and arts institutions alone."[31] This call for a change from being private and insular to being public and inclusive, for a shift of ultimate authority from artists to citizens, was the pivotal statement of the crisis; it forced core changes in the Endowment. The agency itself, in 1991, answered the Independent Commission's call by making major changes in the panel system, by opening all Council meetings to the public, and by limiting the number of awards that can be made to any one grantee. Exclusivity was the new no-no, inclusivity the new goal.

In its first quarter-century, the Endowment's primary success was its stimulation of a vastly increased audience for the arts. By making the arts accessible, the NEA fanned audience growth, a huge quantitative

achievement. In a democracy, it makes sense for the biggest group (the audience) to be in charge, rather than a small group of artists and arts institutions. It may not be as intellectually satisfying, or even as much fun, but quantity is the strongest and the best measure. And so the Endowment, as a balanced agency, should be serving primarily the American people through the arts, rather than the arts and artists for their own sakes.

Another reason why the audience should be served is because the NEA is distributing public money, and the distribution must be in the public interest. To leave decisions only to arts professionals is to put grantees in charge of granting. The granter, not the grantee, should determine who receives funding.

To say that the audience should be served is not to say that all NEA decisions should be made by that audience. We live in a republic, not a pure democracy. Decisions are going to continue to be made by knowledgeable and sophisticated professionals. Also, to say that the audience should be served is not to say that the NEA should be funding them! We are not going to start giving citizens allowances to attend arts events. The primary beneficiaries of the NEA will and should continue to be arts organizations.

Basically, the people of America have a right not to fund what they don't like and don't want. They have no right to prevent its existing, but they have every right not to pay for it. Ensuring that the Endowment serves the people is the essence of balance; and balance is refusing to pay for something inappropriate while continuing to support the whole enterprise.

✳ ✳ ✳ ✳ ✳ ✳ ✳ ✳ ✳ ✳

The entire crisis was caused by a fundamental discrepancy between what the arts community wanted, and what the NEA, as a government agency seeking balance, could comfortably provide. What the arts community wanted is best expressed in the Final Report of the 1990 American Assembly, which says that "Government arts programs should support new work of promise that may prove risky or unpopular."[32] What the government could provide is governed by this statement in the 1990 reauthorization legislation: "The Government must be sensitive to the nature of public sponsorship."[33] The problem is simple: these two statements contradict each other. Public sponsorship makes the "risky and unpopular" dangerous, if not impossible, to support.

Public sponsorship, which is the use of tax money, requires above all *consensus*: agreement that what will be supported deserves to be; that it will be interesting to the largest possible number of taxpayers; and that it will not offend. Because of this need for consensus, government funding is inevitably going to encourage and favor the *mainstream*: the nonexperimental and the nonextraordinary. Up to now, some of the Endowment's most innovative, important, and effective funding has been of the experimental: institutions like the Brooklyn Academy of Music, the Independent Eye in Pennsylvania, Theatre X in Milwaukee, the Walker Art Center in Minneapolis, and The Group in Seattle. Organizations like these are going to continue to be funded, and should be; but they are going to continue to be the exceptions rather than the rule.

Government funding has to foster, promote, and sustain primarily the most predictable, most easily accessible art. That is the natural function of the public sector. As Russell Lynes said, "By and large the patronage that has been afforded to artists by political bodies has been conservative, riskless, and offensive to no one."[34] The essential balance lies in occasionally daring and taking risks, for the good of the arts, while continuing to support mostly what is "offensive to no one," for the good of the people.

There has always been, at the NEA, a tension between supporting the predictable and safe and supporting the strange and exotic. Dick Netzer, in *The Subsidized Muse*, says that "The federal role clearly should be dominant, perhaps even more so than it now is, for example, in supporting artistic innovation and experimentation, because the benefits of both successes and failures are nationwide."[35] In saying this, Netzer is forgetting that all four sources of support of the arts (corporations, foundations, individuals, and government) are basically and primarily conservative. They are, after all, the Establishment of America.

For two of the sources, corporations and government, the conservatism flows from quantification: the need to justify their funding in terms of numbers. Private foundations, like individuals (and unlike either government or corporations) have the freedom to be liberal, to support whatever they want; they can take flyers, go out on limbs, and indulge themselves in whatever interests them (if they can gain the approval of their boards). In the early days of the "cultural explosion," this is what the Ford Foundation and a few others were doing; and the institutions they supported, which have now become establishment, were considered to be experimental then. Now, with the post-1969 government-imposed

restrictions on them, foundations have become more cautious and more conservative, and the shrinkage of broad foundation support means that there may no longer be in the United States a prime funding source for the experimental. Individuals, of course, still have the freedom to be liberal and experimental—but most people are not, and individuals have not been organized into a national force. It is getting tighter and tougher to find the means to experiment. In a funding climate like this, the role of government should probably be to honor its mostly conservative mainstream funding function, while also enthusiastically and wholeheartedly espousing the occasional liberal or experimental artwork. The society has both, so the government should support both, in the interest of maintaining the essential balance.

✳ ✳ ✳ ✳ ✳ ✳ ✳ ✳ ✳ ✳

As these words are written, the National Endowment for the Arts is functioning with a FY 1994 budget request of $174.59 million, $130,000 more than FY 1993. (The American Council for the Arts, though, notes that to restore funding to FY 1990 purchasing power would require $260 million.[36]) The agency is crippled by the 35 percent allotment to the states and accompanying cuts in NEA programs, and by the disaffection within the arts community.

In their book *The Arts in America 1992*, Endowment leaders say, "Over the last three decades, federal investments in the arts have dramatically increased the quality, variety, and availability of the arts for the benefit of the American people."[37] This statement is only partially true. The NEA has succeeded in making the arts accessible to the American people, a noble quantitative achievement. However, the NEA has not increased the *quality* of the arts in America. If this were true, then painting, sculpting, writing, composing, and choreographing would be better today than they were in 1960—and they are not. Nor are they worse. More people are creating, and more people are consuming the creations; but the creations are neither improving nor degenerating. Nor should we expect them to. People's *use* of the arts can grow, and institutions' *delivery* of the arts can improve (and both of these things have happened, thanks in part to the NEA); but the arts themselves will not progress. The arts are not like medicine, accounting, or engineering, where old ideas are replaced with newer, better ones. The arts are like philosophy and religion, where we keep going after the same questions and trying out new answers to them.

Of course, the argument could be made that by increasing quantity (the number of artists and institutions) and stability (the ability of artists and institutions to survive) the NEA at least is laying the groundwork for quality work to be created. The question then has to be broadened beyond quantity versus quality to examine how the NEA can best serve its two constituencies: the arts world and the broader population.

TEN

Some Ideas for the Future

DAVID BRODER WROTE in March 1992 in the *Washington Post,* "A nation that cannot afford to finance its arts—even the occasionally tasteless or offensive variety—is a nation that has lost its perspective, its self-confidence, and probably its soul."[1] The question and the issue, though, is how to finance them.

In the wake of the crisis, there have been very few ideas circulated on how the federal government might do the job differently. The energy of the arts community has been expended on trying to restore the Endowment to what it used to be, not on examining new options for funding. This lack of new ideas shows that in the arts today there is an intellectual vacuum. But a book that has concentrated on how and why the crisis happened must conclude with ideas for the future.

First, I need to answer my final question: Is the NEA worth the bother? The answer is yes, most definitely. Despite the pain and the horrors of the crisis, the NEA has been a noble, honorable, and effective supporter of the arts. Quantitatively, it has made huge strides in increasing the

variety and availability of the arts for the American people. Its existence and its support have encouraged more funding from foundations, corporations, and individuals; and because it has been sometimes daring in how and what it funded, it has paved new ways in the arts and their support. The most important reason why the NEA is worth the bother is because any civilized nation should have a national government that recognizes the importance and value of the arts, and helps to pay their way. Funding the arts, in the words of the 1965 legislation, is an "appropriate" function of the federal government.

If we accept the idea that funding the arts is an appropriate governmental function, and if we have a balanced NEA that occasionally takes chances on behalf of the arts, then we must accept the fact that there will continue to be crises. In our society, there is no way to prevent them, other than to require that the NEA support only the tried, true, and dull. But if it were to do that, it would not longer be an Endowment "for the arts," because the arts embody the new, bold, and different.

Claiborne Pell is on target when he says that "the controversy [surrounding the NEA] will repeat itself every five or ten years." It is useless to spend our energies trying to prevent the inevitable crises. What we can do is to look at some ideas for how the NEA might fund the arts differently—and so maybe divert the national attention away from the government as funder toward other emphases.

For twenty-eight years, we have had an Endowment that makes discretionary grants covering no more than half the cost of projects in several thousand institutions, and all the cost of projects by hundreds of individual artists. Is this the only way to operate? Is it the best way?

Aside from a few revisions in its panel system and other operations, the NEA has not come up with major new ideas. In *The Arts in America 1992*, the Endowment says:

> In the coming decade, the [NEA] . . . will continue its efforts to foster a national climate which encourages freedom of thought, imagination, and inquiry. Part of this effort involves a clear and comprehensive articulation of the many benefits the nation and its citizens derive from the investment in public funds for the arts. At the same time, the Arts Endowment must administer federal support for the arts in order to employ and expand the existing arts infrastructure and to reach new artists and new audiences who will influence the development of our national heritage in ways we have yet to imagine.[2]

This statement recalls the concepts of "freedom of thought, imagination, and inquiry" that were at the core of the original legislation. But it really does not say much of anything, and does not go beyond the quantitative basics that have always ruled the agency.

Somewhat better is the last page of John Frohnmayer's memoir, *Leaving Town Alive*. In his summation, Frohnmayer poses some important questions:

> Can (or should) a society as diverse as ours come to some definition of American culture? Is our country's contribution to culture one of process rather than objects? Has democracy, and particularly the protection of speech, religion, and assembly under the First Amendment, had a defining effect on American culture? Does the Fifth Amendment's protection of private property always supersede the moral claim to an object of a tribe, community, or nation? Who can speak for cultural policy and teach it? Can only those who are genetically related to a culture sing its songs, dance its dances, and tell its stories, or, in a living culture, can all people use and manipulate the symbols? If culture is defined more broadly than just objects and architecture, then what are the limits?[3]

The only in-depth consideration I have seen of how the NEA should operate is Kevin V. Mulcahy's article "The Public Interest in Public Culture" in the *Journal of Arts Management and Law*, Spring 1991. Mulcahy, an associate professor of political science at Louisiana State University, testified to the Independent Commission in the hearing of August 1, 1990; his article is a revised and expanded version of that testimony. Mulcahy argues for a reorganization of the NEA away from discipline-based granting and into four broader, more NEH-like theme categories: Arts Institutions; Individual Artists; Arts Development (for Expansion-like activities); and Arts Education:

> Public culture is not synonymous with private culture. . . . The appropriate question to ask of a publicly supported arts program is not only does it measure up to private standards of artistic excellence, but how does it promote the cultural commonwealth? . . . The NEA's political problems are not likely to go away until it defines what role public culture can play as a complement to, catalyst for, and collaborator with the broader private culture. . . . The "two I's"—support for arts institutions and for Individual artists, and the "two A's"—Arts

development and Arts education . . . represent four general functions that could direct the NEA's present discipline-oriented programs toward a more generalized cultural interest and serve to alleviate some of the present perceived problems. The first function would be to provide institutional support for the basic operational and maintenance costs of selected cultural institutions. . . . Direct subsidy to institutions would be generally provided as distinct from project assistance. . . . A second, and related, NEA function might be concerned with arts development, that is, a comprehensive strategy for the investment of cultural resources. . . . The goal would be to provide greater public access to the diversity of cultural heritages in the United States and to the highest standards of artistic excellence within these different aesthetics. A third possible goal . . . is the need for increased arts education. . . . The NEA should place arts education within the context of its public cultural mission. . . . Art education may be one of the best, long-term means for realizing the goals of broad access and wide support associated with cultural democracy. . . . The NEA should continue to develop programs that assist . . . the personal growth of the creative individual. However, the question that needs to be asked with regard to individual artist programs is the same as for other cultural objectives: what public purpose is to be served? . . . The NEA might want to consider a substantial delegation of this responsibility to the state arts agencies. . . . Such an enhanced role for state arts agencies has a strong potential for success. Not unimportantly, the political fallout of an ill-advised grant would be localized and . . . less threatening to the national objectives of public culture.[4]

In suggesting a move away from specific disciplines and to four broader and more inclusive theme areas, Mulcahy is also proposing major changes in NEA panels, which he calls a "cultural coterie." He writes, "Policymaking by panel has distorted the mission of the NEA as a public arts agency. . . . Overall, the NEA . . . might be better served by a system of interdisciplinary panels . . . and broadly representative panelists, who would ensure some approximation of a public perspective on public culture."[5] Mulcahy wants the panels to represent the people more than they do the arts.

Thinking like Mulcahy's is very much in the spirit of the Independent Commission, which proposed that the American people rather than just artists be served by the NEA. I suppose the primary objectors to Kevin

Mulcahy's ideas would be the leaders of America's arts institutions, who would probably be very nervous about an Endowment not defined and controlled by (their) disciplines, and with panels that they and their friends do not control.

Three Other Options

Another option is to go even further than NASAA tried to do, and turn over most NEA money to state arts agencies: let the states and territories have the money to enlarge and bolster their own current arts subsidy programs. In a $175 million NEA budget, perhaps $130 million could go to states and territories (probably according to a formula based on population, number of arts organizations, and number of individual artists). Forty-five million dollars would stay within NEA: $30 million to be used on Challenge and Advancement (which should come from a national rather than state source); $13.5 million for national programs without state boundaries (like education, international programs, research, and public radio and television); $500,000 for administration (offices, supplies, and travel); and $1 million for a small staff. With the discipline programs all gone, panels could be mostly lay citizens, not artists; and there would be no need for a chair—the enterprise could be led by a director.

This proposal is basically a restatement of NASAA's controversial position: that the states know best what is needed to support the arts. It may have the most potential to guard against crisis, especially as crisis relates to individual artists. If the states received $130 million, they would be in charge of all individual granting (as Mulcahy suggested). Then, if there were controversy over some artist's work, it would not be a national crisis but a state crisis.

However, I do not believe that this is enough of a reason to transfer arts spending to the states. To adopt such a proposal would force the NEA to abdicate what I believe is its responsibility to provide national leadership in arts funding. There is no assurance that arts institutions or individuals would do better (get more money) from their states than they now get from the federal government. To take most of the NEA's money and distribute it to more than fifty other governments would be simply to diffuse and scatter it, not to improve its use. Besides, a greatly reduced NEA would end up being a very uninteresting place to work; that small staff would be mostly people who are not the best in their fields.

Another option is to give much more money to individuals. This option would say that "freedom of thought, imagination, and inquiry" are the point of the Endowment; that individuals, not institutions, are the ones who think, imagine, and inquire; and that the Endowment *should* be a foundation, spending not $8.35 million per year on individuals, but three and a half times that, or $29 million (and supporting not 800 artists, but 2800). A primary spokesman for this option is Edward Arian, who has published a book about the failure of the NEA called *The Unfulfilled Promise*:

> America is made up of three cultures. The first is the performance culture . . . traditional, established organizations such as orchestras, theaters, chamber ensembles, opera companies, ballet and dance companies, and museums. . . . The second culture is the creative culture. This consists of living creative artists. . . . The third culture is community arts. . . . Obviously, the creative culture and the community arts culture constitute the foundations of cultural democracy. . . . Only government support . . . can help the creative artist. . . . The nurturing of our creative artists and the personal development of all our people should be the guiding goals of our national arts policy. . . . One way to support the creative artist would be through . . . a continuing government subsidy at a rate that would support a decent life style and free the individual to pursue a full-time production of art.[6]

I have already made clear my disagreement with Arian; I simply do not favor concentrating on individuals. If we spent $29 million on supporting artists, then we could fund maybe 2800 each year; but that is still only .175 percent of the artists in the country. And if the NEA budget stays stagnant at $175 million (as seems likely), and if we want to maintain the discipline programs as they are, then spending $29 million on supporting individual artists would require giving up something else—like Challenge and Advancement grants, which cost about that much and are very important for institutions, which reach many more people than do creative artists. Individuals are just not a good buy in NEA's quantitative universe.

Susan Jane Gilman came up with another, imaginative, and amusing option for support of individual artists, in a *New York Times* op-ed piece ("New Patrons of the Arts") on April 18, 1992:

At the time of their deaths in the late 1980s, the estate of Andy Warhol was estimated at $100 million, that of Robert Mapplethorpe at nearly $100 million and Keith Haring's at $17 million. . . . What would happen if the 50 richest artists in America made one-time donations of $2.5 million [each] to an endowment administered by and for artists? An endowment of $125 million that awarded 90 percent of its interest earnings annually would be able to give out $9 million—the amount the National Endowment for the Arts currently disburses for individual grants each year. Such an endowment would not replace public financing for the arts—it would protect and supplement it. . . . By providing alternative support for controversial work, an artists' endowment could insulate the N.E.A. from political attacks while freeing up more public money for basic, crowd-pleasing projects like local symphonies and art in the schools.[7]

Ms. Gilman's idea, of course, will never be pursued; our political system does not permit such simple imaginativeness. She was basing her idea on a new way of using the private sector; she said in her article that the $175 million NEA budget is "a sum nearly impossible for private donors to generate annually."[8] I disagree with her: I think the private sector has huge fund-raising potential (witness the *Chronicle of Philanthropy's* Philanthropy 400, in which a mere thirteen arts institutions raised $340 million from private-sector sources, or almost double the NEA budget).

The third option is to concentrate on the have-nots: the arts organizations that are not part of the establishment and so do not have its funding resources. In its first twenty-eight years, the Endowment has probably had its most significant effect in funding the organizations reached through Expansion Arts and Folk Arts, which have grown exponentially in the last twenty years, now numbering over 1700. In FY 1991, these organizations, for African American, Asian American, Latino, and Native American communities, were awarded $24 million in NEA funds, or about 16 percent of the $152.5 million in grantable funds. The third option would greatly increase that percentage.

Fifteen years ago, Billy Taylor, an eminent black jazz musician and former member of the National Council on the Arts, described the special need of ethnic and minority organizations: "The major organizations have shown that they can go to businesses and wealthy individuals and come up with enormous amounts of money. This is simply not possible for smaller organizations in other art forms that are crucial to

who Americans are and what we're about."[9] Establishment organizations, for which the Endowment provides only a small portion of funding, may be very important to the Endowment from a public relations point of view; but the Endowment is not really very important to them (because NEA funds represent a tiny portion of their overall budgets and funding). Nonestablishment groups, on the other hand, are usually funded much more substantially (five to ten times the Establishment percentage); and so the effect of NEA funding is much greater for them. As Robert Hughes said in *Time* magazine, an abolition of the NEA "would do very little to alter the patterns of American 'elite' culture . . . but would fall heavily both on minorities and upon the cultural opportunities of the young, the poor, and the 'provincial.' "[10]

Livingston Biddle is one of many who have suggested that "government support be concerned chiefly with . . . areas of the arts that generally have the least appeal to private philanthropy."[11] A strong case can be made for changing the NEA's focus away from those organizations that need the money least (the Establishment) and concentrating on those that need it more (and that therefore can offer the Endowment more bang for its buck). These organizations are what Edward Arian describes as community arts: "thousands of small arts organizations and programs across the face of America serving ordinary citizens, children, ethnic and racial groups, senior citizens, and disadvantaged constituencies of all kinds. They render their services in the communities and neighborhoods, in an informal manner, as part of daily life."[12]

There may be something to be said for each of these three options; but I would choose none of them. Each would require giving up one kind of funding in order to expand another kind, and so each would destroy the essential balance.

A More Attractive Option: Education

Education in the arts has always been one of the NEA's primary concerns. That "Americans should receive in school background and preparation in the arts and humanities to enable them to recognize and appreciate the aesthetic dimensions of our lives" was part of the enabling legislation in 1965; and all NEA chairs have emphasized its importance. In 1969, the Artists-in-the-Schools Program was begun, to support artist residencies in classrooms; over time, the AIS Program was broadened into the Arts in Education (AIE) Program, which "sought to increase students' skills, awareness, knowledge, and acceptance of the

arts; enhance the skills and support the collaboration of artists, teachers, and administrators involved in arts education; and encourage cooperation among the arts and education communities."[13]

In terms of grants, the commitment to education was modest in the beginning. In FY 1968, the Endowment awarded only $181,220 in seven education grants, and the Laboratory Theatre Project (productions for school students by resident theaters in Los Angeles, New Orleans, and Providence) claimed $134,750, or 74 percent of the entire amount. When Nancy Hanks came in, education began to be emphasized more, and by FY 1978 the Endowment was awarding $5,075,172 in 93 grants in this category. In FY 1991, the Arts in Education Program made 112 grants totaling $6,498,024.* This amount was about 4 percent of the $152.5 million in grantable funds. (It should be noted, though, that in addition to Arts in Education funding, NEA makes many other grants to arts institutions that have educational purposes; it is probable that NEA is putting at least $8 to $10 million dollars a year into education overall.)

Under Frank Hodsoll's leadership during the 1980s, two major initiatives in education were developed. One was a new series on public television for arts education, which continues weekly. The other was the publication in 1988 of *Toward Civilization: A Report on Arts Education*. Specifically requested by Congress, this report defined arts education, gave a history of it in the United States, defined an arts curriculum, proposed testing and evaluation techniques, described ideal arts teachers, presented an impassioned plea for teaching the arts sequentially, and ended by saying that the NEA, "which is to arts education what the National Science Foundation is to science education, should . . . assist states, localities, and the arts education community generally to develop a clearer vision of what arts education in the United States can and should be."[14]

Still, *Toward Civilization* did not bring much change to what the NEA was doing in and for education. When the Independent Commission in 1990 looked at the whole agency, it concluded the introduction to its final report with a new call to action:

* It is interesting to note that, in the NEA's quantitative universe, arts education did not grow much between 1978 and 1991, in numbers of grants (from 95 to 112) and total money awarded ($5,075,172 in 1978 and $6,498,024 in 1991). Just to keep up with inflation, total grants should have grown by 75 percent in those thirteen years, to near $9 million.

> The Endowment must become a more visible and vigorous advocate of arts education, developing opportunities to foster partnerships with government, education, business and the arts, to provide American children an opportunity to understand and to participate in the arts. . . . The arts will not fully contribute to American life until arts education is an integral part of the education of all our children.[15]

Congress agreed with the Independent Commission, and put into the 1990 reauthorization legislation the requirement that NEA "work to increase accessibility to the arts through providing education to all Americans . . .; develop and stimulate research to teach quality education in the arts; and encourage and facilitate the work of artists, arts institutions, Federal, State, regional and local agencies in the area of education in the arts."[16] This last stipulation meant that Congress was requiring the NEA to involve *all of its constituencies* in arts education. And Congress capped its requirement by further stipulating that half of all future NEA monies above $175 million be devoted to arts education. As of 1990, Congress was insisting that the NEA concentrate on it.

When Bill Clinton came to the White House in 1993, it looked as if arts education had gained a new friend. The Clinton-Gore camp issued this statement during the campaign: "The arts should play an essential role in educating and enriching all Americans."[17] As governor of Arkansas in the 1980s, Clinton had instituted major educational reforms, including adding arts education to the high school curriculum. His new secretary of education, Richard W. Riley, impressed and pleased the arts community on Advocacy Day 1993 with a speech entitled "The Importance of the Arts in Education": "The arts, along with the other core subjects, are an integral ingredient in creating successful schools and students who can compete in our global economy."[18]

Education is one of the half-dozen primary concerns in America today. Improving American education has become a major social priority. Yet, arts programs in the schools have been decimated, due to cuts in local school budgets. Education may hold for the arts an opportunity not to be missed, and arts leaders recognize this; as John Frohnmayer says, "Arts education was at the top of almost every arts group's agenda."[19] There are very few arts institutions in our country that do not have some kind of programming in arts education. (One recent example is the publication, by the American Association of Museums, of *Excellence and Equity: Education and the Public Dimension of Museums*, which calls on museums to make education their primary function.)

The fact that nearly all arts institutions concentrate on education opens up an extraordinary opportunity for the NEA: *to devote all of its institutional grants to arts education.* Let the NEA fund only what our museums, performing arts companies, and community arts centers do in education; let organizations apply for funding of services to grade school and high school students, programs for college and university students, training of artists, colloquies, seminars, conferences, or research; and let the agency encourage its grantees to experiment to find new ways to reach and serve people educationally. I am willing to bet that nearly all our arts institutions, large and small, could find educational purposes that would merit funding at least equal to their FY 1991 grants. (If we found that institutions could not match their standard NEA grant levels, then we could drop the rule that NEA awards no more than 50 percent of a project's cost, and award 70 or 80 percent of an educational project. Conversely, there would have to be a way to limit grants to organizations devoted *only* to education, like Young Audiences, so that the Endowment does not end up paying 100 percent of their costs.)

Adopting an idea like this would not cover everything; there would still be a need for other programs, like Individuals, International, Research, State and Local arts agencies, perhaps arts service organizations, maybe even other education not centered in institutions. One major question would be how to fit in Challenge and Advancement (which fund institutions)—whether inside or outside the education emphasis. The structure of the Endowment under an education emphasis might be much like that proposed by Kevin Mulcahy: a generalization moving away from discipline-based granting and involving more broadly representative panels, perhaps with more citizens than artists. My education idea could make the NEA much more an agency that serves the American people while maintaining the levels of support that it provides for arts institutions; and so everybody wins.

We have seen in this book that institutions now get almost two-thirds of NEA money: in FY 1991, $96.7 million of $152.5 million grantable (and before the crisis, in FY 1988, they got $108 million of $150.6 grantable, or nearly 72 percent); so the education option gives the Endowment a way to protect the bulk of its money and a high percentage of its constituency. After all, no one is going to object to education as a purpose, as a reason for the Endowment to exist and to support the arts of America. The education option puts NEA on the side of the angels, and allows it to continue to fund arts institutions fully and for the good of the American people.

My Own Options

Earlier, when discussing denial of funding and censorship, I made the point that there is a big difference between *allowing* something and *subsidizing* it. Allowing is passive; subsidizing is active. The NEA got into trouble by being too active. The future may rest in finding ways to be creatively and dynamically passive: to fund the arts, basically, by *doing* as little as possible!

I have two ideas for Endowment support of institutions that build upon the strengths of American philanthropy. The first idea, which I call "The Audit Allowance," provides automatic giving by NEA based on what an institution raises elsewhere, from other sources. The second idea, which I call "The 10 Percent Benefit," basically replaces the NEA with a vast expansion of individual giving. Both ideas reward those institutions that have captured the support of other, nonfederal sources. The American government should be supporting most the groups that involve the most different funders: I am trying to find a way for the government, in its funding, to follow the rest of the society.

The Audit Allowance

This idea provides an automatic "allowance" from the federal government to institutions based upon giving to them from non-NEA sources. It starts with all institutions that seek funding sending to NEA their last five independent audits by a certified public accountant. The audits must include specified giving from five sources: state and local governments, foundations, corporations, and individuals (in short, all non-NEA givers). NEA takes the audits from these submitting institutions for all five years, and comes up with a total amount of money that has been given to all institutions over the five years by all non-NEA sources. Then, NEA adds up all the money that it has given to those same institutions in the same five years, for a second total. (The first total is in billions, the second in millions.) NEA then divides the second total by the first total, to give it a percentage of all non-NEA giving that NEA giving represents for those five years. This is the NEA percentage that future NEA giving will be.

In any year in which an institution wants a grant, it must submit an independent audit by a certified public accountant for the previous year; and that audit must specify giving by all non-NEA sources. The NEA examines the audit, determines how much money the institution raised

from non-NEA sources in the previous fiscal year, and awards a grant that is the NEA percentage of that non-NEA giving.

For example, at the start of the program, a museum submits five audits in which non-NEA giving over five years adds up to $40 million. All audits from all institutions add up to $25 billion in non-NEA giving in the five years. NEA giving to all the institutions in those five years adds up to $500 million, which means that the NEA percentage is 2 percent. In the first year of the audit allowance, the museum submits an audit from the previous year that shows that it raised $10 million from all non-NEA sources (better than its average in the five years). So NEA's grant to the museum is $200,000 (2 percent of $10 million).

Obviously, the institution that steadily does better in raising money from state and local governments, foundations, corporations, and individuals (ie., non-NEA sources) also gets more funding from the American government: that is the government following the society.

After the audit allowance starts, the NEA percentage should be recalculated every three years. If the next ten years are like the last twenty, then non-NEA giving will grow substantially. This could mean that the NEA percentage goes down, in later calculations, especially if NEA money stays stagnant; and this could mean that the Endowment would become progressively less important to American arts institutions (because its grants are declining). But the institutions would be better off: they would have ever more money from various other sources, and be ever less dependent on the federal government. On the other hand, if NEA budgets rise substantially and institutional funding also rises, then the NEA percentage would also rise over the years; and so institutions would get more NEA money, as they should.

What is exciting about the audit allowance is that it can be for the entire arts community. Different institutions have different strengths in their fundraising; establishment groups tend to get most of their money from the private sector, and alternative nonestablishment groups are often most heavily supported by local governments. The audit allowance, though, does not consider *where* the money comes from; it cares only about the fact of support from a variety of sources outside the federal government. Groups like the Jamaica Arts Center, which gets most of its funding from the City of New York (local government), and Meet the Composer, which gets most from foundations, are accounting for just as much in the mix as are the Metropolitan Opera and the Boston Museum of Fine Arts and the Houston Symphony and the Seattle Repertory Theatre, whose funding comes mostly from people.

By calling this idea an "allowance," I am suggesting that there is a certain inevitability to it. Any 501(c)3 (tax exempt) arts institution that can submit an independent audit with specified giving is eligible to receive funding on the basis of the NEA percentage; and perhaps that funding is then an entitlement! By being an automatic system, the audit allowance removes discretion from the granting process; it allows the NEA, unlike a foundation, to boast about its partnership with the other funders in their giving. The audit allowance allows the NEA to be dynamically and creatively passive: to help by doing as little as possible.

The 10 Percent Benefit

Individuals are by far the primary supporters of the arts in the United States. It is sobering to realize that European countries, which traditionally have supported their arts only with government funding, are now coming to us to learn how to activate and enlist their private sectors. America is the only country in the civilized world that has a huge individual involvement in arts funding; that is the genius of our system. If there is to be a new way for the NEA, it must be one that involves the federal government and individuals in a collaboration; and so it must be a way that relates to taxation. Tax deductibility of contributions is a gigantic government subsidy—much larger than any government program of modest direct support. In 1964 (the year before the NEA was created), Alvin Toffler in *The Culture Consumers* said it plainly: "The federal government can do incomparably more—more than has been dreamed of—for the arts through imaginative manipulation of the machinery of taxation than it can in any other way."[20]

When a person gives $100 to his or her favorite theater, museum, or arts center, and deducts that $100 on Form 1040, the federal government "foregoes" or loses the tax on that $100. Let's assume that the average tax rate for people giving to the arts is 30 percent; so the government "foregoes" $30 on the $100 gift. I showed earlier that individuals, in 1991, gave $7.29 billion to the arts, culture, and humanities; removing humanities from this, individuals probably gave near $6 billion to arts institutions that year. This $6 billion was sixty-two times the Endowment's $96.7 million in grants to arts institutions in 1991. If everyone who gave deducted the gift on Form 1040, then the federal government lost $1.8 billion in tax revenues, or more than eighteen times the money that NEA gave to institutions that year. This shows

again the smallness of NEA compared to individual giving, and, I think, the potential of individual giving to take the NEA's place.

Let us imagine a system in which American individuals are allowed to take an *extra tax deduction* for any money they give in a year to an arts institution. As will be seen, I am proposing that the extra deduction be 10 percent; this means that for every $100 given, a person can deduct $110 on Form 1040. Let us also imagine that for 60 percent of the dollars given to arts institutions, the extra deduction is taken (for the other 40 percent, people are simply unaware of the extra deduction or do not take it). And let us agree that the average tax rate for people giving to the arts is 30 percent, which means that the additional tax "foregone" by the government is 30 percent of the 10 percent.

For example: a ballet company raises $1 million from individuals in a year. The extra deduction is taken on $600,000. At 10 percent, the extra deduction on all gifts is $60,000. At the 30 percent tax rate, the taxes lost by the government are $18,000. The ballet company is not getting this $18,000; all that is happening is that the government is giving it up. It is a kind of "phantom" gift. But I think it has potential to become a new kind of government subsidy, and its growth potential is phenomenal.

My idea is that the 10 percent benefit could replace the NEA's institutional funding. Let individual givers take the extra deduction; let the government forego the tax on that extra deduction; and let the foregoing be the federal government's support. This is the most passive idea of all: the Endowment does nothing—support is provided by the Internal Revenue Service not receiving taxes!

I have chosen 10 percent as the extra deduction because that is what is needed to deliver the $108 million that NEA gave to institutions in FY 1988, the last year before the crisis:

$7.29	B	Individual giving to arts/culture/humanities, 1991
$6.00	B	Individual giving to arts
$3.60	B	Extra deduction taken on 60 percent of the giving
$360.00	M	Extra deduction at 10 percent
$108.00	M	Taxes foregone

The extraordinary potential of the 10 percent benefit can be seen by looking at how it would play with the Philanthropy 400. On that list in the *Chronicle of Philanthropy*, I found thirteen American arts institutions that raised in 1991–1992 $340 million from the private sector.* Since 82.7 percent of private giving comes from individuals, we can say that these thirteen raised about $281.2 million from individuals. Let's now trace this through the 10 percent benefit idea:

$281.20	M	Individual giving
$168.72	M	Extra deduction taken on 60 percent of the giving
$16.87	M	Extra deduction at 10 percent
$5.06	M	Taxes foregone

The thirteen arts institutions in the Philanthropy 400 received just over $3 million from NEA in FY 1991; so my 10 percent benefit idea would have the government giving up 67 percent more money than NEA awarded. Again, it should be stressed that the thirteen institutions would not be receiving the extra $5.06 million; all that would happen is that the government would be giving it up in tax revenues.

Because of the complete absence of money coming to them (no NEA grants), it might be nearly impossible to convince the arts community that the 10 percent benefit idea is worth considering. Why should they give up an almost sure thing for something that looks like a crazy alternative?

The reason lies in the awesome potential of the 10 percent benefit to change the rules completely over time. The idea would have arts institutions saying to people, "Give to us, and get to deduct 110 percent of your gift." It would have the government saying to people, "We're getting out of this, and we'll reward you for taking our place." A pair of messages like these could lead to gigantic growth in the numbers of individual givers. (A further way to stimulate giver growth might be to allow to first-time givers, in their first year of giving, a 20 percent extra deduction: a kind of extra bonus for getting involved.) Over time, the scale of individual giving could balloon dramatically:

* In order of magnitude of giving, they were the New York's Metropolitan Museum, Metropolitan Opera, Boston's Museum of Fine Arts, National Gallery, Art Institute of Chicago, Los Angeles County Museum of Art, Lincoln Center, Music Center of Los Angeles County, Kennedy Center, Museum of Modern Art, Indianapolis Museum of Art, New York City Ballet, and Chicago Symphony.

	Year 1	Year 6	Year 10
Individual giving	$6.00 B	$10.00 B	$15.00 B
% taking extra deduction	60%	80%	90%
Extra money deducted	$3.60 B	$8.00 B	$13.50 B
10% extra deduction	$360.00 M	$800.00 M	$1.35 B
Taxes forgone @ 30%	$108.00 M	$240.00 M	$405.00 M

Under the 10 percent benefit idea, the function of government is no longer to be making grants; it is to be stimulating giving by individual Americans. As I have shown in the chart just above, there is potential to have individual giving in Year 10 be two and a half times what it is now. If it were $15 billion then, it would be more than 150 times what the National Endowment gave to institutions in FY 1991. Institutions then would no longer need an NEA; they would have much more money from people, which is the purest, least entangled kind of money to get. And the federal government, by doing nothing except foregoing taxes, would have greatly increased its commitment to the arts: it would be forfeiting $405 million rather than spending $175 million.

As I have said, it might be very difficult to persuade the arts community to go with the 10 percent benefit idea. It fits best establishment institutions with the largest number of individual givers and the strongest connections to private money, and it rewards organizations with the best fund-raising departments. There are many other organizations—mostly alternative, experimental, and minority ones—that do not have many individuals on their side and for which NEA funds have always been a bigger percentage of both budget and funding (and which any government should be supporting). It would be essential to continue programs that serve such organizations. And surely there may be institutions (museums, theaters, orchestras, dance and opera companies, and their service organizations) that do not involve large numbers of individual givers and so would not benefit from my idea. If the 10 percent benefit idea were to be instituted, perhaps it should be *optional*: another program that an institution could become involved in if it chose. Maybe 20 to 30 percent of grantable funds might end up coming out of such a program. Over time, NEA would find itself needing less money for granting (because mainline institutions would be sustained by individuals enjoying the tax forfeiture). Maybe $75 to $85 million now granted by NEA to establishment institutions could eventually be removed from

the NEA budget; and a lower-budget agency with a smaller staff could concentrate on the alternative-experimental-minority functions that may suit government better. Both sides could end up winning: the establishment, by the government encouraging individuals to sustain it, and the nonestablishment groups, by the government concentrating its grants programs on it.

It is possible, I think, that either of my two ideas might work throughout the nonprofit sector. The arts could lead the way, by being a test case. Other nonprofit institutions—schools, colleges, hospitals, libraries, whatever is well connected to generous individuals—could be treated by the federal government in the same way.* (No single institution by itself should be allowed to participate; the plan should be made available only to entire industries.) Ideas like these could change American philanthropy and American government dynamically.

In presenting my two ideas, I am not suggesting that they are the only way to go; I am simply looking for ways for the federal government to be passive but effective. I would hope that if we get a reconsideration of the NEA, my ideas could be considered. Other government crises of the last thirty years, like Vietnam and Watergate, have led to analysis and reform. We have a right to expect that the NEA crisis, too, will allow us as a nation to look in depth at this whole enterprise, and plan a better future for it. There should be, in the next few years, not just another "blue-ribbon" study, but a comprehensive, careful, insightful, and challenging analysis of the Endowment: where it has come, where it should go, and how it should function—not only on behalf of the arts, but on behalf of the American people. Such an analysis might cost half a million dollars, and that money should come only half from the federal government; the other half should come from foundations, corporations, and even individuals. As I have shown in this book, the NEA is not the only player.

* But some would never want it. For instance, CARE has a budget of $330 million, of which $290 million comes from the federal government in money and food. CARE would never give up that kind of federal subsidy for an extra deduction system.

AFTERWORD

On Leadership

THE NEA CRISIS had a subtext: the lack of leadership in America.

In this country, we have thousands of celebrities, but very few leaders. Our politics, business, education, religion, social services, and the arts all lack people who provide true inspiration and guidance for their fellow citizens and for institutions. When we have people who seem to be leaders, either we assassinate them, or we let the media destroy them.

The NEA crisis would not have happened if our president had stood up in May 1989 and had told us, strongly and persuasively, that the religious right, their cohorts in Congress, and the media were being ridiculous and should not be heeded. I keep thinking about John F. Kennedy: if he had been in the White House then and had spoken with the grace and eloquence that he used at Amherst College, he could have laughed off the crisis and buried it. The crisis could also have been averted by an NEA chair with sophistication, vision, and persuasion skills. There was also very little leadership in either Congress or the arts community, both of which were riddled with pettiness and meanness.

As this is written, actress Jane Alexander has just been confirmed to be the next NEA chair. She comes to the job with no political experience or connections; but being well known, she might be someone around whom we can rally. Her lack of management experience need not be a problem, because the chair's job now is not so much to run the agency, but rather to be out in the country, rebuilding confidence and consensus.

We must hope that Jane Alexander will be a real leader, one who fulfills a superb definition of leadership: "the capacity to dream dreams, and have visions, and so to articulate those dreams and visions that other people, of their own volition, say yes."

If Jane Alexander is that kind of leader, then the rest of us can and will follow, and say "yes" to a continuation of the National Endowment for the Arts.

Notes

INTRODUCTION

1. Frank Hodsoll, letter to the author, 31 March 1993.
2. John Frohnmayer, *Leaving Town Alive: Confessions of an Arts Warrior* (Boston: Houghton Mifflin, 1993), 70.

ONE

1. American Council for the Arts, *The Arts and Humanities Under Fire: New Arguments for Government Support* (New York: ACA, 1990), 9.
2. Russell Lynes, *The Lively Audience: A Social History of the Visual and Performing Arts in America, 1890–1950* (New York: Harper and Row, 1985), 393.
3. Charles Christopher Mark, "I Find the Actions of the Congress Very Confusing," *Arts Reporting Service* (11 September 1989): 1.
4. Dick Netzer, *The Subsidized Muse: Public Support for the Arts in the United States* (New York: Cambridge University Press, 1978), 53.

5. Michael Straight, "A New Artistic Era (If the Money Lasts)," *The New York Times*, 20 October 1974.

6. Alexis de Toqueville, *Democracy in America*, ed. Richard D. Heffner (New York: Mentor Books, 1956), 169.

7. *Ibid.*, 111.

8. *Ibid.*, 172.

9. Fannie Taylor and Anthony L. Barresi, *The Arts at a New Frontier: The National Endowment for the Arts* (New York: Plenum Press, 1984), 8.

10. Russell Lynes, *op. cit.*, 396–397.

11. Fannie Taylor and Anthony L. Barresi, *op. cit.*, 8.

12. Russell Lynes, *op. cit.*, 397.

13. Dick Netzer, *op. cit.*, 47.

14. Judith Balfe and Margaret Wyszomirski, "Public Art and Public Policy," *Journal of Arts Management and Law* 15, no. 4 (Winter 1986): 11.

15. Fannie Taylor and Anthony L. Barresi, *op. cit.*, 9–10.

16. Russell Lynes, *op. cit.*, 202.

17. Claire S. Chow, "Looking Back on the Federal Theatre Project," *Cultural Post* (November/December 1976): 6.

18. Alvin Toffler, *The Culture Consumers: A Study of Art and Affluence in America* (New York: St. Martin's Press, 1964), 192.

19. Claire S. Chow, *op. cit.*, 6.

20. Michael Straight, *Nancy Hanks: An Intimate Portrait* (Durham, NC: Duke University Press, 1988), 93.

21. Gary D. Larson, *The Reluctant Patron* (Philadelphia, PA: University of Pennsylvania Press, 1983), 98.

22. Russell Lynes, *op. cit.*, 417–418.

23. Anthony Keller, "Patrons and Policies," *American Arts* (November 1983): 10.

24. Russell Lynes, *op. cit.*, 421.

TWO

1. Philip Hart, *Orpheus in the New World: The Symphony Orchestra as an American Cultural Institution* (New York: W.W. Norton, 1973), 355.

2. *Remarks of the President upon Receiving Honorary Degree of Doctor of Laws, Amherst College*, Office of the White House Press Secretary (26 October 1963): 5.

3. Philip Hart, *op. cit.*, 354.

4. *Ibid.*, 127.

5. Fannie Taylor and Anthony L. Barresi, *op. cit.*, 29.

6. Dick Netzer, *op. cit.*, 59.

7. Livingston Biddle, *Our Government and the Arts: A Perspective from the Inside* (New York: ACA Books, 1988), 52–55.

8. Livingston Biddle, interview with the author, 4 May 1993.

9. Albert A. Blum, ed., *The Arts: Years of Development, Time of Decision* (Austin, Texas: University of Texas Press, 1976), 18.

10. *Congressional Declaration of Purpose Establishing the National Endowment for the Humanities and the National Endowment for the Arts; National Foundation on the Arts and Humanities Act of 1965*, Public Law 89-209 (Washington, D.C.: U.S. Government Printing Office, 1975), 1.

11. William J. Baumol and William G. Bowen, *Performing Arts: The Economic Dilemma* (New York: Twentieth Century Fund, 1966), 359.

12. *Remarks of the President at the Signing of the Arts and Humanities Bill*, Office of the White House Press Secretary (29 September 1965): 1–3.

13. Fannie Taylor and Anthony L. Barresi, *op. cit.*, 67.

14. *Ibid.*, 67–68.

15. Livingston Biddle, *Our Government and the Arts*, 159.

16. Frank Getlein, "The Man who's Made 'the Most Solid Contribution to the Arts of Any President Since F.D.R.,'" *The New York Times*, 14 February 1971.

17. William J. Baumol and William G. Bowen, *op. cit.*, 367.

18. Margaret Wyszomirski, "The Politics of Art: Nancy Hanks and the National Endowment for the Arts," in *Leadership and Innovation: Entrepreneurs in Government*, ed. Jameson W. Doig and Erwin C. Hargrove (Baltimore, Maryland: Johns Hopkins University Press, 1990), 176.

19. Michael Straight, *Nancy Hanks*, 142.

20. Philip Hart, *op. cit.*, 356.

21. Charles Christopher Mark, *Reluctant Bureaucrats: The Struggle to Establish the National Endowment for the Arts* (Dubuque, IA: Kendall/Hunt Publishing, 1991), 158–159.

22. Philip Hart, *op. cit.*, 357.

23. Fannie Taylor and Anthony L. Barresi, *op. cit.*, 97–99.

24. *Ibid.*, 99.

25. Richard F. Shepard, "Stevens and Heckscher Discuss Fund Crisis in Arts," *The New York Times*, 8 April 1969.

26. Roger L. Stevens, "Putting It Together," *Cultural Affairs* (Summer 1969): 8.

THREE

1. Andrew Glass, "She's an Artist at Getting Money for the Arts," *The New York Times*, 14 December 1975.

2. Livingston Biddle, *Our Government and the Arts*, 318–319.

3. Leonard Garment, interview with the author, 4 May 1993.

4. Andrew Glass, *op. cit.*

5. Nancy Hanks, "The Arts in America: A Single Fabric," *Museum News* (November 1973): 47.

6. Margaret Wyszomirski, "The Politics of Art: Nancy Hanks and the National Endowment for the Arts," in *Leadership and Innovation: Entrepreneurs in Government*, 178.

7. Michael Straight, *Nancy Hanks*, 389.

8. Nancy Hanks, "Active Voice," *Cultural Post* (November/December 1976): 2.

9. David Dempsey, "Uncle Sam, The Angel," *The New York Times*, 24 March 1974.

10. Michael Straight, *Nancy Hanks*, 329–331.

11. *Ibid.*, 333.

12. "Tax Money for Arts: What It Is Buying," *U.S. News and World Report*, 5 February 1973, 84.

13. Fannie Taylor and Anthony L. Barresi, *Op cit.*, 138.

14. Michael Straight, *Nancy Hanks*, 158.

15. Michael Straight, *Twigs for an Eagle's Nest: Government and the Arts, 1965–1978* (New York: Devon Press, 1979), 27.

16. Fannie Taylor and Anthony L. Barresi, *op. cit.*, 139.

17. Michael Straight, *Twigs for an Eagle's Nest*, 28.

18. Michael Straight, *Nancy Hanks*, 142.

19. Ana Steele, in an interview with Margaret Wyszomirski, as quoted in "The Politics of Art: Nancy Hanks and the National Endowment for the Arts," 199.

20. National Endowment for the Arts, *New Dimensions for the Arts: 1971–1972* (Washington, D.C.: NEA, 1973), 29.

21. "Viewpoint: A.B. Spellman," *Cultural Post* (July/August 1980): 14.

22. Michael Straight, *Nancy Hanks*, 214.

23. "Challenge Grants," *Cultural Post* (November/December 1976): 1.

24. "Special Supplement," *TCG Newsletter* (15 October 1976): 3.

25. "The Endowment of Livingston Biddle," *The New York Times*, 5 November 1977.

26. Lawrence D. Mankin, "The National Endowment for the Arts: The Biddle Years and After," *Journal of Arts Management and Law* 14, 2 (Summer 1984): 62.

27. Laura Foreman, "Arts Leaders Meet in Capital on Practical Issues," *The New York Times*, 19 June 1977.

28. Grace Glueck, "John Brademas, The Congressman They Call 'Mr. Arts,'" *The New York Times*, 4 September 1977.

29. National Endowment for the Arts, *1981 Annual Report* (Washington, D.C.: NEA, 1981), 481.

30. "Culture: Populism vs. Elitism," *Newsweek*, 31 October 1977, 39.

31. "Bringing the Best to the Most," *The New York Times*, 3 August 1977.

32. John Friedman, "A Populist Shift in Federal Cultural Support," *The New York Times*, 13 May 1979.

33. "Celebrating Agnes de Mille's Home-Grown Choreography," *The New York Times*, 4 July 1976.

34. Michael Straight, *Nancy Hanks*, 381–382.

35. Hilton Kramer, "The Threat of Politicalization of the Federal Arts Program," *The New York Times*, 16 October 1977.

36. National Endowment for the Arts, *Program Announcement for Institutional Advancement Grants* (Washington, D.C.: NEA, 1980), 2.

37. Livingston Biddle, *Our Government and the Arts*, 486.

38. Livingston Biddle, interview with the author, 4 May 1993.

39. Livingston Biddle, *Our Government and the Arts*, 398

40. *Ibid.*, 399–400.

41. *Ibid.*, 400.

42. John Friedman, "A Critical Congressional Study," *The New York Times*, 13 May 1979.

43. Frank Hodsoll, interview with the author, 3 May 1993.

44. "Carter Scored on Arts Aid," *The New York Times*, 24 August 1977.

FOUR

1. Ronald Reagan, "Opinions on the Arts," *American Arts* (May 1980): 21.

2. Carla Hall, "Reagan and the Endowments," *Washington Post*, 23 November 1980.

3. "What's Next for the Arts?" *American Arts* (March 1981): 16.

4. "50% Cut in U.S. Arts Aid Drafted by Budget Head," *The New York Times*, 7 February 1981.

5. Livingston Biddle, *Our Government and the Arts*, 496.

6. *Statement by the President on the Task Force on the Arts and Humanities*, Office of the White House Press Secretary (6 May 1981).

7. "Living and Thriving Forever: An Interview with Charlton Heston," *American Arts* (July 1981): 17–18.

8. Presidential Task Force on the Arts and the Humanities, *Report to the President* (Washington, D.C.: U.S. Government Printing Office), 1981.

9. Livingston Biddle, *Our Government and the Arts*, 506.

10. Frank Hodsoll, "The Arts: Maintaining the Momentum," *Cultural Post* (May/June 1982): 2.

11. Grace Glueck, "A Federal Benefactor of the Arts Comes of Age," *The New York Times*, 10 November 1982.

12. Richard Goldstein, "Art Beat: The Politics of Culture," *Village Voice*, 28 December 1982.

13. Frank Hodsoll, interview with the author, 3 May 1993.

14. William H. Honan, "Making Arts Grants: Intuition or Formula?" *The New York Times*, 21 April 1988.

15. Letter from Congressman Mario Biaggi to NEA Chair Frank Hodsoll, 18 January 1984.

16. Letter from Hodsoll to Biaggi, 2 February 1984.

17. U.S. Congress, House Subcommittee on Postsecondary Education, *Hearing on the Grant Making Process of the National Endowment for the Arts*, 28 June 1984.

18. Kevin V. Mulcahy and Harold F. Kendrick, "Congress and Culture: Legislative Reauthorization and the Arts Endowment," *Journal of Arts Management and Law* 17, 4 (Winter 1988): 40.

19. "House Passes Freeze on NEA, NEH and IMS Funding," *ACA Update* (29 August 1985): 2–3.

20. Irvin Molotsky, "House Panel Blocks Move to Censor Arts Funding," *The New York Times*, 15 September 1985.

21. "National News," *Report to the Field* (Trenton, NJ: New Jersey State Council on the Arts, 1985), 5.

22. "House Subcommittee Holds Last Hearing on NEA, NEH, IMS Reauthorizations," *ACA Update* (30 September 1985): 7.

23. Kevin V. Mulcahy and Harold F. Kendrick, *op. cit.*

24. "Reauthorization of the NEA, NEH, and IMS Signed Into Law by President," *ACA Update* (31 December 1985): 12.

25. Pat Williams, interview with the author, 4 May 1993.

26. Richard Bernstein, "Subsidies for Artists: Is Denying a Grant Really Censorship?" *The New York Times*, 18 July 1990.

27. Fannie Taylor and Anthony L. Barresi, *op. cit.*, 107.

28. Russell Lynes, "After Hours: How to Make Politics from Art, and Vice Versa," *Harper's*, August 1969, 24.

29. Michael Straight, *Twigs for an Eagle's Nest*, 15.

30. John Updike, *Hugging the Shore* (New York: Alfred A. Knopf, 1983), 418.

31. Paul DiMaggio, "Decentralization of Arts Funding from the Federal Government to the States," in *Public Money and the Muse: Essays on Government Funding for the Arts*, ed. Stephen Benedict (New York: W.W. Norton, 1991), 249.

32. Peter J. Ognibene, "Charlton Heston Talks Candidly About the NEA and Its Impact," *Horizon* (September 1985): 15.

33. National Endowment for the Arts, *So Here They Are* (Washington, D.C.: NEA, 1990), 3.

34. American Association of Fund-Raising Counsel, *Giving USA 1991* (New York: American Association of Fund-Raising Counsel, 1992).

35. Dick Netzer, "Who Benefits? The Distributional Consequences of the Nonprofit Sector" (paper delivered at a Conference of the Center for the Study of Philanthropy and Voluntarism, Durham, NC, 29–30 November 1990), 6.

36. "The Philanthropy 400," *The Chronicle of Philanthropy* (3 November 1992): 27–35.

37. Telephone interview with Diane Berry-Pardee, Business Committee for the Arts, in response to an 18 September 1992 letter from the author.

38. "Corporate Giving to the Arts Dipped 18% in 3 Years," *The Chronicle of Philanthropy*, 12 January 1993.

39. Paul DiMaggio, "Can Culture Survive the Marketplace?" *Journal of Arts Management and Law* 13, no. 1 (Spring 1983): 72.

40. Edward Rothstein, "The Tully Behind the Hall Turns 90," *The New York Times*, 16 September 1992.

FIVE

1. John Frohnmayer, *op. cit.*, 52.

2. Hugh Southern, interview with the author, 4 May 1993.

3. Livingston Biddle, interview with the author, 4 May 1993.

4. Peter J. Boyer, "Mean for Jesus," *Vanity Fair*, September 1990, 225.

5. *Ibid.*

6. Richard Bolton, ed., *Culture Wars: Documents from the Recent Controversies in the Arts* (New York: New Press, 1992), 27.

7. *Ibid.*, 28.

8. *Ibid.*, 31.

9. *Ibid.*, 29–30.

10. Hugh Southern, interview with the author, 4 May 1993.

11. "Corcoran Cancels Mapplethorpe Exhibition," *New Art Examiner* (June 1989): 62.

12. Freeborn G. Jewett and David Lloyd Kreeger, "The Corcoran: We Did the Right Thing," *Washington Post*, 29 June 1989.

13. Barbara Gamarekian, "Corcoran, to Foil Dispute, Drops Mapplethorpe Show," *The New York Times*, 14 June 1989.

14. Letter from members of the House of Representatives to Hugh Southern, acting chair, National Endowment for the Arts, 8 June 1989.

15. Charlotte R. Murphy, "At the Corcoran, a Chilling Case of Censorship," *Washington Post*, 18 June 1989.

16. Robert Brustein, "Don't Punish the Arts," *The New York Times*, 23 June 1989.

17. Hilton Kramer, "Is Art Above the Laws of Decency?" *The New York Times*, 2 July 1989.

18. Bruce Selcraig, "Reverend Wildmon's War on the Arts," *The New York Times*, 2 September 1990, 24.

19. Sidney Yates, interview with the author, 3 May 1993.

20. Elizabeth Kastor, "Art and Accountability: Yates Proposes Changing NEA Grant Procedure," *Washington Post*, 22 June 1989.

21. Richard Bolton, *op. cit.*, 73–74.

22. *Ibid.*, 78.

23. *Ibid.*, 121.

24. *Ibid.*

25. Sidney Yates, interview with the author, 3 May 1993.

26. Edward deGrazia, *Girls Lean Back Everywhere: The Law of Obscenity and the Assault on Genius* (New York: Random House, 1992), 681.

27. Richard Bolton, *op. cit.*, 92.

28. Helen Frankenthaler, "Did We Spawn an Arts Monster?" *The New York Times*, 17 July 1989.

29. Barbara Gamarekian, "Arts Endowment Plans Its Strategy," *The New York Times*, 12 May 1990.

30. Richard Bolton, *op. cit.*, 354–355.

31. Testimony by Jessica Tandy, quoted in *American Theatre* (August 1990): 34.

SIX

1. Richard Bolton, *op. cit.*, 147–148.
2. *Ibid.*, 148–149.
3. *Ibid.*, 350.
4. John Frohnmayer, *op. cit.*, 138.
5. Gerald Harris, "My Brief on Lenny Bruce," *The New York Times*, 19 September 1990.
6. Jon Pareles, "Raunchy Rap from the 2 Live Crew," *The New York Times*, 20 July 1990.
7. Jon Pareles, "Louisiana Legislators Take a New Attitude toward Song Lyrics," *The New York Times*, 19 July 1990.
8. Larry Rohter, "Two Families Sue Heavy-Metal Band as Having Driven Sons to Suicide," *The New York Times*, 17 July 1990.
9. Glenn Collins, "Judge Upholds X Rating for Almodovar Film," *The New York Times*, 20 July 1990.
10. Judith Balfe and Margaret Wyszomirski, "Public Art and Public Policy," *Journal of Arts Mangement and Law* 15, no. 4 (Winter 1986): 27.
11. Katherine Bishop, "Nude Photos of Children Spark Obscenity Debate," *The New York Times*, 23 July 1990.
12. Dick Netzer, *The Subsidized Muse*, 78.
13. Joan Simpson Burns, *The Awkward Embrace: The Creative Artist and the Institution in America* (New York: Alfred A. Knopf, 1975), 95.
14. Stephen Sinclair, "CPB: A Model for the Endowment?" *Cultural Post* (September/October 1981): 11.
15. Edmund L. Andrews, "Government Seeks to Extend Ban on Broadcast of Offensive Shows," *The New York Times*, 13 July 1990.
16. "Mapplethorpe's Photos Now an F.C.C. Issue," *The New York Times*, 17 August 1990.
17. *Ibid.*
18. Barbara Gamarekian, "Arts Aide Backs Cincinnati Museum," *The New York Times*, 30 March 1990.
19. Isabel Wilkerson, "Test Case for Obscenity Standards Begins Today in an Ohio Courtroom," *The New York Times*, 24 September 1990.

20. "Museum Is Acquitted: Mapplethorpe Case Ends in 'Not Guilty' Verdict for Dennis Barrie and Arts Center," *American Theatre* (November 1990): 44.

21. Michael Straight, *Nancy Hanks*, 352.

22. Russell Lynes, "After Hours: How to Make Politics from Art, and Vice Versa," 24.

23. James Backas, "In Defense of the Endowment," *American Arts* (September 1981): 22.

24. Carol Lawson, "Papp Urges Replacing U.S. Arts Endowment with State Agencies," *The New York Times*, 21 February 1981.

25. Barbara Gamarekian, "Arts Endowment Faces Challenge From the States' Arts Agencies," *The New York Times*, 16 May 1990.

26. Letter from Jonathan Katz to the author, 17 March 1993.

27. Pat Williams, interview with the author, 4 May 1993.

28. Barbara Gamarekian, "Arts Endowment Faces Challenge From the States' Arts Agencies."

29. Peter Zeisler, "Has Courage Vanished?" *American Theatre* (August 1990): 5.

30. Hugh Southern, interview with the author, 4 May 1993.

31. Paper on the NASAA proposal by Anthony J. Radich, executive director of the Missouri Arts Council, 12 June 1990.

32. Pat Williams, interview with the author, 4 May 1993.

33. Peter J. Boyer, *op. cit.*, 271.

34. Barbara Janowitz, "NEA Chronicle: 30 Days That Shook the Arts," *American Theatre* (September 1990): 37.

35. *Concluding Statement of the United Arts Group*, 25 May 1990.

36. Pat Williams, interview with the author, 4 May 1993.

37. Richard Bolton, *op. cit.*, 356.

38. Barbara Janowitz, *op. cit.*, 45–46.

SEVEN

1. Peter J. Boyer, *op. cit.*, 264–265.

2. Edward deGrazia, *op. cit.*, 639.

3. National Endowment for the Arts, *General Information and Guidance for Fellowship and Individual Project Grant Recipients* (Washington, D.C.: NEA, revised November 1989).

4. John Frohnmayer, *op. cit.*, 133–134

5. *Ibid.*, 134.

6. Sidney Yates, interview with the author, 3 May 1993.

7. John Frohnmayer, *op. cit.*, 87.

8. Edward deGrazia, *op. cit.*, 644.

9. William H. Honan, "The Endowment vs. the Arts: Anger and Concern," *The New York Times*, 10 November 1989.

10. *Ibid.*

11. *Ibid.*

12. *Ibid.*

13. Edward deGrazia, *op. cit.*, 645.

14. "Frohnmayer Says He'll Seek End of Art Grant Law," *The New York Times*, 16 November 1989.

15. Nicols Fox, "An Orderly Demise?" *New Art Examiner* (January 1992): 21.

16. Edward deGrazia, *op. cit.*, 646.

17. William H. Honan, "Arts Chief's Potholed Paths to a Grants Decision," *The New York Times*, 20 November 1989.

18. Barbara Gamarckian, "Committee Opens Hearings on Grants to the Arts," *The New York Times*, 16 November 1989.

19. Livingston Biddle, interview with the author, 4 May 1993.

20. "Editorial," *New Art Examiner* (October 1990): 9

21. "Bending to the Political Winds, the NEA Cuts Off Grants to Four Artists Amid Charges of Censorship," *People*, 6 August 1990.

22. *Ibid.*

23. *Ibid.*

24. Rowland Evans and Robert Novak, "The NEA's Suicide Charge," *Washington Post*, 11 May 1990.

25. John Frohnmayer, *op. cit.*, 178.

26. All quotations in this paragraph are from Barbara Gamarekian, "Arts Agency Denies Four Grants Suggested by Advisory Panel," *The New York Times*, 30 June 1990.

27. John Frohnmayer, *op. cit.*, 188.

28. *Ibid.*, 195.

29. "New NEA Flap Over Conflict of Interest," *American Theatre* (October 1990): 61.

30. John Frohnmayer, *op. cit.*, 195.

31. William H. Honan, "Two Who Lost Arts Grants Are Up for New Ones," *The New York Times*, 2 August 1990.

32. "New Endowment Panel to Watch for Obscenity," *The New York Times*, 24 August 1990.

33. Barbara Gamarekian, "Arts Agency Chairman Backs Pledge on Obscenity," *The New York Times*, 18 September 1990.

34. "Frohnmayer Rejects Grant for Boston Show," *The New York Times*, 23 October 1990.

35. William H. Honan, "U.S. Arts Chief Overturns an Approval," The New York Times, 27 November 1990.

36. William H. Honan, "Arts Council Rejects Decency Rules for Advisers," The New York Times, 15 December 1990.

37. Barbara Gamarekian, "Arts Endowment Reverses a Stand," *The New York Times*, 5 January 1991.

38. "One Wrong Dance Step, and It's Curtains," Letter to the Editor, *The New York Times*, 24 August 1990.

39. "Are Artists Godless Perverts?" *Time*, 10 September 1990.

40. Edward deGrazia, *op. cit.*, 666, 671–672.

41. Lindy Zesch, "Sondheim, Stegner Spurn White House Honor," *American Theatre* (August 1992): 48.

42. Richard Bolton, *op. cit.*, 353–354.

43. "'Frohnmayer Four' Sue NEA," *New Art Examiner* (October 1990): 13.

44. Barbara Janowitz, *op. cit.*, 44.

45. ArtTable, *The Impact of Government on the Arts: Money, Legislation, Censorship, an ArtTable Panel Discussion*, 2 October 1989 (New York: American Council for the Arts, 1989).

46. Richard Bolton, *op. cit.*, 358.

47. *Ibid.*, 357–358.

48. "Court Rules Against NEA Obscenity Pledge," *American Theatre* (March 1991): 35.

49. Edward deGrazia, *op. cit.*, 678.

50. Leonard Garment, "The Feds and the Arts: Where It Went Wrong," *Washington Post*, 25 February 1992.

51. Pat Buchanan, "Losing the War for America's Culture," *The Washington Times*, 5 May 1989.

52. Pat Buchanan, "Pursued by Baying Yahoos," *The Washington Times*, 2 August 1989.

53. Pat Buchanan, "Where a Wall is Needed," *The Washington Times*, 27 November 1989.

54. William H. Honan, "Frohnmayer Says He'll Seek End of Art Grant Law," *The New York Times*, 16 November 1989.

55. John Frohnmayer, *op. cit.*, 80.

56. "To See or Not to See," *Newsweek*, 2 July 1990, 50.

57. Gladys Engel Lang and Kurt Lang, "Public Opinion and the Helms Amendment," *Journal of Arts Management and Law* 21, no. 2 (Summer 1991): 127–139.

EIGHT

1. Richard Bolton, *op. cit.*, 122.

2. Sam Hope, "A Critique: The Continuing Crisis Distills an Old Idea," *Journal of Arts Management and Law* 20, no. 3 (Fall 1990): 90.

3. Leonard Garment, interview with the author, 4 May 1993.

4. "Independent Commission at Work," *Dance USA Update* (September 1990): 21.

5. "Bipartisan Independent Commission Unanimously Opposes Specific Content Restrictions on NEA-Funded Art, Urges Sweeping Reforms in Arts Endowment System," news release from the Independent Commission, 11 September 1990.

6. Margaret Wyszomirski, "A Preface to the Special Issue," *Journal of Arts Management and Law* 20, no. 3 (Fall 1990): 4.

7. John Frohnmayer, *op. cit.*, 210.

8. Independent Commission, *A Report to Congress on the National Endowment for the Arts* (September 1990), 2, 57.

9. *Remarks of the President at the Signing of the Arts and Humanities Bill*, Office of the White House Press Secretary, (29 September 1965), 3.

10. Hilton Kramer, "A Critique from the *New York Observer*, 1 October, 1990." Reprinted in *Journal of Arts Management and Law* 20, no. 3 (Fall 1990): 84.

11. Leonard Garment, interview with the author, 4 May 1993.

12. Independent Commission, *Report*, 57, 91.

13. "President Bush Reaffirms Support for the NEA Without Restrictions," *ACA Update* (March/April 1990): 3.

14. Pat Williams, interview with the author, 4 May 1993.

15. Barbara Gamarekian, "Compromise on Endowment Sought," *The New York Times*, 13 June 1990.

16. William H. Honan, "Legislators Rebuff One-Year Extension for U.S. Arts Panel," *The New York Times*, 7 June 1990.

17. Richard L. Berke, "House Approves Compromise Bill to Continue the Arts Endowment," *The New York Times*, 12 October 1990.

18. Martin Tolchin, "Supporters Vow to Save Compromise on Arts Endowment," *The New York Times*, 18 October 1990.

19. Pat Williams, interview with the author, 4 May 1993.

20. Both Kyros and Frohnmayer are quoted in William H. Honan, "Finding Fault with New Arts-Grant Law," *The New York Times*, 10 November 1990.

21. Kim Masters, "The NEA's Long and Winding Road," *Washington Post*, 29 October 1990.

22. William H. Honan, "Arts Endowment Takes and Then Gives Away," *The New York Times*, 22 December 1990.

23. Barbara Gamarekian, "Frohnmayer Says Grants Are Being Spread Thinner," *The New York Times*, 22 February 1991.

24. Letter from Shirley M. Green, Special Assistant to the President for Presidential Messages and Correspondence, to Mr. and Mrs. James Edward Stark, Jr., 3 August 1990.

25. "Where's Mr. Bush on the Arts?" *The New York Times*, 4 July 1990.

26. Andrew Rosenthal, "Bush's Balancing Act Over Financing of Arts," *The New York Times*, 19 June 1990.

27. Bill Lichtenstein, "The Secret Battle for the NEA," *Village Voice*, 10 March 1992.

28. John Frohnmayer, *op. cit.*, 294.

29. Minutes of the 111th Meeting of the National Council on the Arts, 31 January and 1 February 1992, 21–22.

30. Barbara Janowitz, "Council Kills 2 Grants to Visual Arts Centers," *American Theatre* (April 1992).

31. Pat Buchanan, in *The Washington Times* of 21 February 1992, quoted in *American Theatre* (May 1992): 43.

32. Michael Kramer, "Searching in Vain for the True Bush," *Time*, 9 March 1992, 26.

33. Mendoza, Lichtenstein, and Serrano all quoted in "Frohnmayer Steps Down," in *For Your Information* (New York: New York Foundation for the Arts, Spring 1992).

34. Kim Masters, "Frohnmayer Decries Cultural War," *Washington Post*, 24 March 1992.

35. John Frohnmayer, "Talking Points" (remarks at the *International Conference on Free Expression and Global Media: Barriers and Boundaries*, Washington, D.C., 23 March 1992), 12.

36. Anne-Imelda Radice, opening remarks to the National Council on the Arts, 1 May 1992, quoted in *Opera America Newsline* (June 1992): 3.

37. Barbara Janowitz and Ed DuRante, "NEA Vetoes Unleash Protests, Walkouts," *American Theatre* (July/August 1992): 47.

38. "Chairman's Decision on Declining to Fund Applications from the List Center and the Anderson Gallery," press statement released by the National Endowment for the Arts, 12 May 1992.

39. "Rock to the Rescue," *Time*, 1 June 1992, 89.

40. Brooklyn Museum/Franklin Furnace, *Too Shocking to Show* (New York: Brooklyn Museum/Franklin Furnace, 1992).

41. "U.S. Arts Endowment Rejects Grants for Gay Film Festivals," *The New York Times*, 21 November 1992.

42. "House Backs Restrictions on Arts Grants," *The New York Times*, 17 October 1991.

43. Maureen Dezell, "Helms's New Pals," *Boston Phoenix*, 25 October 1991.

44. David Kelly, "Crane Bill Would Kill NEA Funding," *The Hollywood Reporter*, 20 November 1991.

45. "Compare and Contrast: Quotes from the Platforms," *The New York Times*, 16 August 1992.

46. "Where They Stand," *American Theatre* (June 1992): 47.

47. William H. Honan, "U.S. Panel on Arts May Be Revived," *The New York Times*, 16 November 1992.

48. National Endowment for the Arts, *Annual Report 1991* (Washington, D.C.: NEA, 1991), 11.

49. Advertisement from the American Family Association, *The New York Times*, 4 April 1993.

50. William H. Henry III, "A Cheap and Easy Target," *Time*, 9 March 1992, 72.

51. Peter Zeisler, *op. cit.*

52. *The Arts and Humanities Under Fire*, 9–10.

53. Stephanie Coen, "Golub Takes Grassroots Approach," *American Theatre* (March 1993): 32–33.

54. "Five National Arts Service and Membership Organizations Launch Initiative To Support National Endowment for the Arts," press release, 25 June 1992, 2.

55. National Cultural Alliance, *Summary*, a one-page statement of purpose, undated.

56. "Study Shows Americans Understand Value and Importance of the Humanities and the Arts," press release from the National Cultural Alliance, 16 February 1993.

57. National Endowment for the Arts, Washington, D.C. Research Division Note #50, 25 October 1993.

58. David Kissinger, "The Pressure's On: Government Controversies Threaten Private Giving," *Vantage Point* (Fall 1990): 6.

59. Livingston Biddle, interview with the author, 4 May 1993.

60. Hugh Southern, interview with the author, 4 May 1993.

61. "Orchestra's Budget Woes," *Washington Post*, 15 June 1992.

62. Barbara Janowitz, "Theatre Facts 92." *American Theatre* (April 1993): 2.

63. National Endowment for the Arts, *The Arts in America 1992* (Washington, D.C.: NEA), II-9.

64. "110,000 Charities Created in 3 Years, Study Finds," *The Chronicle of Philanthropy*, 5 November 1991, 34.

65. Vince Stehle, "Increased Financial Troubles in the Arts," *The Chronicle of Philanthropy*, 8 October 1991, 1.

66. Philip Morris, in conversation with the author, 31 October 1991.

67. Transcript of *This Week with David Brinkley* (Washington, D.C.: ABC News, 23 February 1992), 17.

68. Leonard Garment, *op. cit.*

69. Leonard Garment, interview with the author, 4 May 1993.

NINE

1. Richard Bernstein, "Subsidies for Artists: Is Denying a Grant Really Censorship?" *The New York Times*, 18 July 1990.

2. Timothy Healy, "In Defense of Freedom," *Vantage Point* (Spring 1990): 4.

3. Richard Bernstein, *op. cit.*

4. Ronald Berman, "Lobbying for Entitlements: Advocacy and Political Action in the Arts," *Journal of Arts Management and Law* 21, no. 3 (Fall 1991): 259.

5. Richard Bernstein, "The Endowment: A Reflective Defense of It and a Show that Tweaks It," *The New York Times*, 14 August 1990.

6. Richard Bernstein, "Subsidies for Artists: Is Denying a Grant Really Censorship?"

7. Joan Jeffri and Robert Greenblatt, "Between Extremities: The Artist Described," *Journal of Arts Mangement and Law* 19, no. 1 (Spring 1989): 11.

8. *National Foundation on the Arts and the Humanities Act of 1965.* 89th Congress, Public Law 89-209 (Washington, D.C.: U.S. Government Printing Office, 1975).

9. Michael Straight, *Nancy Hanks*, 143–144.

10. Charles Christopher Mark, "Where Has All The Money Gone?" *Arts Reporting Service* (19 March 1973), 4.

11. Hugh Southern, interview with the author, 4 May 1993.

12. Mary Ann Tighe, "Deputy Chairman's Statement," *NEA Annual Report* (Washington, D.C.: NEA, 1979), 8–9.

13. "The Independent Commission's Report to Congress on the National Endowment for the Arts," *Journal of Arts Management and Law* 20, no. 3 (Fall 1990): 57–58.

14. "Nancy Hanks Explains Arts Endowment," *The Washington Star*, 29 September 1975.

15. "An Interview with Frank Hodsoll," *American Arts* (January 1982): 9.

16. *The Arts and Humanities Under Fire*, 4.

17. Robert Porter, *op. cit.*

18. *The Arts in America 1992*, II-15-II-17.

19. Michael Straight, *Nancy Hanks*, 333–334.

20. Jonathan Yardley, "The Case Against," *American Arts* (May 1982): 11.

21. ArtTable, *op. cit.*

22. Anthony Keller, "An Interview with Laurie Anderson," *Journal of Arts Management and Law* 13, no. 1 (Spring 1983): 143, 147–148.

23. John Updike, *Odd Jobs* (New York: Alfred A. Knopf, 1991), 121–122.

24. Edward deGrazia, *op. cit.*, 661.

25. "Subsidies for Artists: Is Denying a Grant Really Censorship?" *The New York Times*, 18 July 1990.

26. John Updike, *Odd Jobs*, 863.

27. Leonard Garment, interview with the author, 4 May 1993.

28. James Backas, "The Case For," *American Arts* (May 1982): 11.

29. *National Foundation on the Arts and the Humanities Act of 1965*, 1.

30. *Remarks of the President at the Signing of the Arts and Humanities Bill*, Office of the White House Press Secretary (29 September 1965), 3.

31. The Independent Commission, *A Report to Congress on the National Endowment for the Arts* (September 1990), 57, 91.

32. Stephen Benedict, *op. cit.*, 259.

33. *National Foundation on the Arts and the Humanities Act of 1965*, 2.

34. Russell Lynes, *The Lively Audience*, 394.

35. Dick Netzer, *The Subsidized Muse*, 167.

36. American Council for the Arts, "Advocates Urged to Act on Behalf of NEA," *ACA Update* (July 1993): 7.

37. *The Arts in America 1992*, I-3.

TEN

1. David Broder, "Who's Afraid of the Arts?" *Washington Post*, 11 March 1992.

2. *The Arts in America 1992*, I-3.

3. John Frohnmayer, *op. cit.*, 342.

4. Kevin V. Mulcahy, "The Public Interest in Public Culture," *Journal of Arts Management and Law* 21, no. 1 (Spring 1991): 9–23.

5. *Ibid.*, 19.

6. Edward Arian, *The Unfulfilled Promise: Public Subsidy of the Arts in America* (Philadelphia: Temple University Press, 1989), 6, 7, 103, 108.

7. Susan Jane Gilman, "New Patrons of the Arts," *The New York Times*, 18 April 1992.

8. *Ibid.*

9. Billy Taylor, "Toward a More American Tradition," *Cultural Post* (September/October 1978): 11.

10. Robert Hughes, "Whose Art Is It, Anyway?" *Time*, 4 June 1990, 47.

11. Livingston Biddle, *Our Government and the Arts*, 486.

12. Edward Arian, *op cit.*, 6.

13. *The Arts in America 1992*, III-1.

14. National Endowment for the Arts, *Toward Civilization: A Report on Arts Education* (Washington, D.C.: NEA, 1988), 171–173.

15. Conclusion of *Introduction to The Independent Commission's Report to Congress on the National Endowment for the Arts* as reprinted in *Journal of Arts Management and Law* 20, no. 3 (Fall 1990), 15.

16. *The Arts in America 1992*, III-2.

17. "Clinton/Gore Position on the Arts," *ACA Update* (December 1992): 2.

18. Richard W. Riley, "The Importance of the Arts in Education," *ACA Update* (March/April 1993): 11.

19. John Frohnmayer, *op cit.*, 315.

20. Alvin Toffler, *op cit.*, 202.

Index

Joseph Wesley Zeigler has been for twenty-five years a consultant to arts institutions in long-range planning, audience and market research, programming, marketing and communications, and funding. He has helped hundreds of arts institutions address their futures and the world around them.

A graduate of Harvard College, Mr. Zeigler also studied at the Yale School of Drama. He has taught graduate courses at Brooklyn College, City University of New York, New York University, Adelphi, and SUNY-Purchase. He is a consulting editor of the *Journal of Arts Management, Law and Society* and the author of *Regional Theatre: The Revolutionary Stage*, published by the University of Minnesota Press in 1973 and by DaCapo in 1977.